WALKING FLAGSTAFF

A Photo Journal by George Breed

Soulstice
PUBLISHING

books with *soul* • Flagstaff, AZ

Walking Flagstaff
A Photo Journal by George Breed

© 2020 by George Breed

ISBN: 978-1-7331887-7-7 (hardcover)
Library of Congress Control number: 2020917165

Book Editor: Julie Hammonds
Photo Editor: Jake Bacon
Graphic Designer: Rudy Ramos
Proofreader: Catherine Bell

Front cover: Mural "Sound of Flight" by Sky Black and Mural Mice Universal artists R.E. Wall and Margaret Dewar

Author photo © Jake Bacon

SOULSTICE PUBLISHING
PO Box 791
Flagstaff, AZ 86002
(928) 814-8943
contact@soulsticepublishing.com
www.soulsticepublishing.com

Solvitur ambulando:
it is solved by
walking around.

<div align="right">–Diogenes</div>

DO YOU MIND IF I TAKE YOUR PICTURE?

George Breed stepped out of his front door to go for a walk one day, and in the process has become a Flagstaff legend through his "Walking Flagstaff" photographs, which most discover in his social media posts.

In an age when many spend their lives in the frantic rush of trying to do it all, George walks through life and our community at a slower pace. He doesn't just stop to smell the roses and photograph them; he stops to talk with cats as he follows an undetermined path through the neighborhoods and alleyways of Flagstaff.

With an open spirit, a mischievous smile, and a genuine curiosity about EVERYTHING, George moves among us, capturing the everyday things that so many of us are too busy to see.

What's unusual about George's work is its sheer breadth. Many photographers quickly specialize, drawn to what speaks to them or what they find they're good at, be it landscape photography, portraiture, wildlife, or street photography. It's a rare thing to find a photographer who feathers his nest with such diverse discoveries across a range of photographic niches.

Over the years that George has spent walking Flagstaff, he's stopped to chat with hundreds if not thousands of the characters who make this community what it is. From artists to shopkeepers, judges to the homeless, a child riding a first bike to an old man fishing by the side of a pond, George takes the time to stop and talk with each before gently asking, "Do you mind if I take your picture?" His camera is an Olympus point-and-shoot that fits snugly in one hand.

As the chief photographer at Flagstaff's daily newspaper, the *Arizona Daily Sun*, I thought I was the person documenting life in our community. It was a pleasant surprise to discover George's work years ago. Since then, he's become a mentor.

What draws me to George's work is how he approaches his subjects over time, subjects that each of us sees as staples of our community, that we see every day and that, to a degree, fade into the background. George looks at those subjects with fresh eyes and keeps looking. He has photographed the Nativity of the Blessed Virgin Mary Catholic Church in every season and from every angle. In these pages, you'll discover detail shots of the gargoyles and crosses; photos of the church under snow, monsoon clouds, and rainbows; and a sublime series taken months and years apart, showing the church floating across the sky in various puddles.

This is what sets George apart. With the simplest of cameras, he sees new ways to capture the beauty all around us. That beauty could be something as simple as weathered wood clothespins on a rusty wire washing line, or it could be legions of plastic pink flamingos lining the edge of a manicured lawn.

As a documentarian moving through our community, he captures moments in time and preserves what is and what was. Many of the subjects that have stood before George's lens are gone now: buildings torn down; blank walls covered with new, vibrant murals; and people who once flavored the taste of our community now memories and stories to be told with a smile and a misty eye. You will see some of these things and people scattered across these pages.

Each photo is its own story. Take the one George shot from a ridgeline looking down at a crossroads in a valley. A white pickup truck is about to arrive at the intersection. Without any accompanying text, George has created an image filled with mystery and promise. There is nothing visible to make any of the four directions stand out, and yet the driver below is about to make a decision. Where is that person going? Where did they come from? How long did the photographer wait to compose the perfect moment?

While they do not need words, the stories that accompany some of the images are almost as magical as the photos themselves. As I was editing thousands of George's photos for this book, friends asked how I chose 250 photos from the 4,500 candidates he offered from his archive of 50,000?

My answer is a simple one. The photos and, in some cases, the stories that accompany them chose themselves. I've also been asked if I have a favorite, and without hesitation, it is the raven's cough.

Once again, the image could speak for itself, and if there were no back story, I would still be drawn to it. An adult raven sits in profile on a fence, feathers ruffled against the cold. At the moment the camera shutter opens, the raven coughs out a white cloud of vapor in the perfect shape of an angel's face. It's an incredible moment, perfectly witnessed and perfectly captured.

Every time I see the image, I hear George's voice. "I was walking along the road with no particular direction in mind, just walking along, when I passed an alley. The raven was down in the alley and was looking at me and yelling. I told him to hold on, that I was coming, and went down to see what he had to say. I walked up to him and told him I was here. That's when he coughed."

To me, the story of how this image was captured sums up the beauty of George Breed's photography. It's what sets his work apart from that of all the other talented photographers who call this community home. George feels a pull and surrenders to the urge to move through our community. He goes where his camera takes him,

but he is also open to many other inputs that may direct his walk. Along the way, he may take photos, but in his interactions with cats, architecture, and the characters of our home, he gives so much back.

George's photos are iridescent threads that weave together to reflect the fabric of the very special place that is Flagstaff. I hope that as you walk through this collection of George Breed's work, you get a sense of what it is to slow down and see, to appreciate how much beauty there is all around us if we just step outside our front door and go looking for it.

–Jake Bacon, photo editor
Flagstaff, Arizona
July 2020

He called
to me as I
walked past
a downtown
alley. No
one else was
around. Loud!
Insistent! I
turned in. He
flew to the
chain link
fence, sat
waiting. As I
took his photo,
he breathed
out an angel.

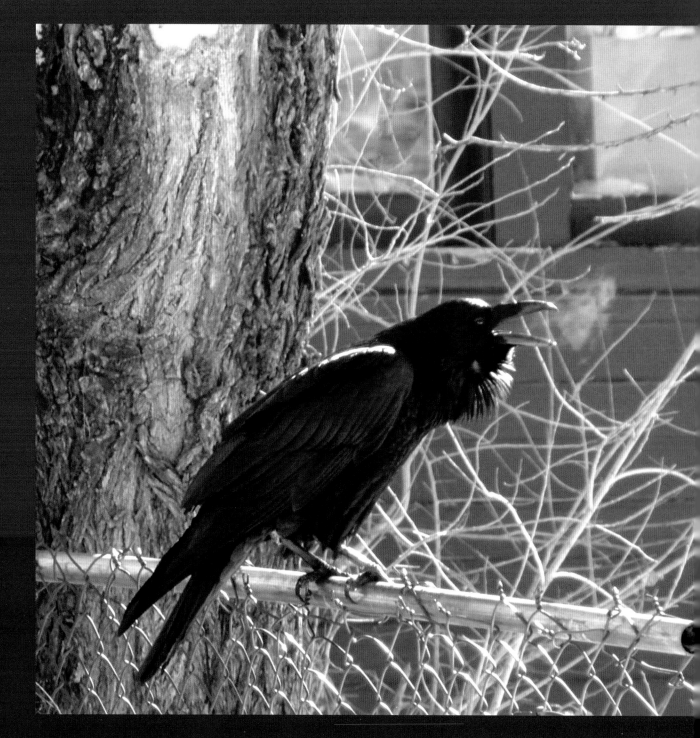

WELCOME

I walked almost every day from
2010 to 2019 through different
parts of the small town of Flagstaff,
Arizona. I wanted to share what I
saw. I bought a camera, learned
how to use it, and began taking
photos. Here is a selection. I hope
you enjoy looking at these images
as much as I enjoyed taking them.

–George Breed

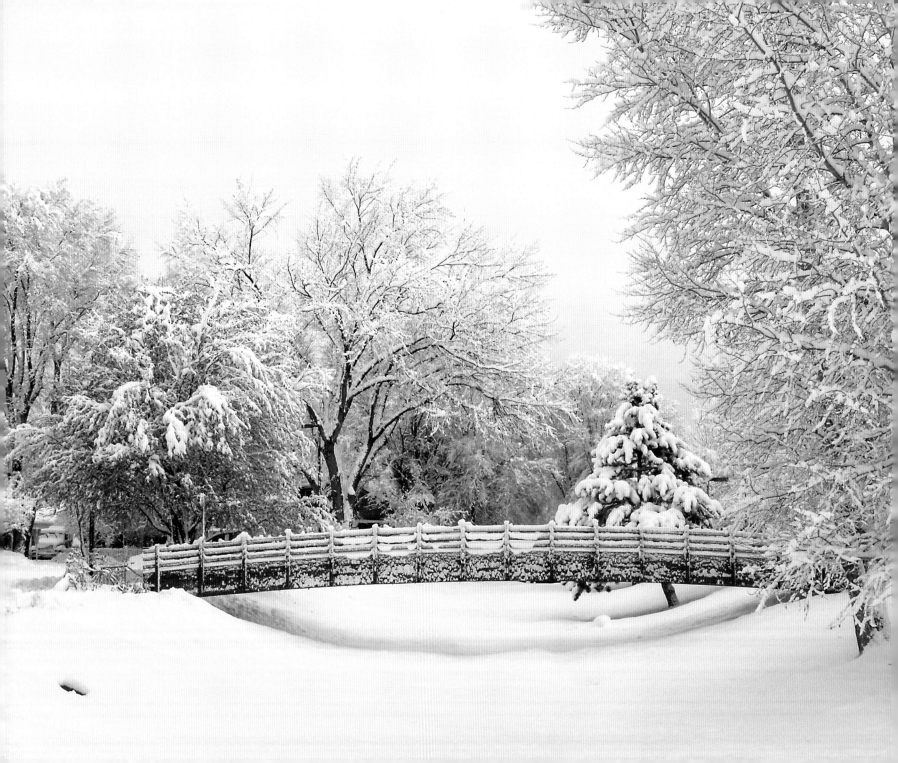

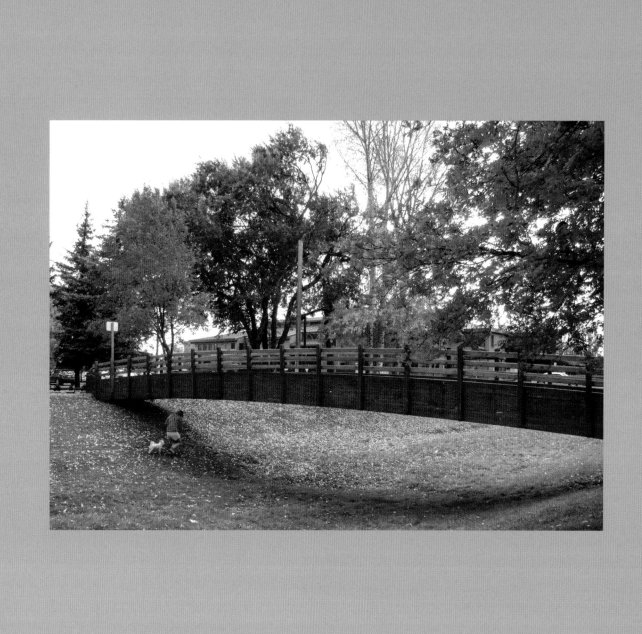

3

In these peculiar times, I am going to pretend that I live in a small town at the base of a dormant volcano surrounded by forest containing elk, deer, fox, lion, bear, eagle, and raven, and in a community in which my neighbors are friendly, helpful, and conversational, and hiking trails leading miles in several directions are just outside the front door, and a local library and a large university library provide an immense source of books and journals, and artists and musicians of all types and of incredible talent are met casually on the streets, and where interfaith dialogue and conversation are taken as normal, and martial artists of various disciplines open their dojo doors, and the dress code is laid-back-as-you-like-it, and the town is dark at night, allowing spectacular views of planets and stars and the Milky Way.

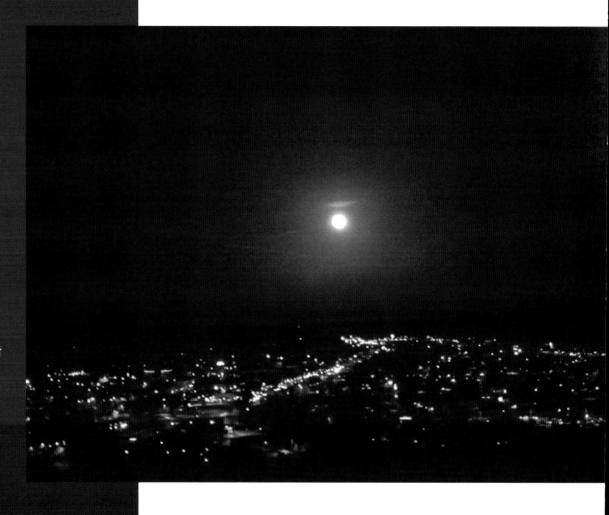

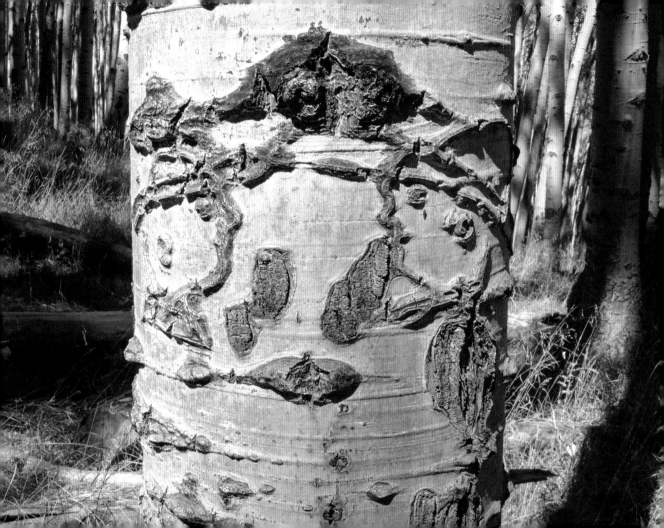

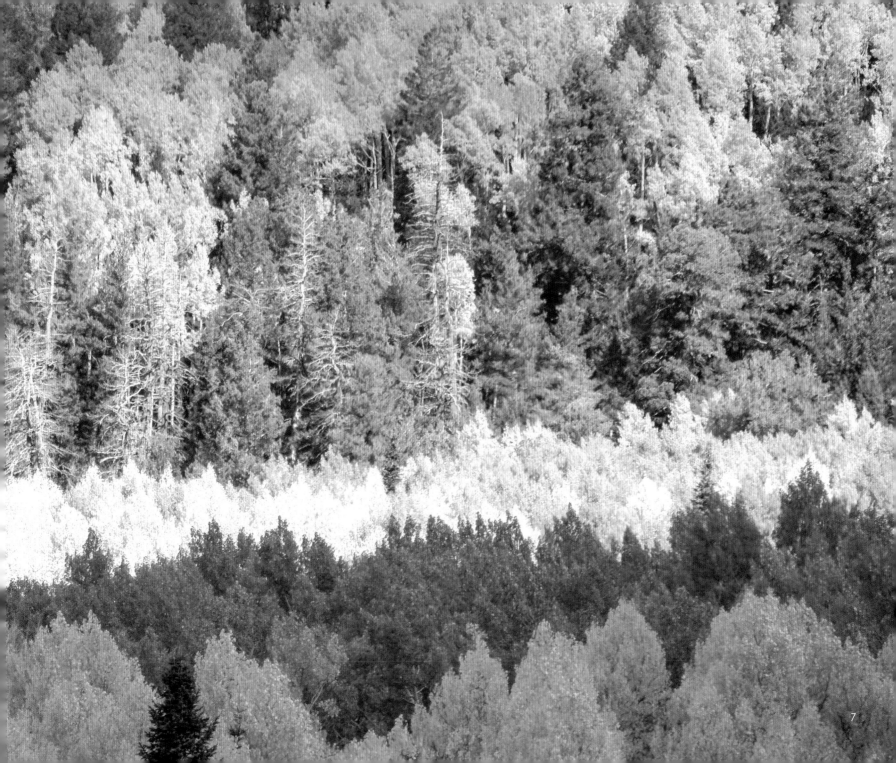

7

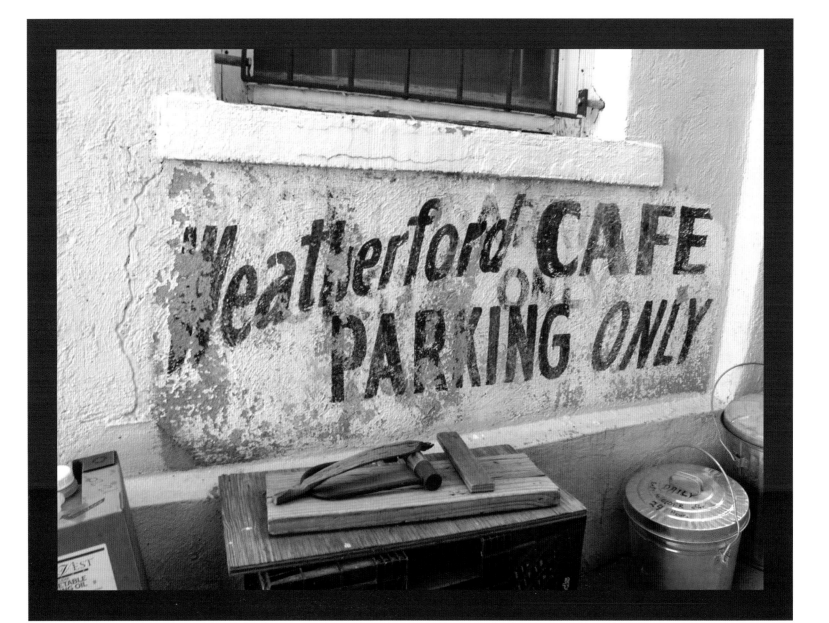

I walk around until I stop trying to accomplish something. Then I start taking photos.

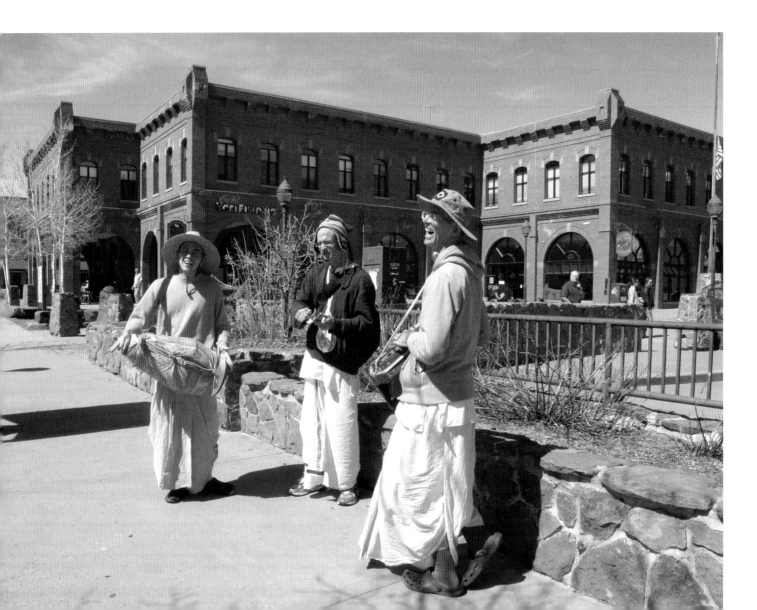

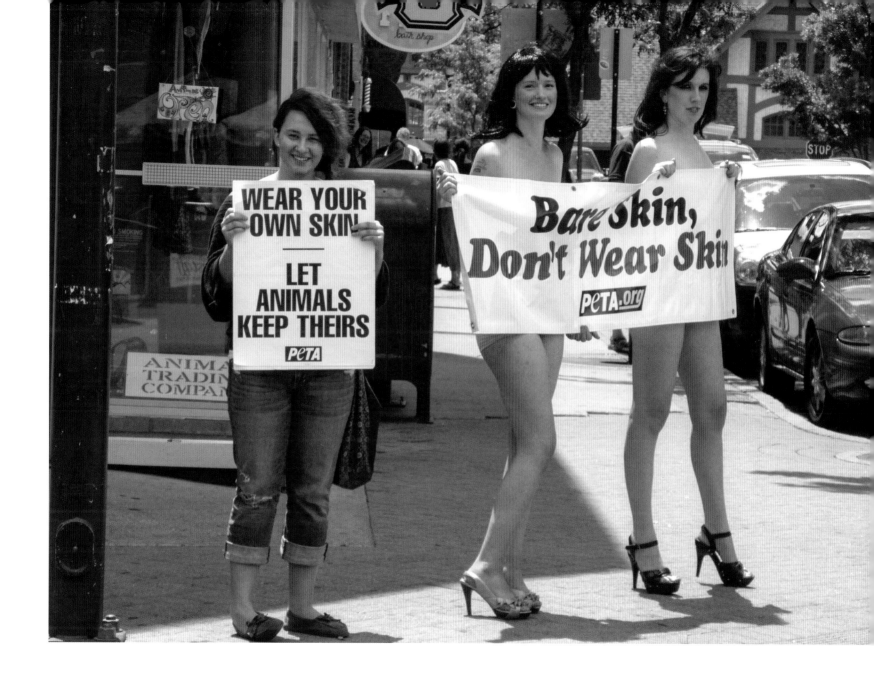

When we get out of our houses and cars and put our feet on the ground, we inherit the feel of the air on our face, the earthy smell of a fresh rain, the sky of birds in flight. When we walk about the land, it becomes ours while we are simultaneously possessed by it. It is given to us. We merge.

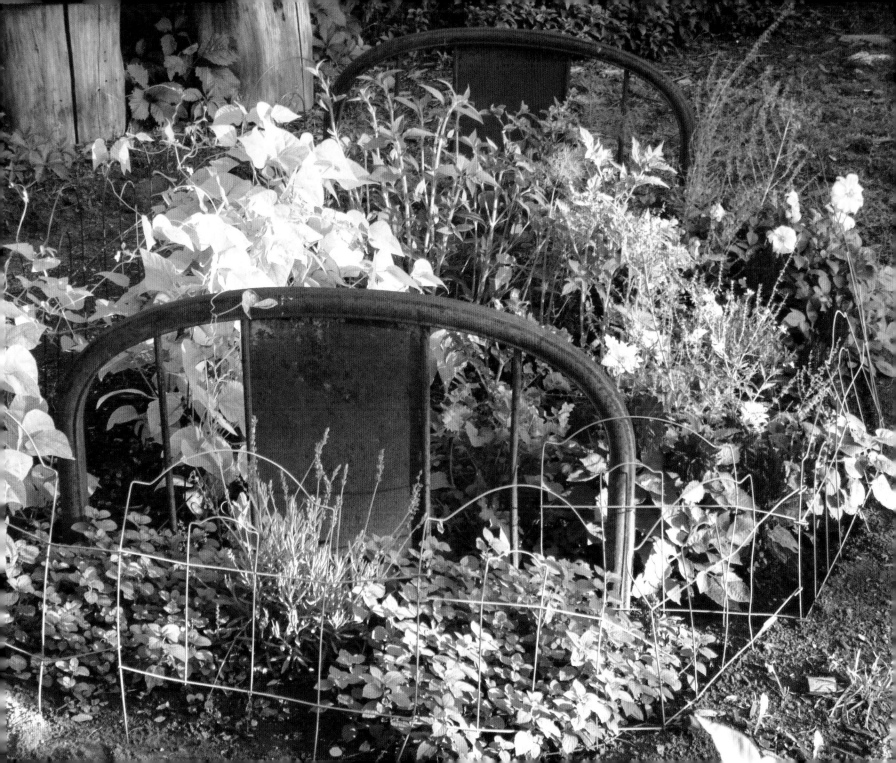

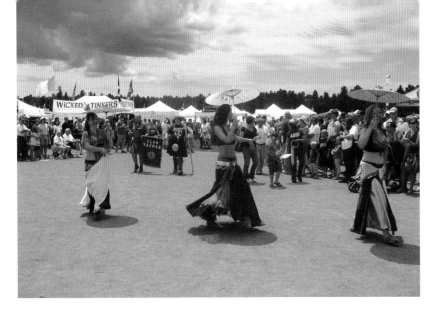

I have been **FORTUNATE** in living my life outside of conventional realms. I often had no car. Walking never failed me.

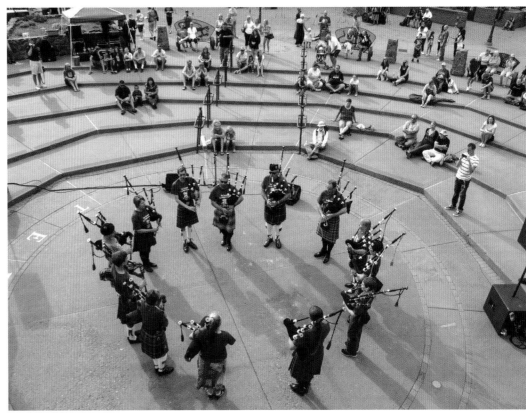

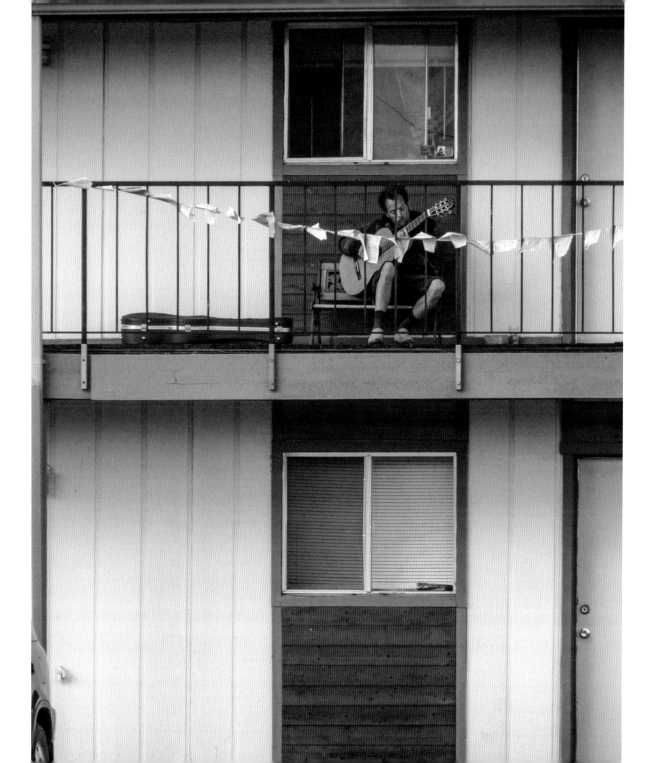

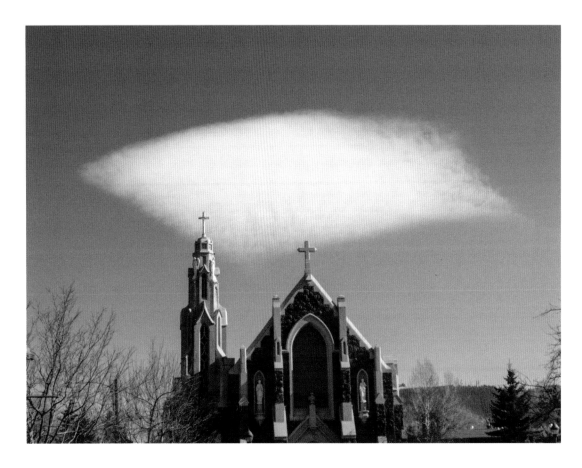

Walking was a way of life in my birth family. We walked to church, we walked to school, always a possible adventure along the way. Walking allowed time for dawdling and daydreaming, two arts I have not lost.

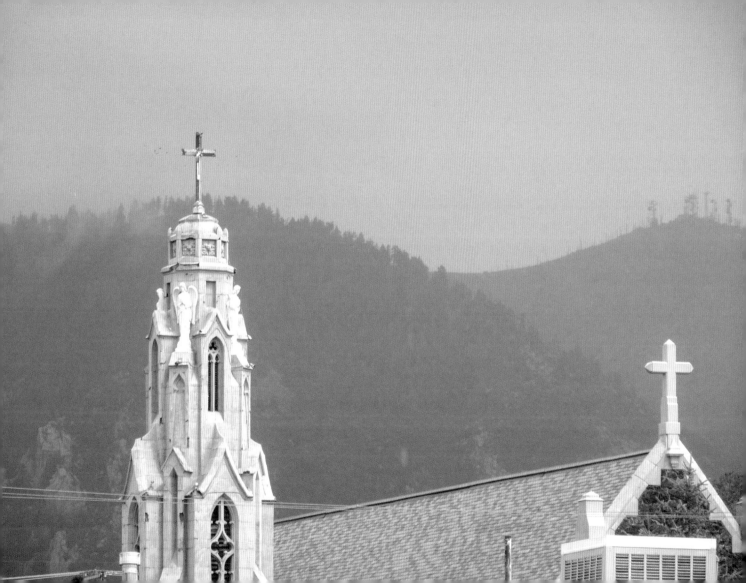

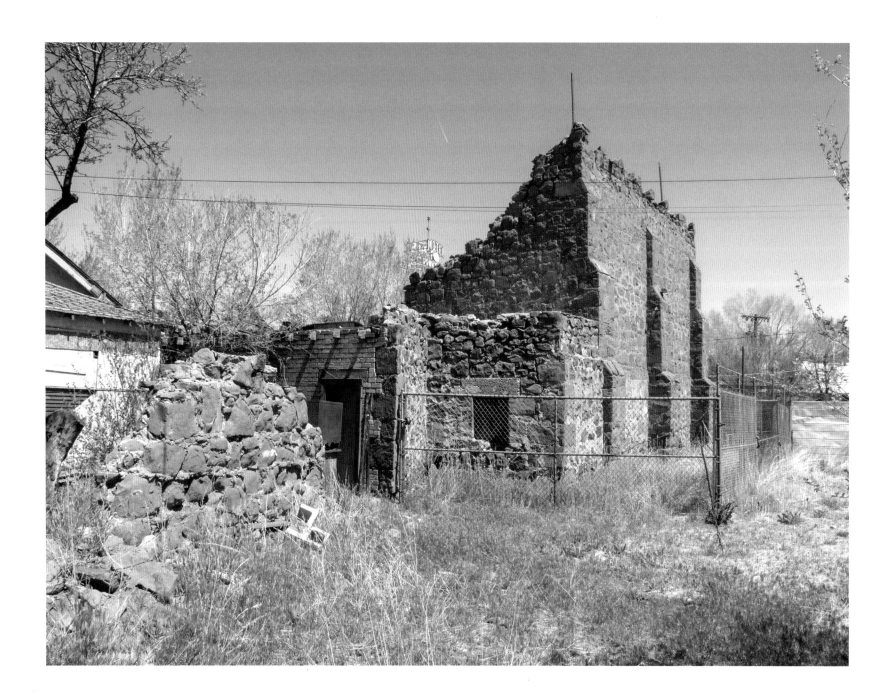

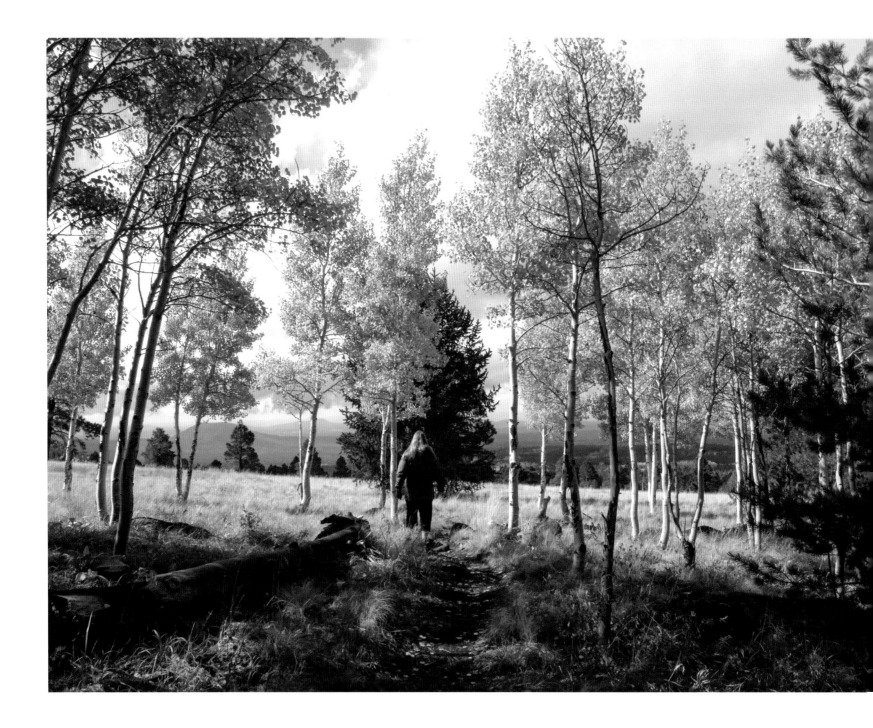

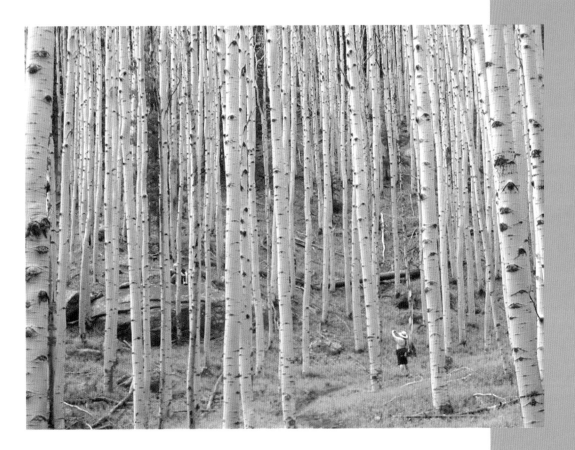

"What is required of you, O human, but to do justly, to love mercy, and to walk humbly with your God?" (Micah 6:8)

To walk humbly means to have no excess baggage—to become like humus, like the dirt beneath our feet from which all growth springs.

Walking humbly means to get out of our cars, including the cars of our minds, and put our feet on the ground of existence. We become grounded: not "ground dead" but a continuous ground-ing.

Walking is a moving experience. Walking transforms us, gets us out of any trance we are in. We transcend (trance-end) when we walk. Feet on the ground, head in the sky, we re-vive, come back to life again.

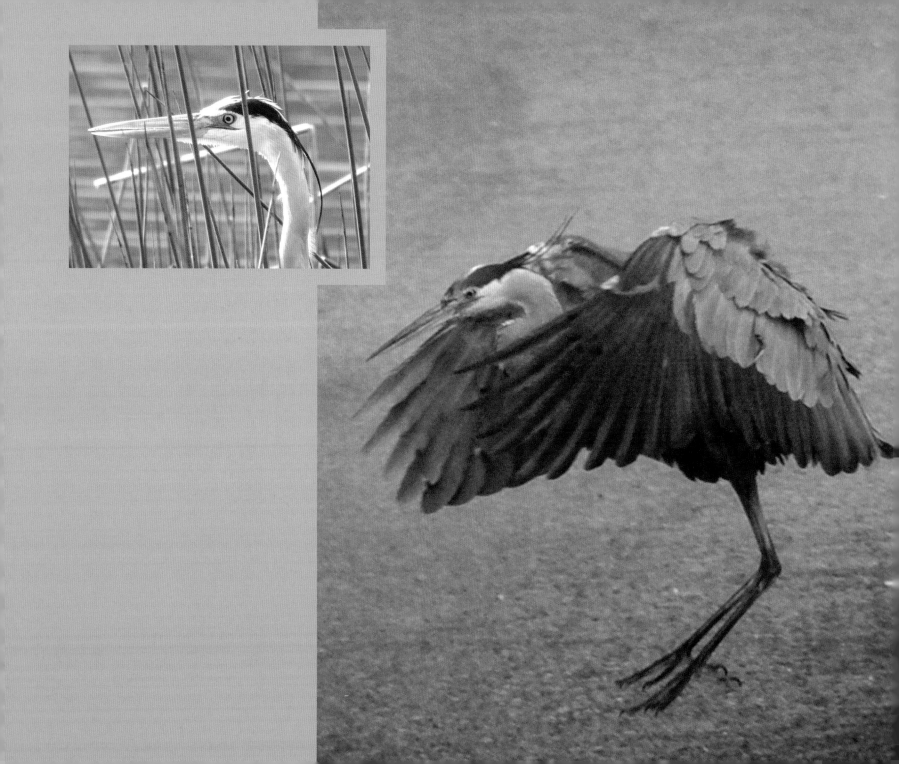

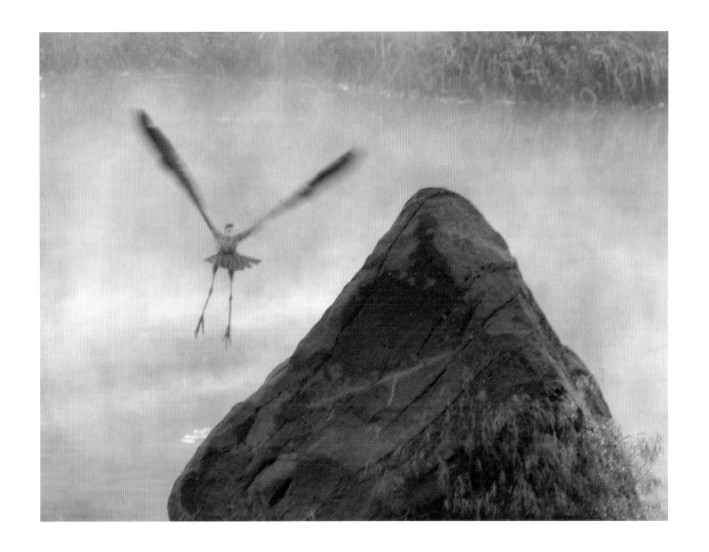

THE ART OF GEEZER WALKING

Since I am a bonafide Geezer, having been dubbed this by an irate man some time ago, I feel I am qualified to make some remarks on the Art of Geezer Walking.

You can be a Geezer regardless of your age. One requirement is that you not take yourself too seriously. So most anyone can do the Geezer Walk.

Some guidelines (no rules; Geezers do not care for rules nor abide by them):

Choose asphalt over concrete, dirt over asphalt. It's easier to let flowers bloom in your footsteps with dirt, though concrete may need them more.

Choose neighborhood streets over traffic-stream streets. With traffic-stream streets, it is too easy to get irritated at the constant engine roar and tire-whir noise and/or fall into pity and depression for all those poor folks locked away in their mobile cubicles. Of course, if you are a Zen Marine, you will welcome this opportunity to practice deep meditation.

Choose back alleys over neighborhood streets. Man! The sights you see!

Take a new route rather than an old route. The reasons are obvious.

Always return a different way. Walk the unexpected, the unpredictable.

Take shortcuts, even though they are longer.

Stay open to change. Pennies, nickels, dimes, quarters are everywhere. Pick them up, put them in your walking savings jar.

Notice side paths (human game trails) and follow them. Most are shortcuts. All lead to interesting places.

Keep a soft-eyed, open gaze. You see more; are perceived as less of a threat or challenge; get in less trouble.

Keep your head up and look around. No head-bouncing. When your head bounces, your visual world bounces. Keep an even keel.

No marching. Amble. Amble fast or amble slow, but amble. Because you are amble-atory, you are less likely to need an amble-ance.

Stop, look, and listen. At any time. For as long as you care to.

If you have a watch, leave it at home. You will get there when you get there. And you will never get there, since you are always here.

Carry a teeny notebook to record your teeny thoughts.

Well, that's way too many guidelines. So here's what it boils down to:

JUST GO OUT THERE AND WALK AROUND.

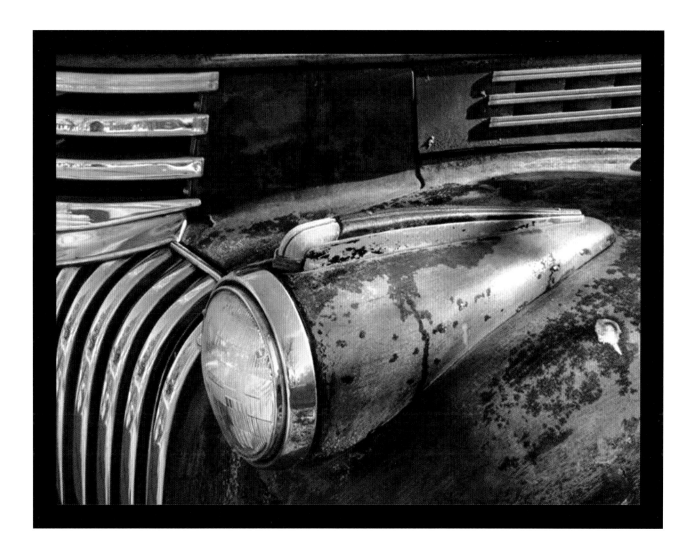

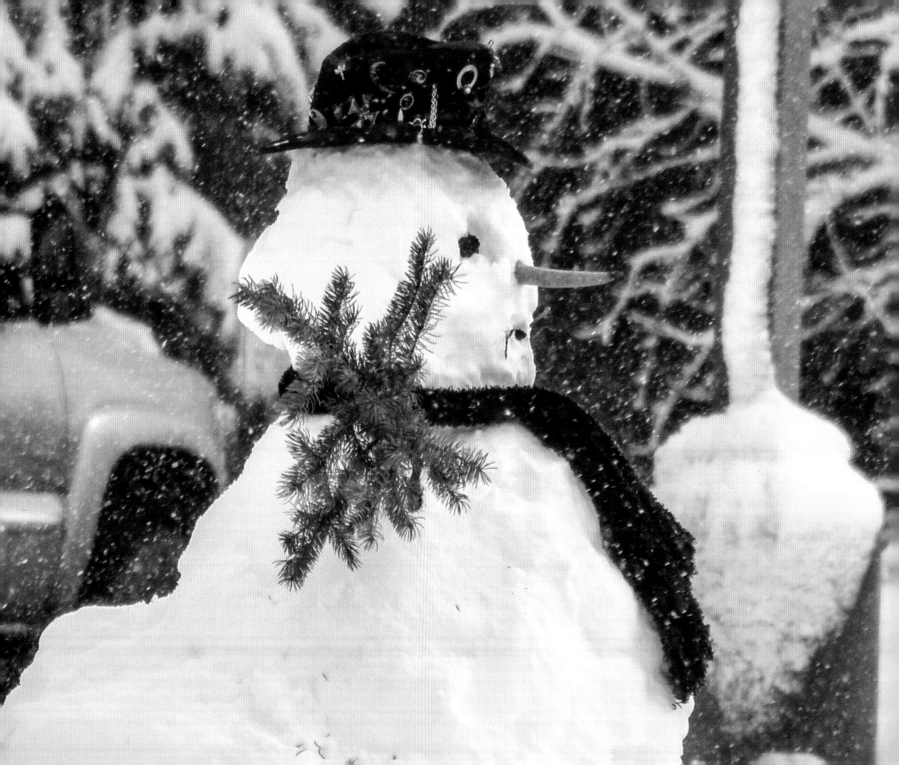

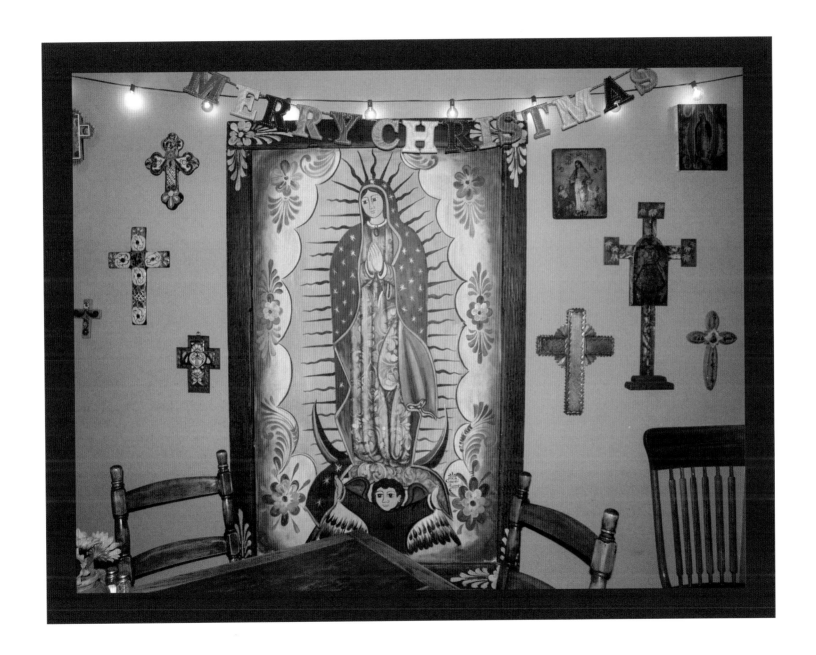

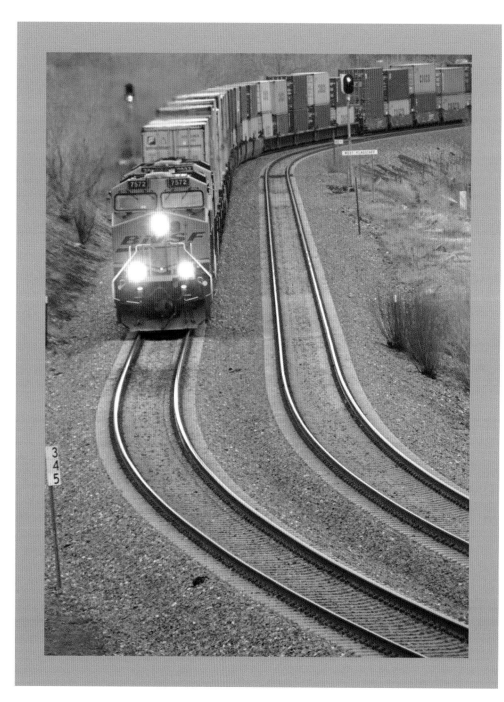

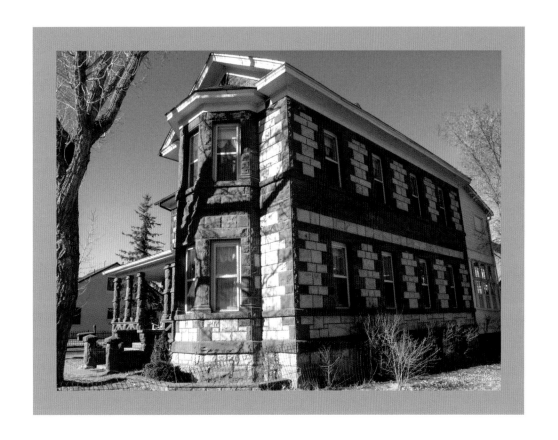

BRING IT ON HOME.

When starting to drag at the end of a long walk, I remember something I learned in the Marines. In Advanced Infantry Training, we would have gone 20 miles or more (full gear: heavy packs, weapons, helmets, the lot). About a mile from our base camp, a sergeant would shout, "OK, let's bring it on home!" We would close ranks as a platoon. Heads rise into the sky, crown chakras blazing. Spines straighten. Breathing deepens. Boots hit the ground in rhythmic stride. New energy! A force to be reckoned with. And we brought it on home.

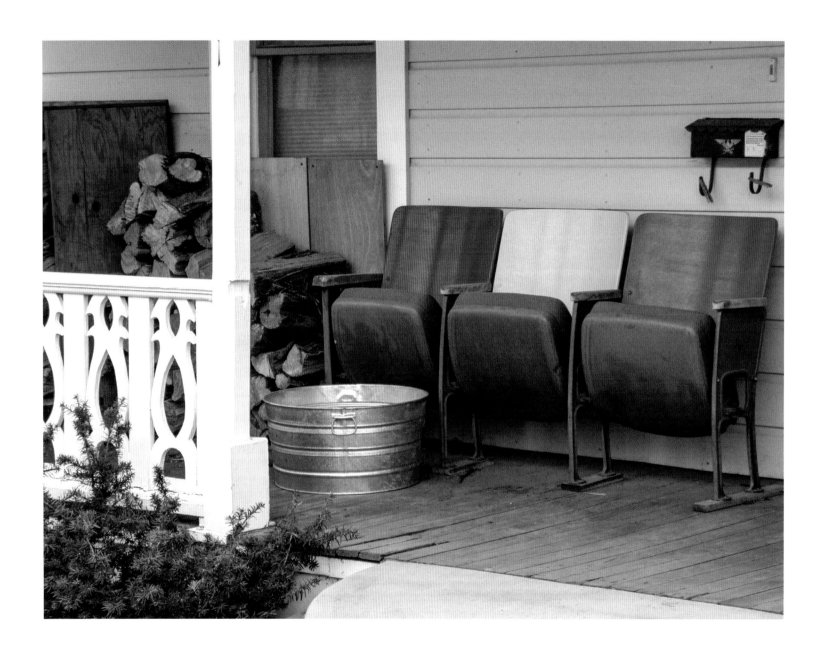

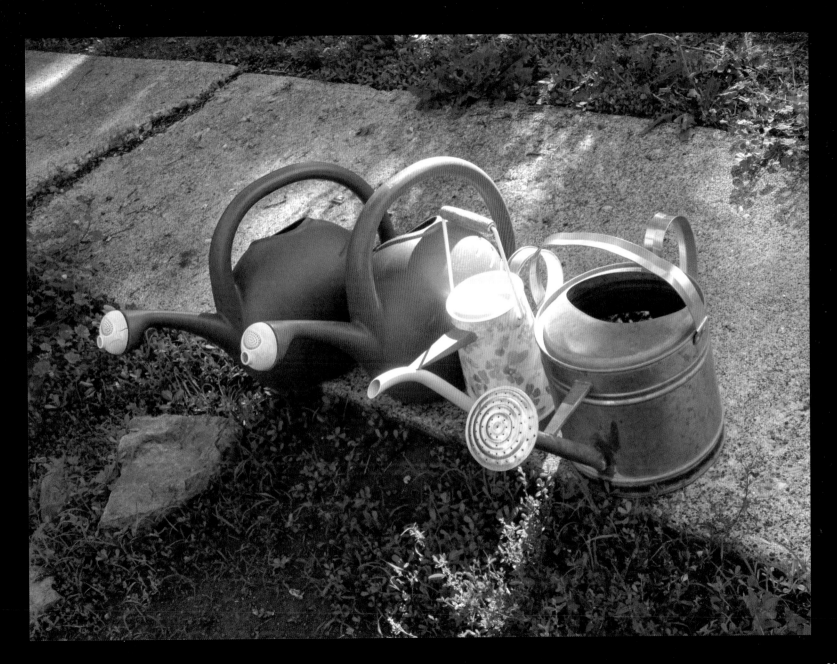

We are
embodiments
of the Earth.
We are Earth
walking.

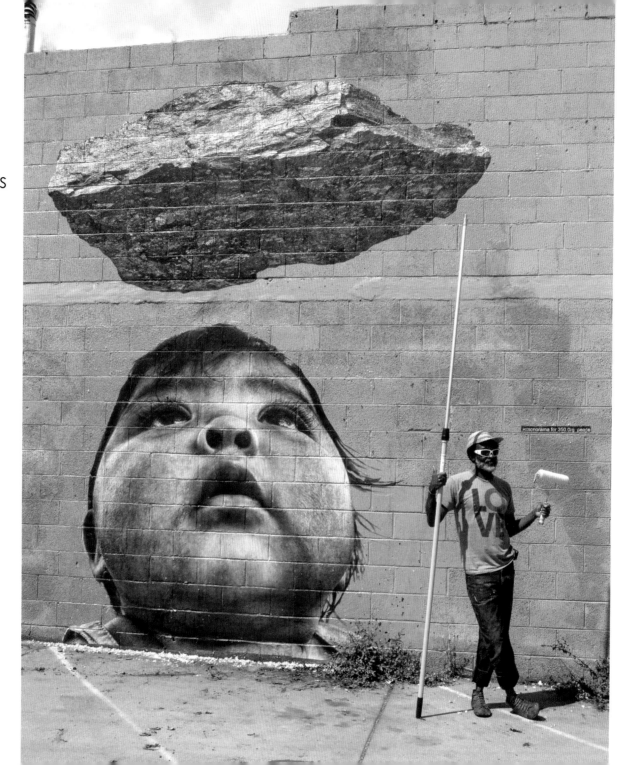

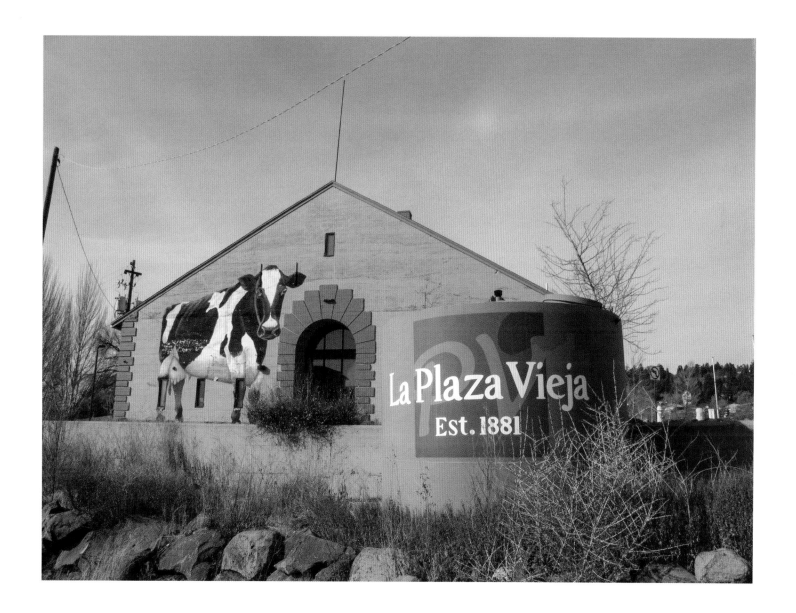

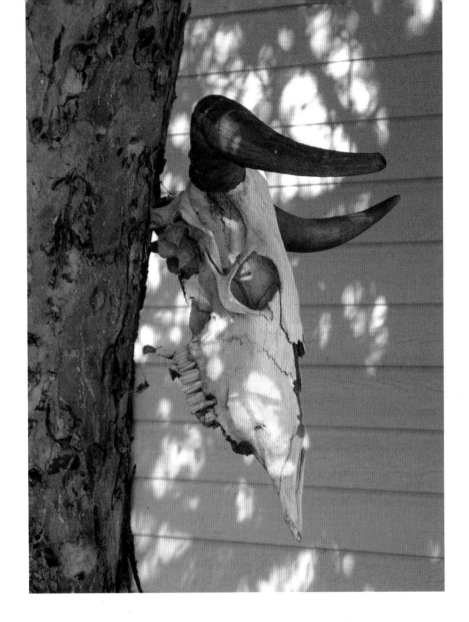

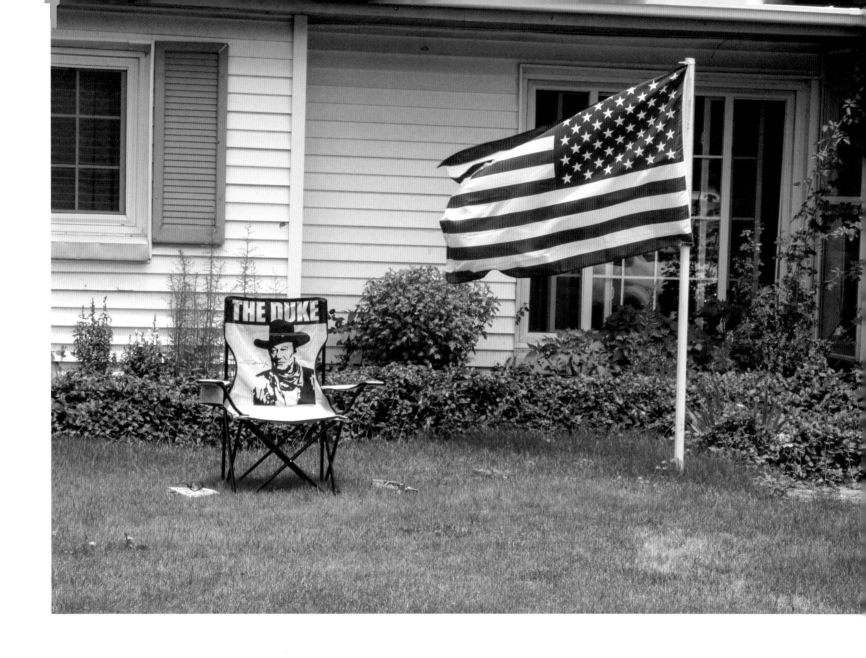

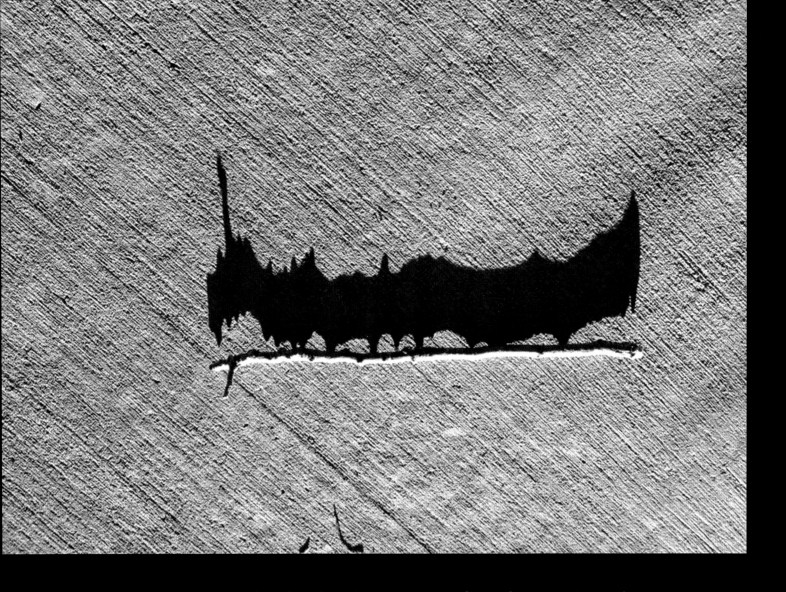

How amazing walking is. Simply extend a foot forward, set it down, put your weight on it, then swing the other foot forward. Repeat. Before long, miles go by, many sights are seen.

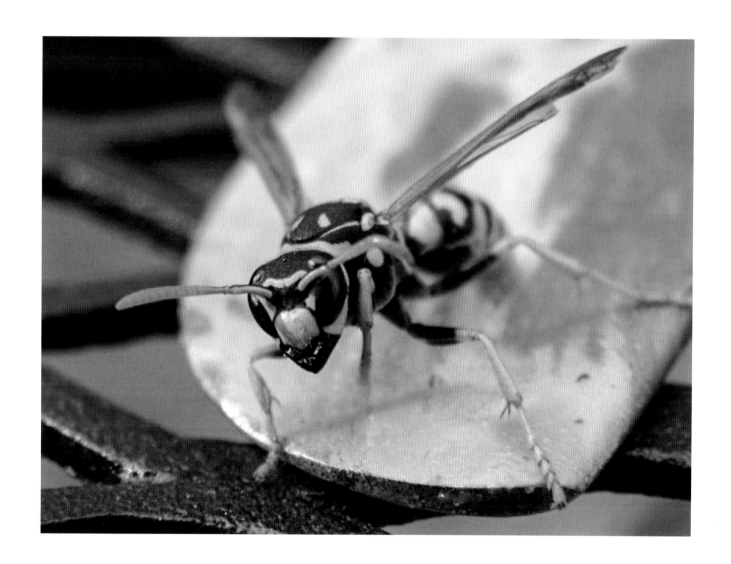

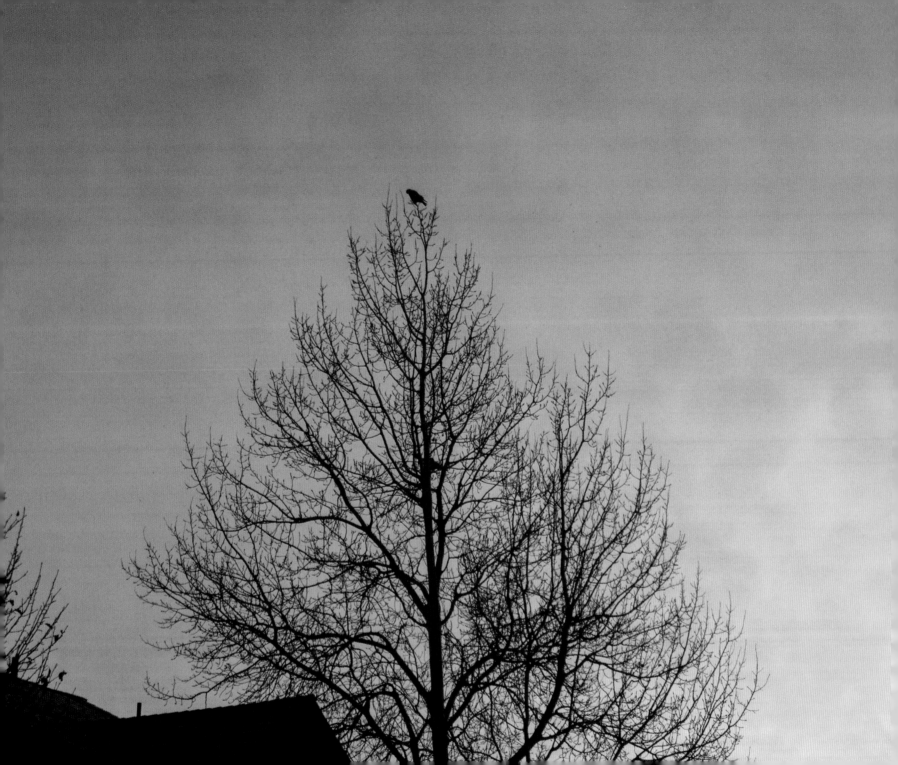

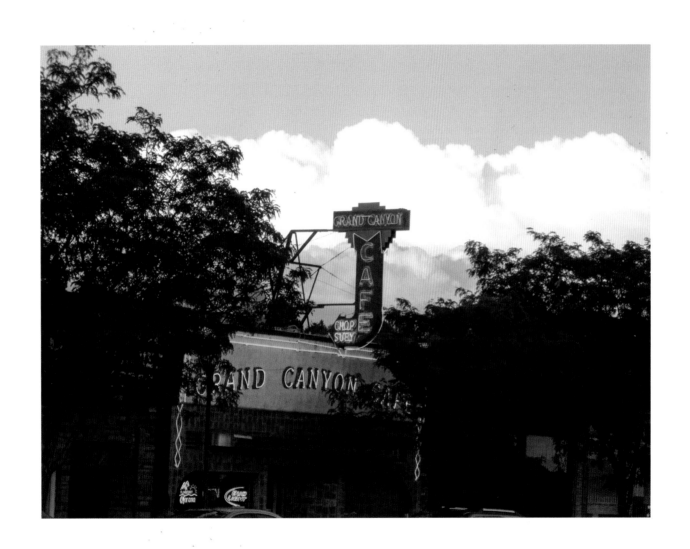

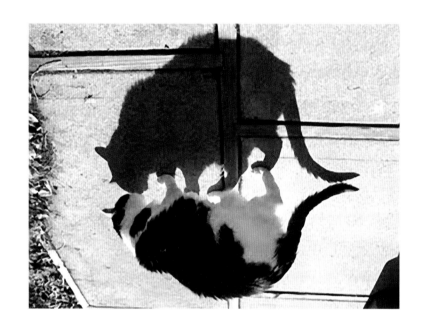
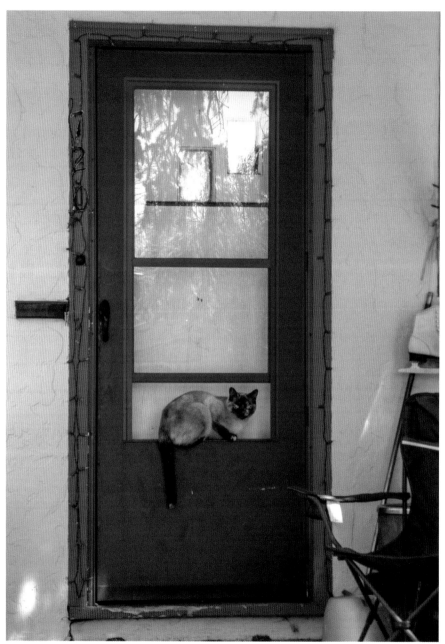

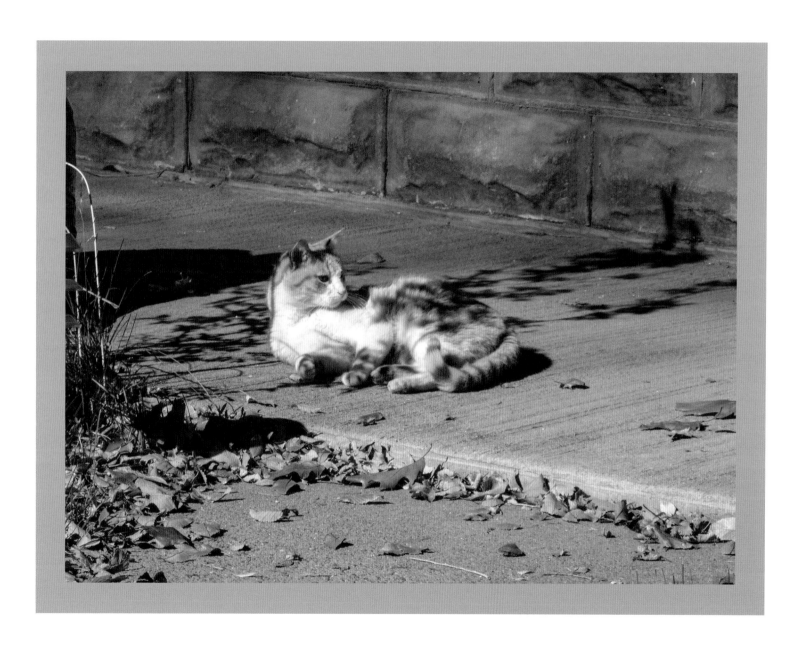

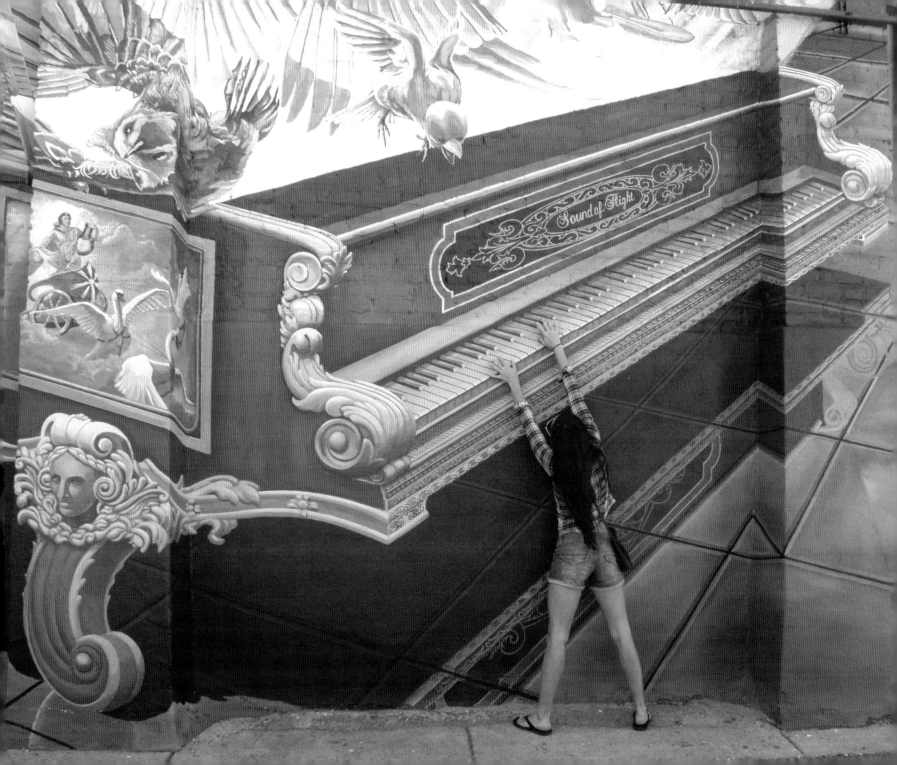

I don't know why folks walk around looking at their feet. Our eyes are close to the top of our head for a reason.

I climbed up a never-taken route, and there they were. **Three** is a holy number in every culture.

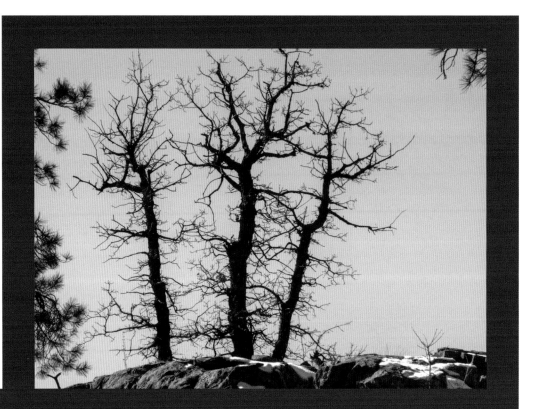

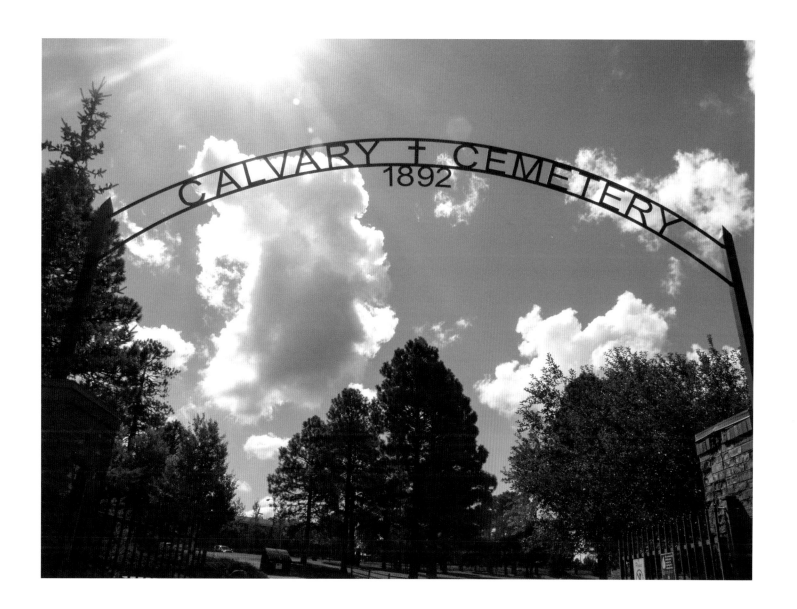

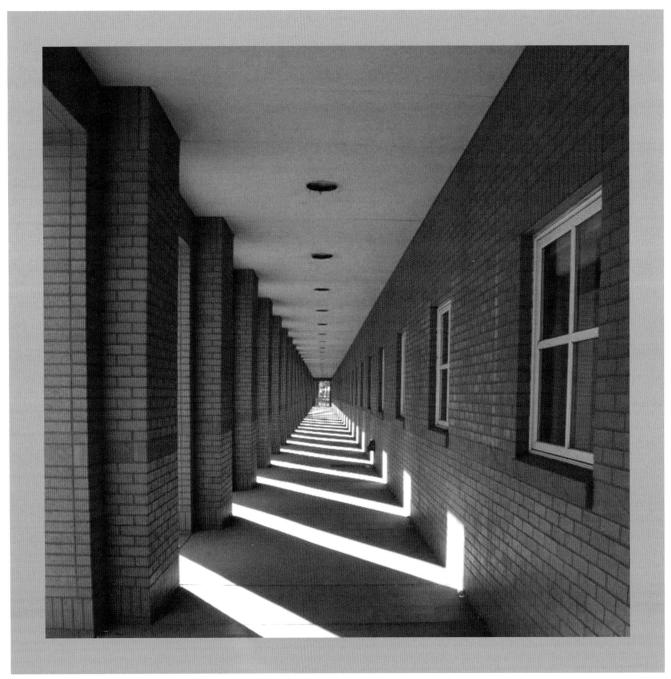

Patterns

call to my
eye, stop
me in my
tracks.
Here is
replication
in pleasing
form.

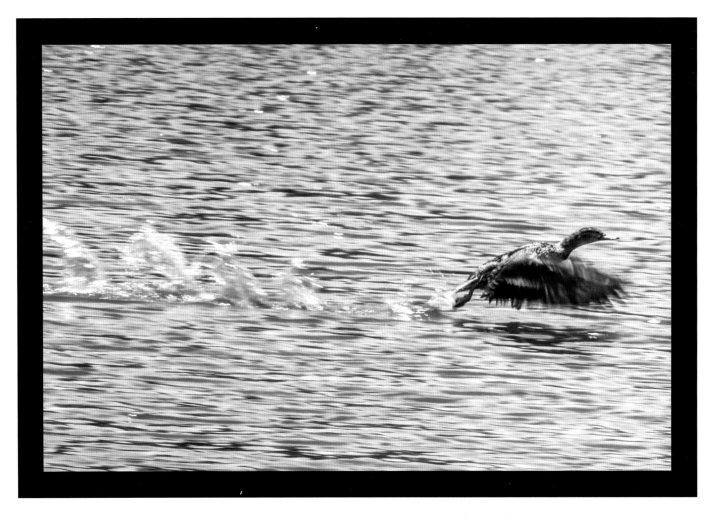

Putting a label on something is a sure way of not seeing
it. "Oh, that's just a _____," you say to yourself.
Dismissed! Nothing to see here! Move on!

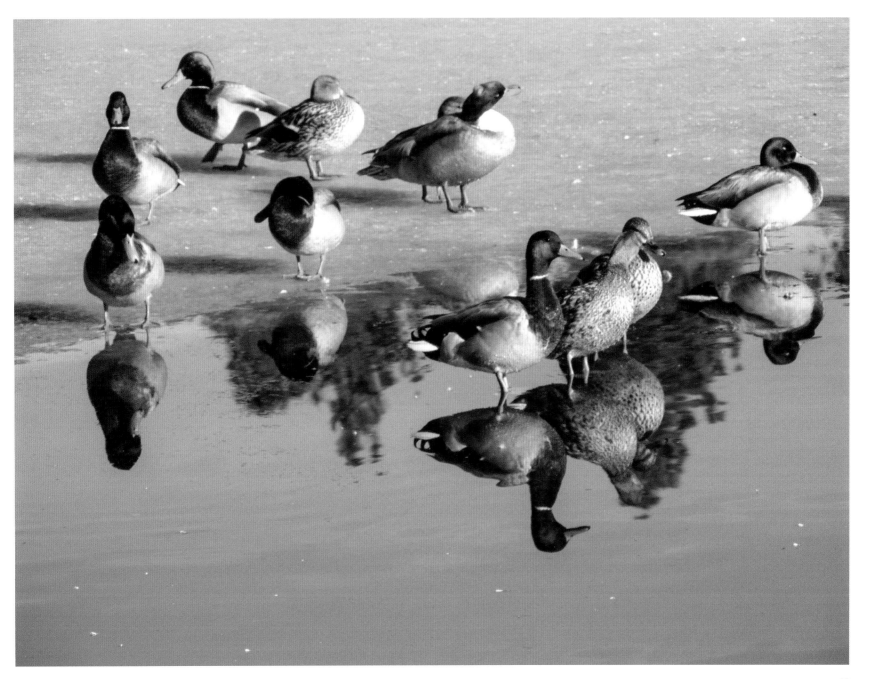

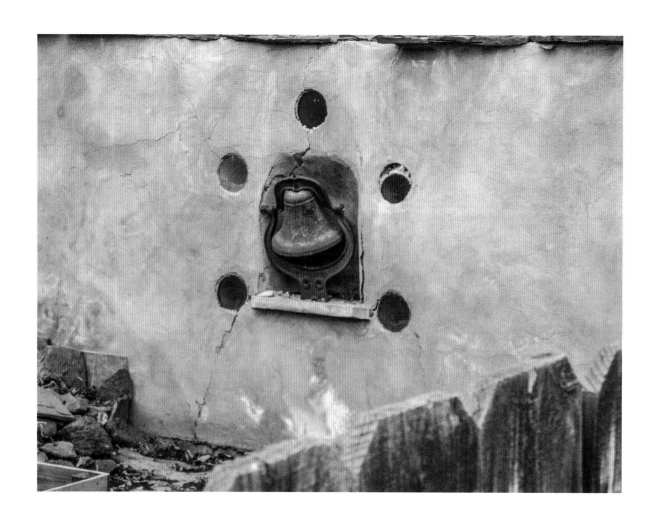

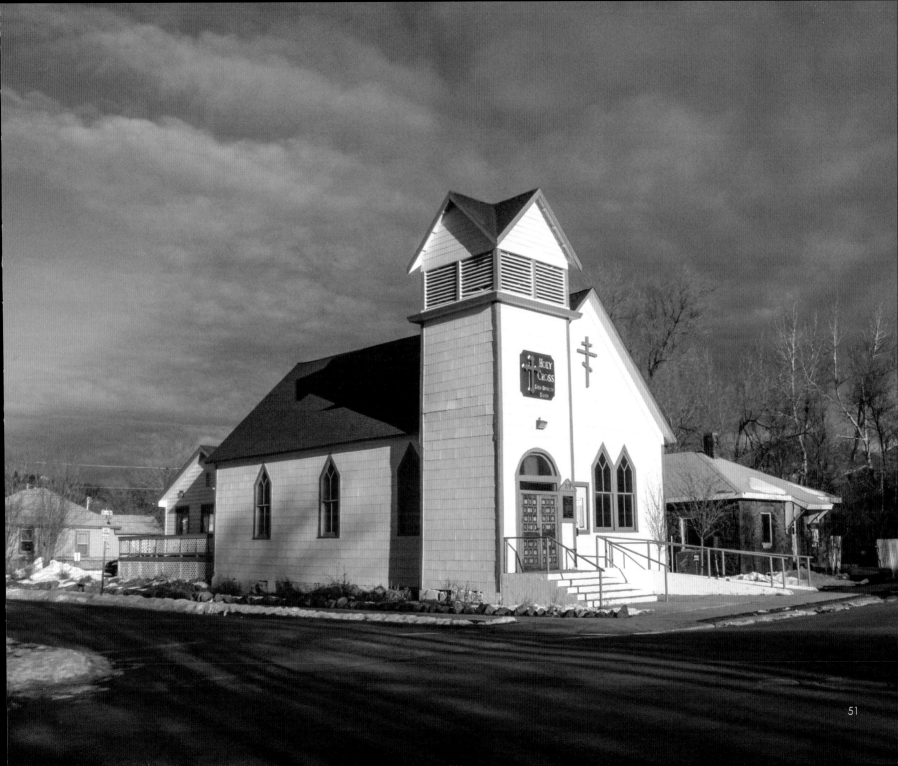

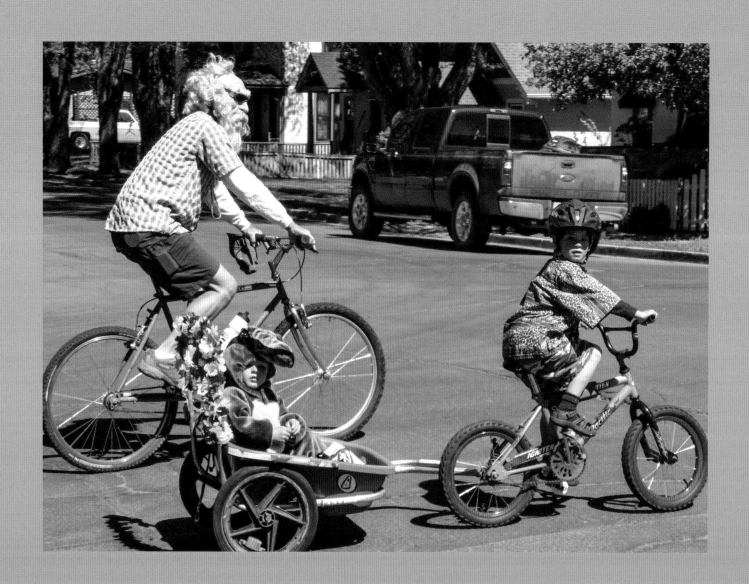

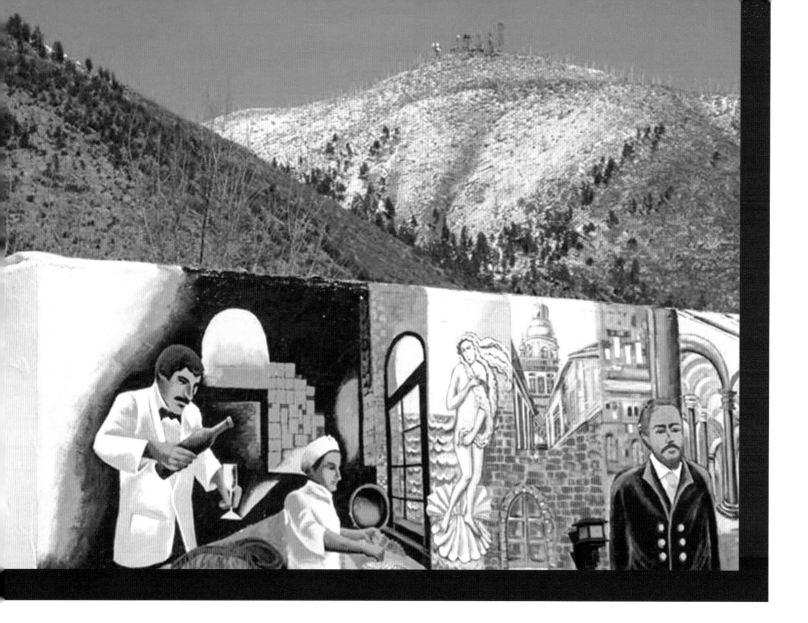

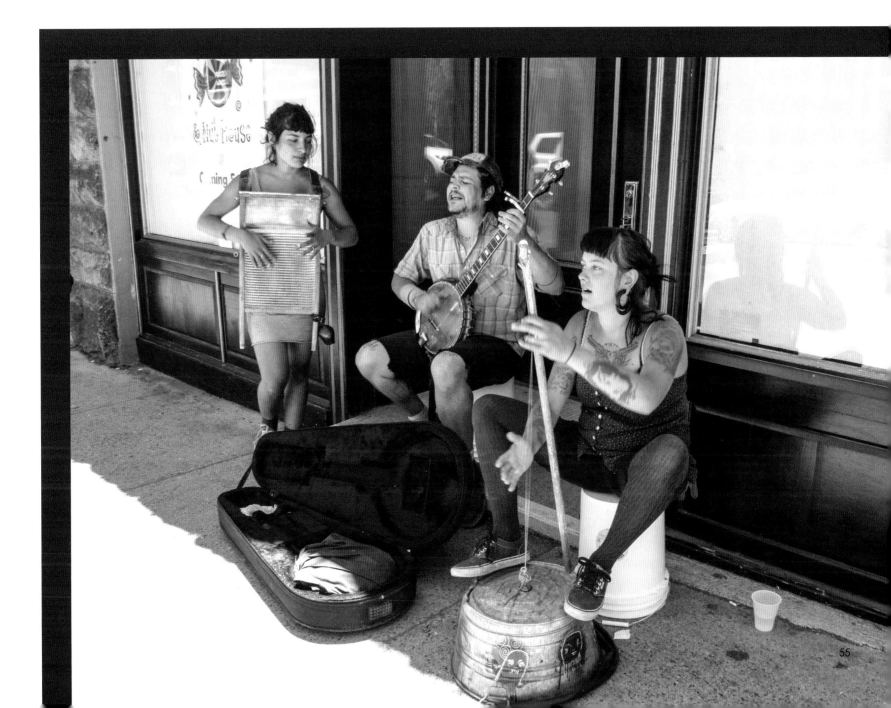

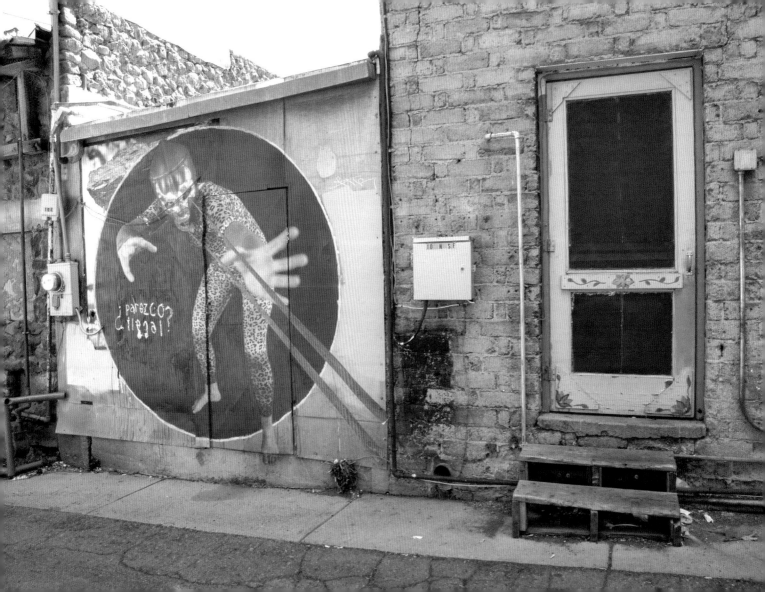

Ignoring common items as unworthy of
attention is the height of arrogance.
BEAUTY IS EVERYWHERE.
Do not let stupor-idity make you pass by

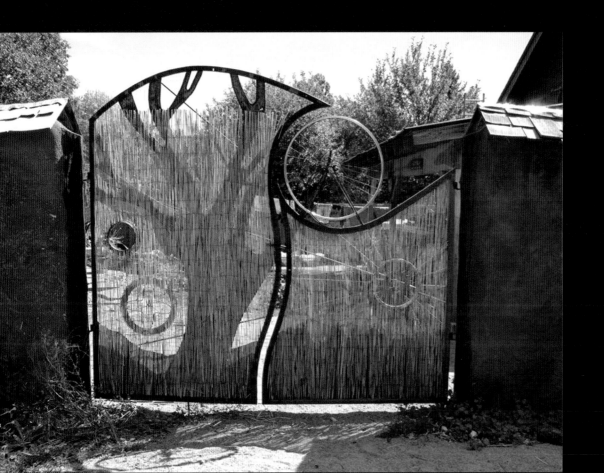

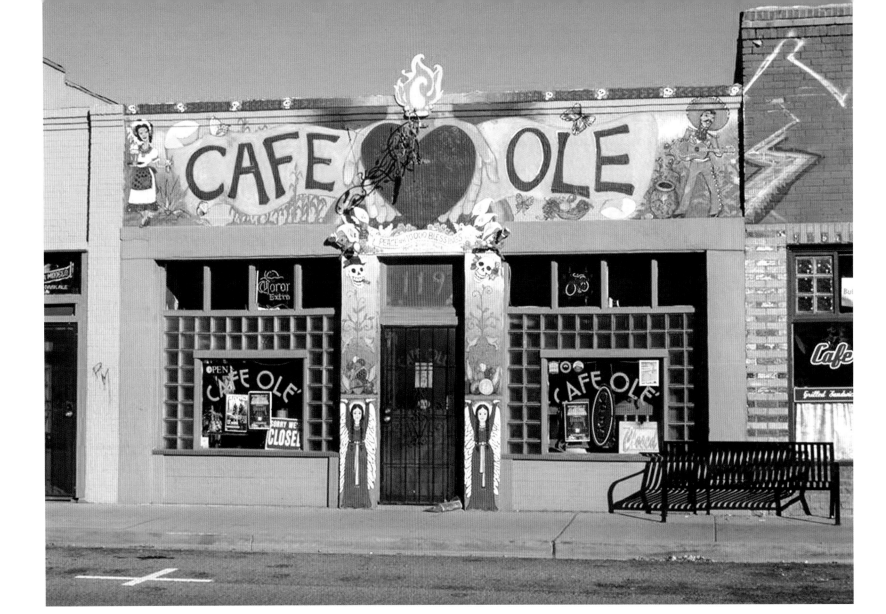

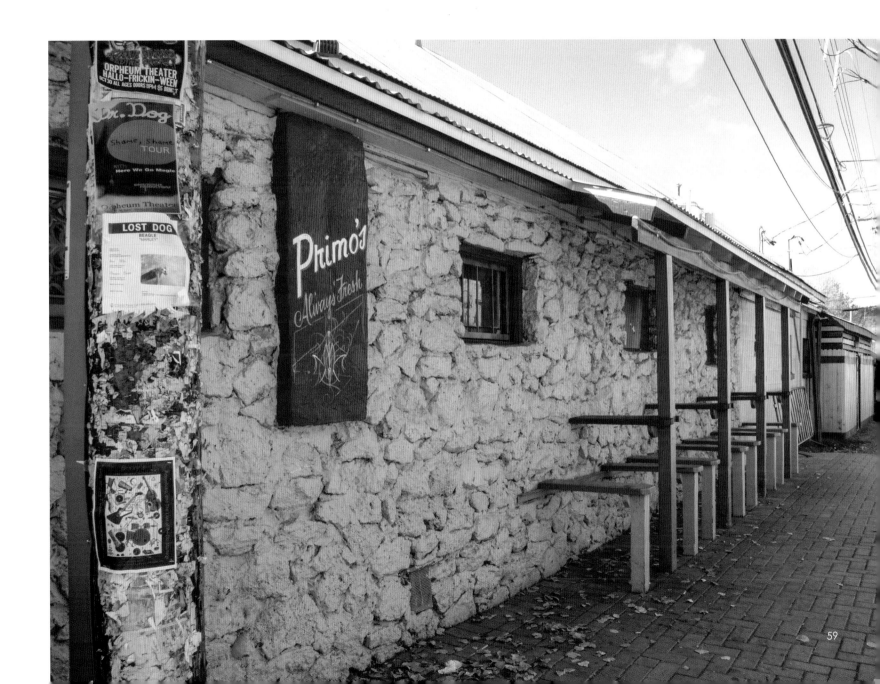

WARNING

Characters I meet downtown are making
more sense than "respectable" citizens.

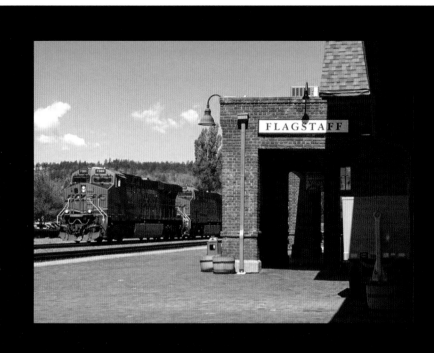

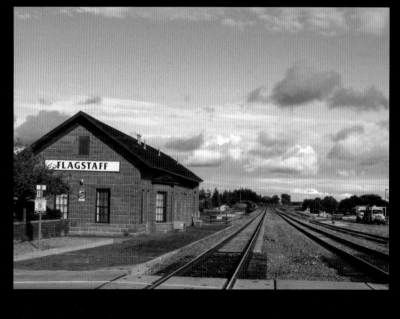

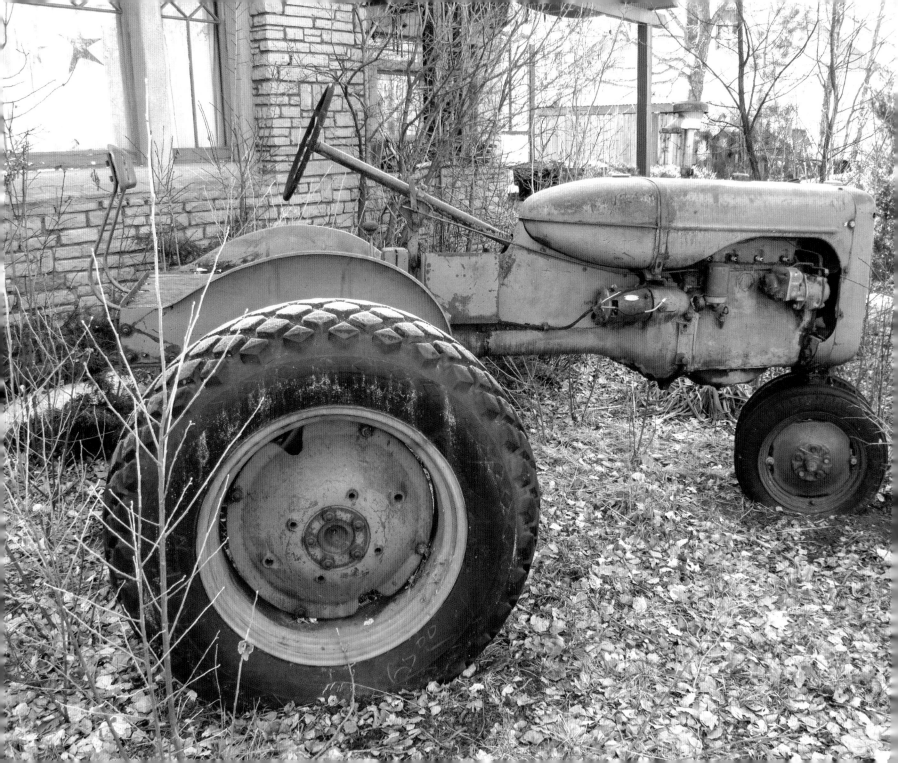

A sense of humor is essential when walking.
Serious leads to grave, the receptacle of death.
Laugh and the world laughs with you, reveals itself.

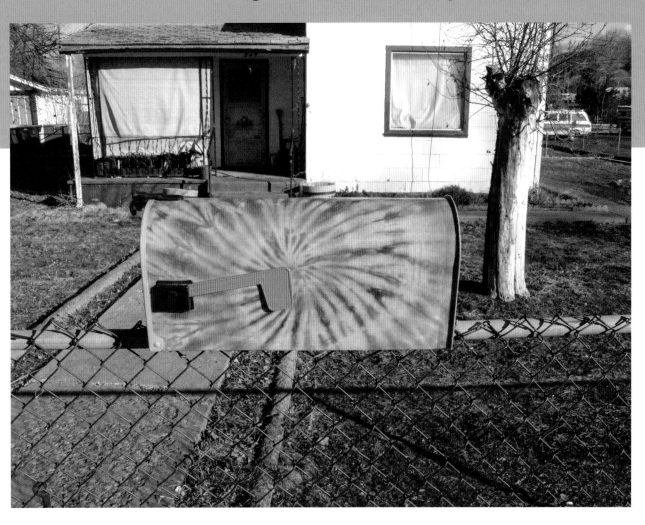

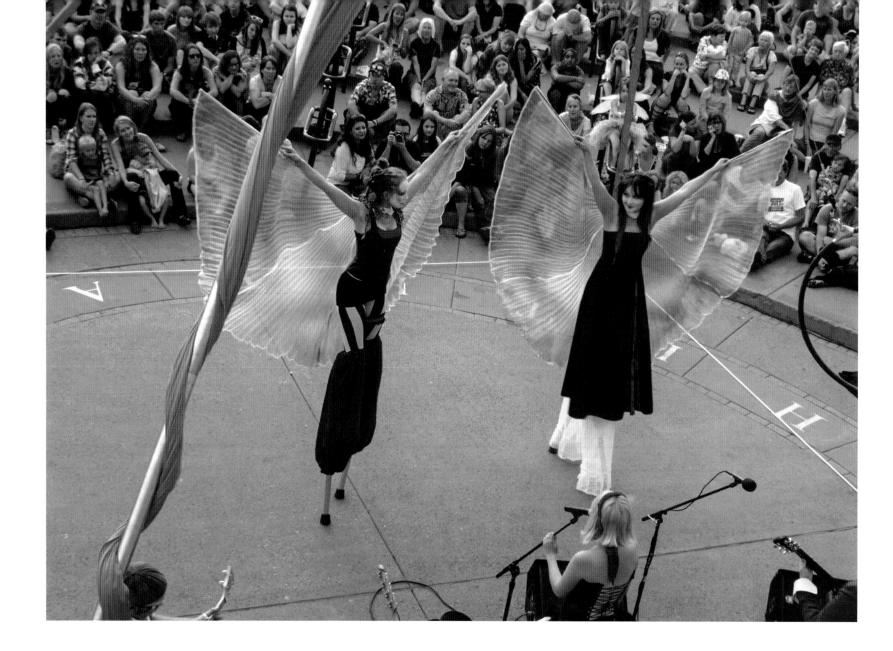

Bluebirds

of Happiness
perched on
daily life.

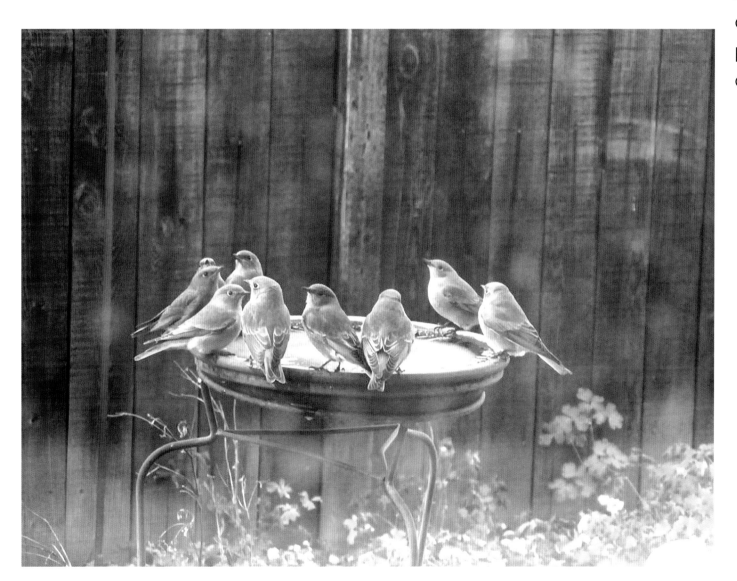

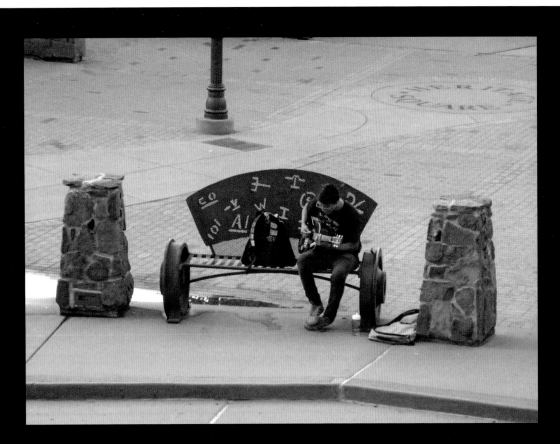
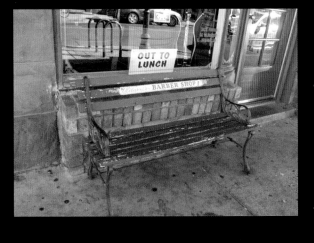

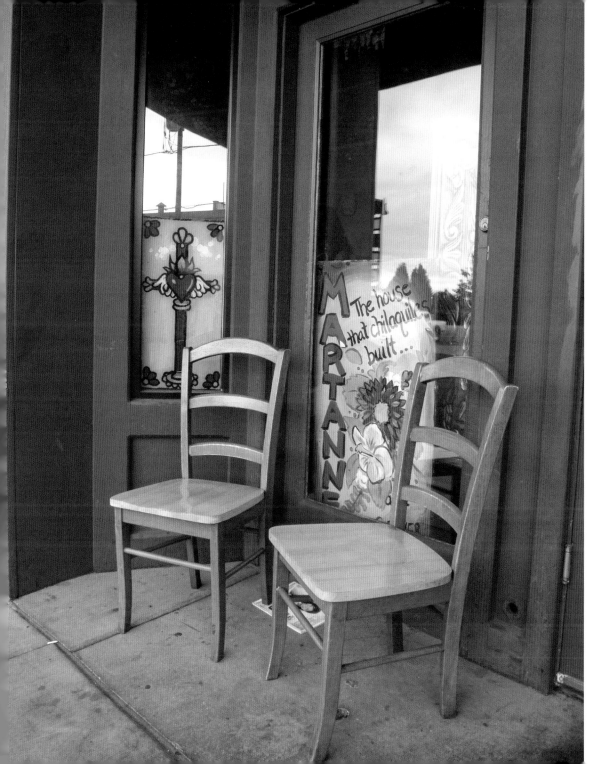

My procedure

in taking a photo follows my heart instead of my head. I do not use a tripod nor lie in wait for the right moment. I am on the move and shoot as I go. I shot "Expert" with a .45 pistol in the Marines by following a breathing pattern that allowed a steady focus on the target combined with a delicate squeeze of the trigger. Bam! Bullseye and move on. Similarly, my camera work is a kinesthetic flow containing a momentary stillness. As I walk, I see a desired target coming up. Upon reaching the foreseen time/space coordinate, one never to be occupied by me or by anyone in the same way again, I fall into a momentary stance, take the shot, and move on. A much more peaceful process with a camera. Almost no sound. Nothing disturbed.

Stop often. Stand still. Life will disclose itself.

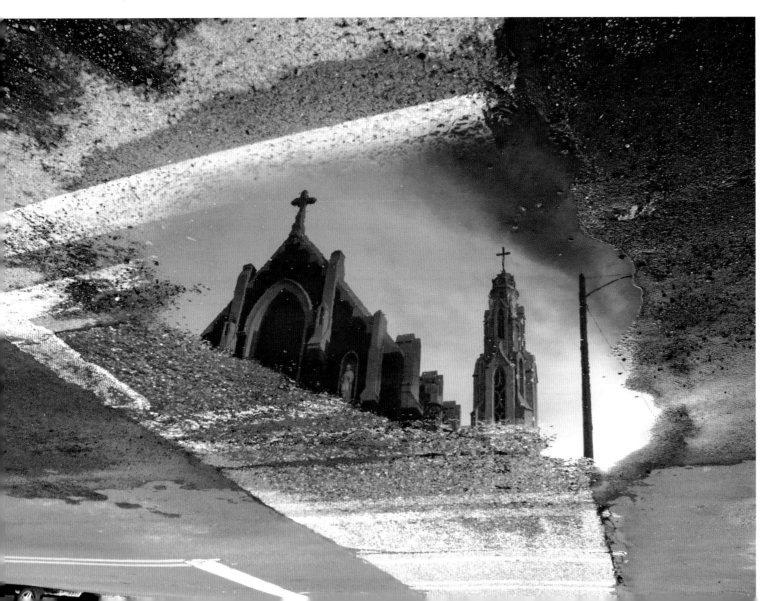

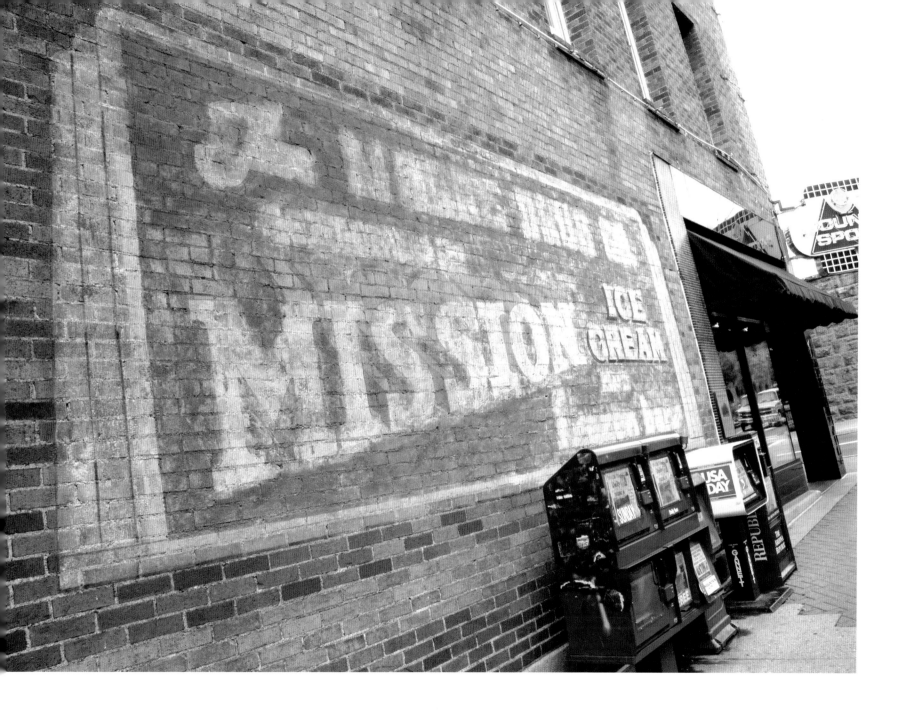

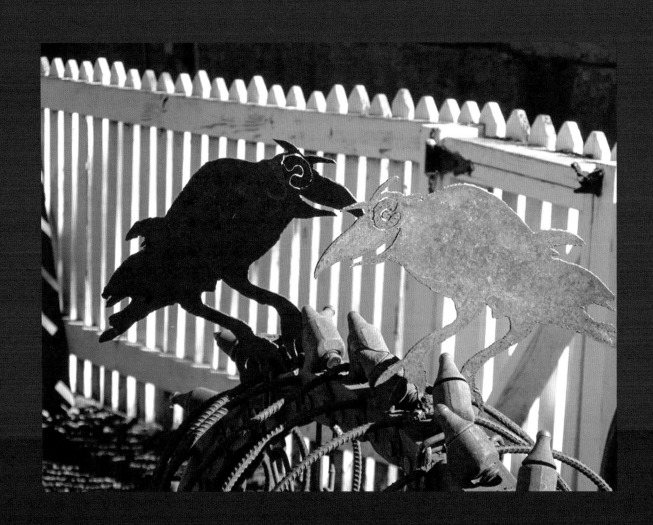

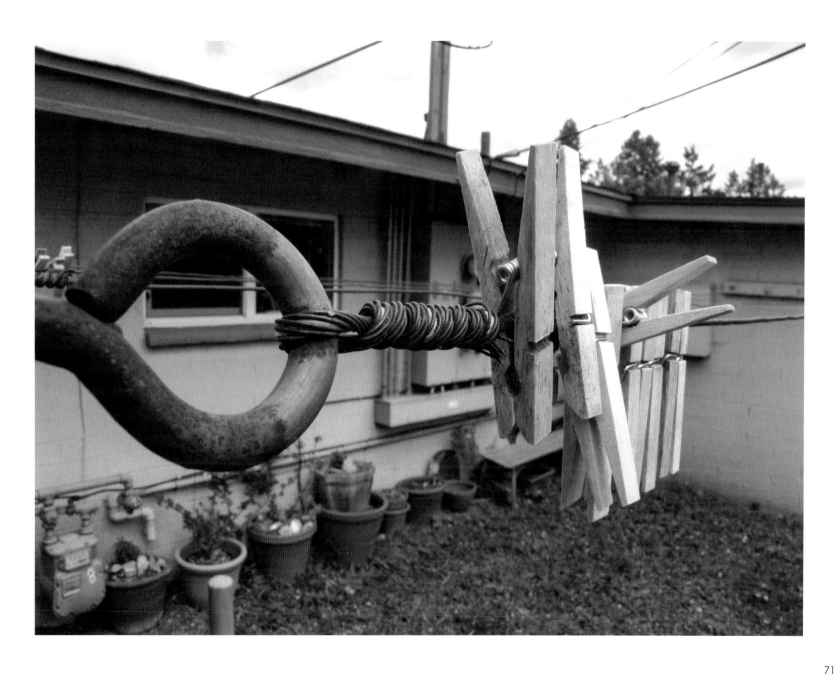

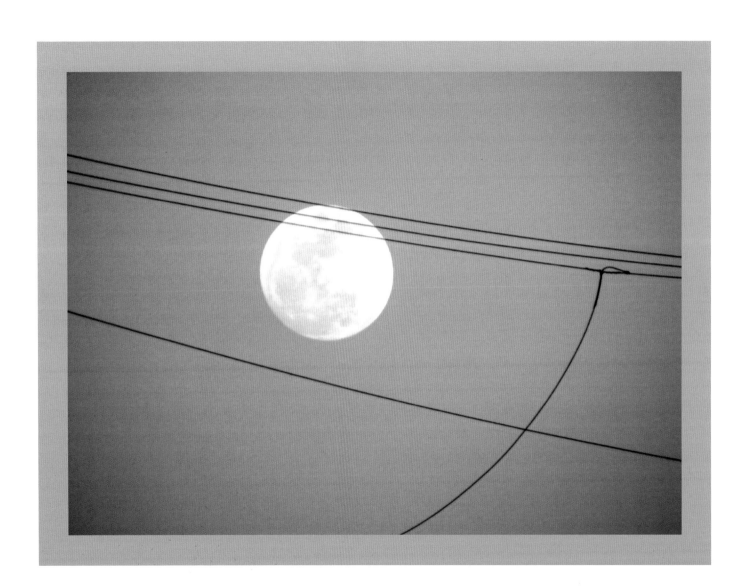

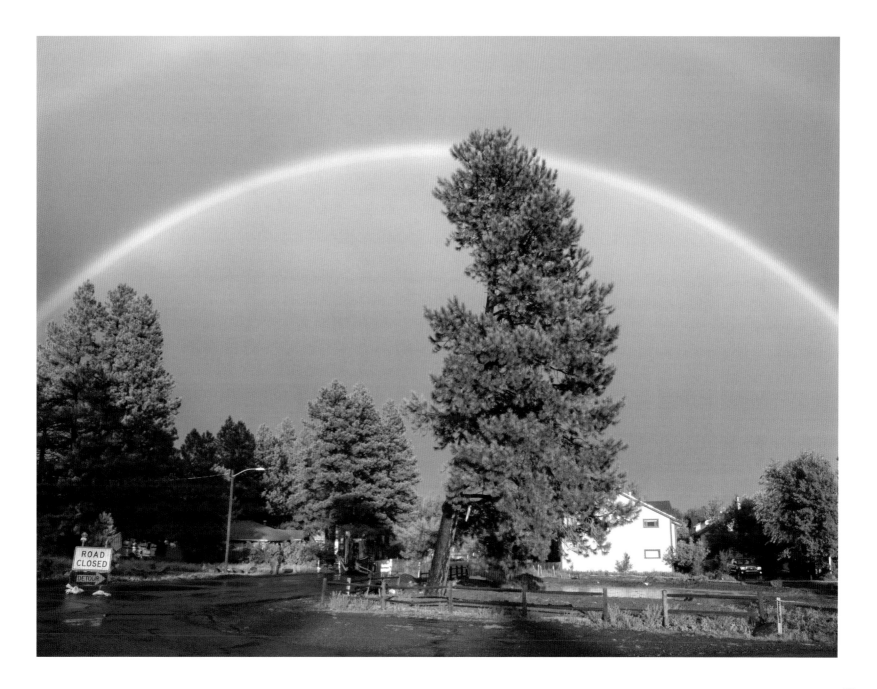

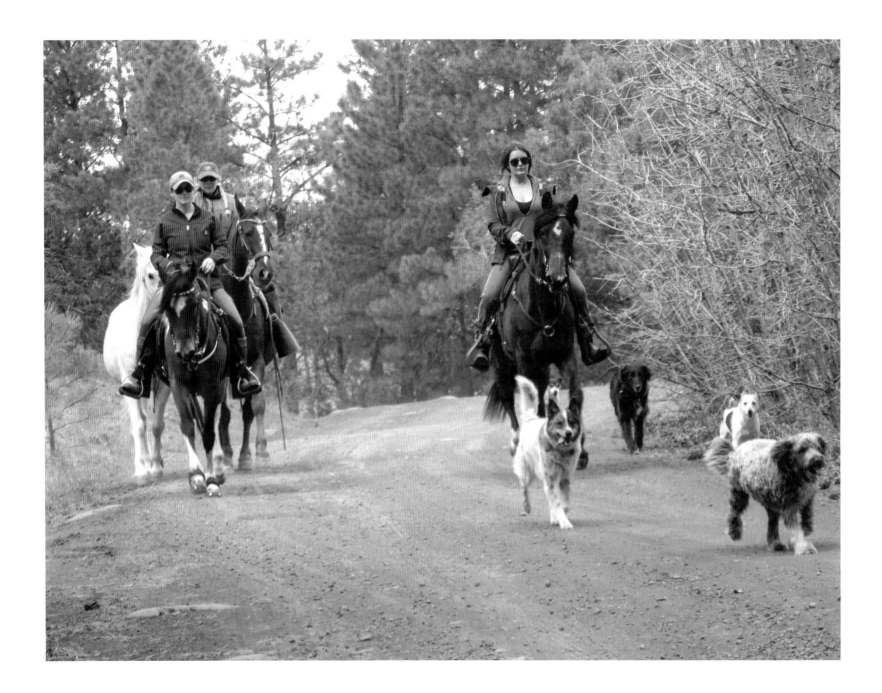

Sometimes I think I'm in Mr. Rogers' Neighborhood. As I walk along, I meet person after person. I hear "Hi George" and "How are you?" and "What's up?" and "Lovely day" and "Seen any coyotes around?" and a person on a bike gives me a smile with a hand wave. Love this town.

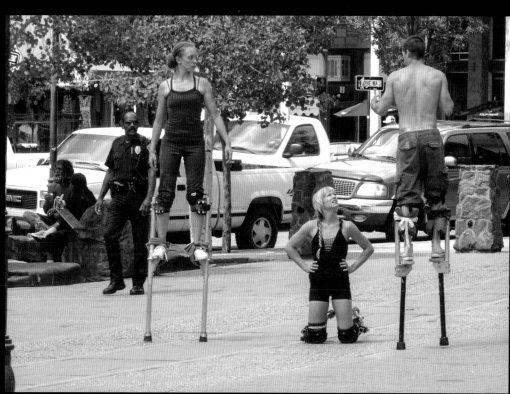

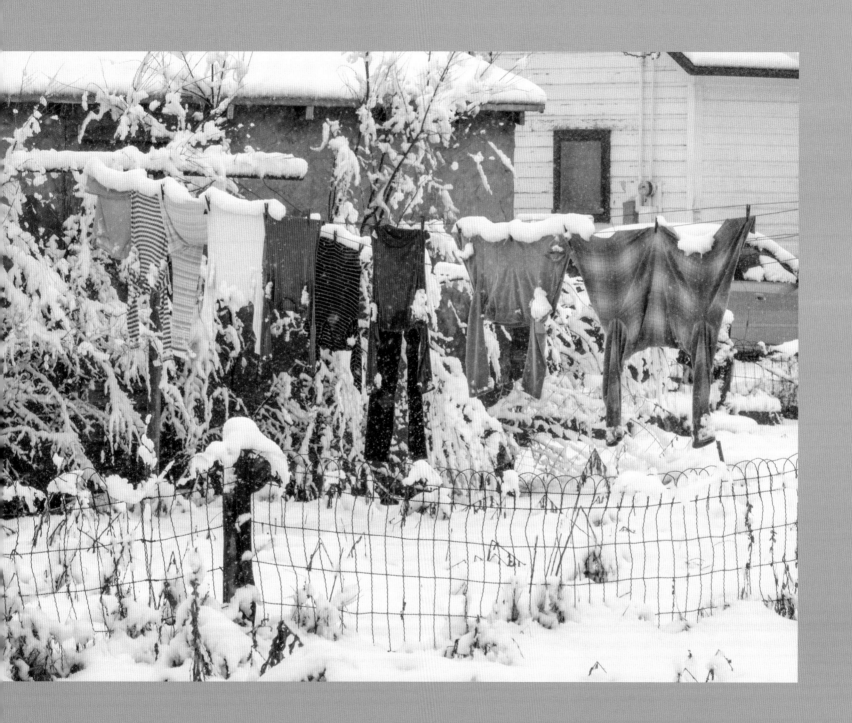

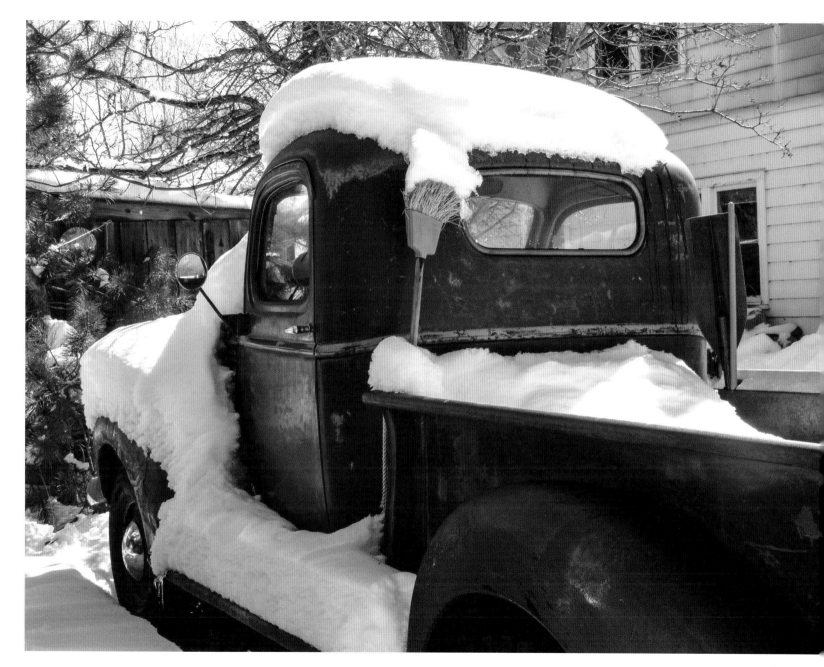

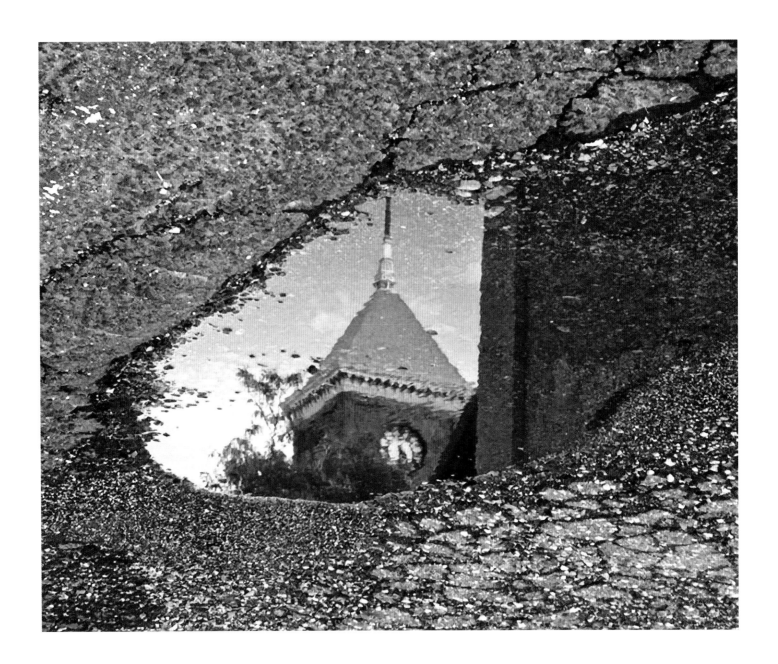

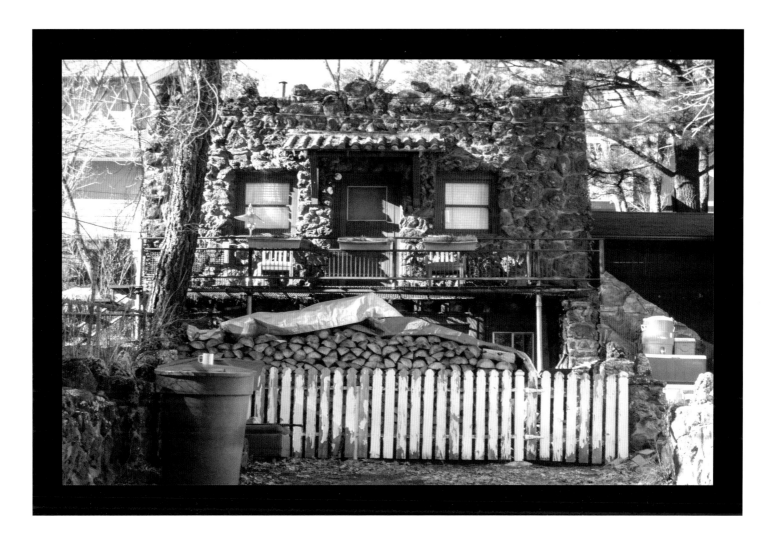

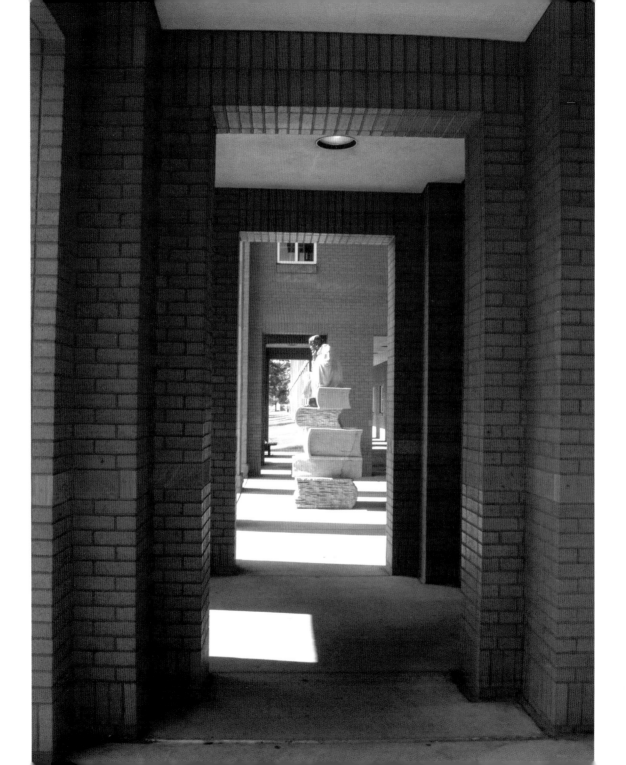

Give a man a photo and he will sit and gaze. Give a man a camera and he will walk the earth.

These shoes are plumb wore out, as they say in my birth land. Pieces are falling off as I walk. Figure I walk an average of thirty miles a week and say fifty weeks in a year for easy calculation: that's 1,500 miles a year. I've had these shoes for three years, so that's 4,500 miles on their pedometer—the U.S. from coast to coast and halfway back. Not bad mileage on these vehicles. And not a single cent spent on gas, oil, and maintenance. Guess I better start looking for a newer model. I can tell whether I'm standing on a dime or a nickel with these soles.

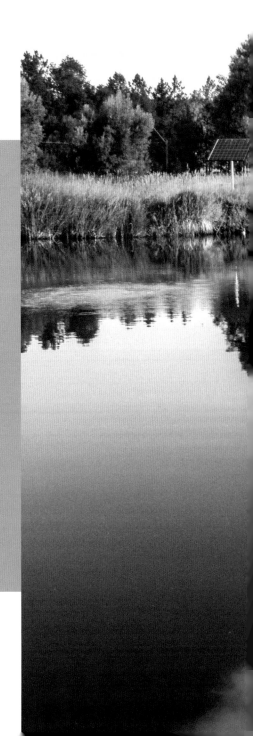

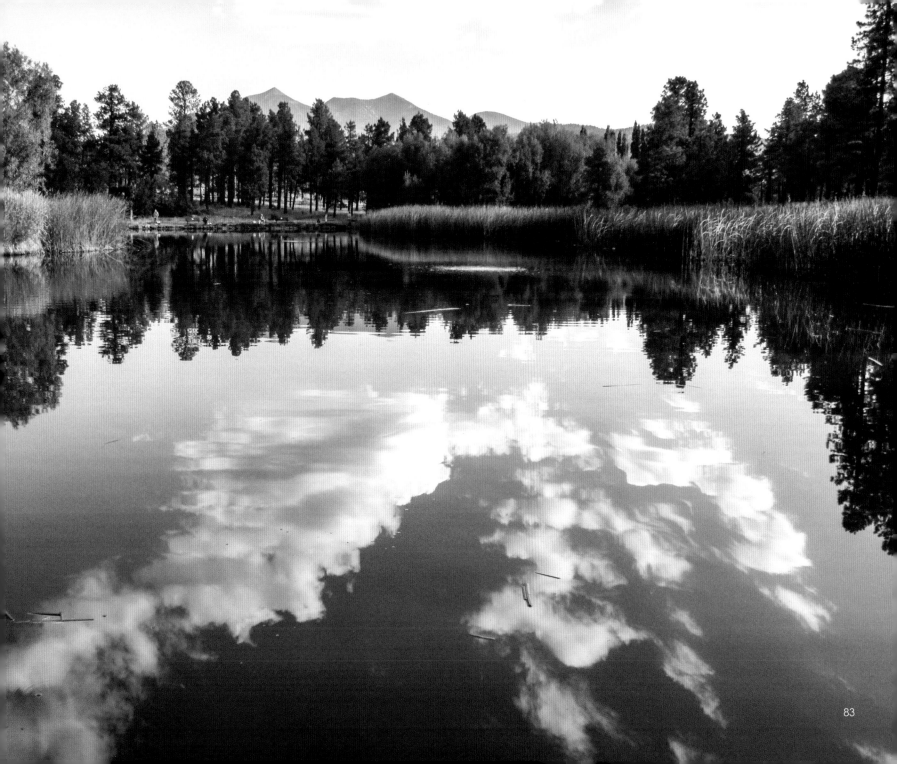

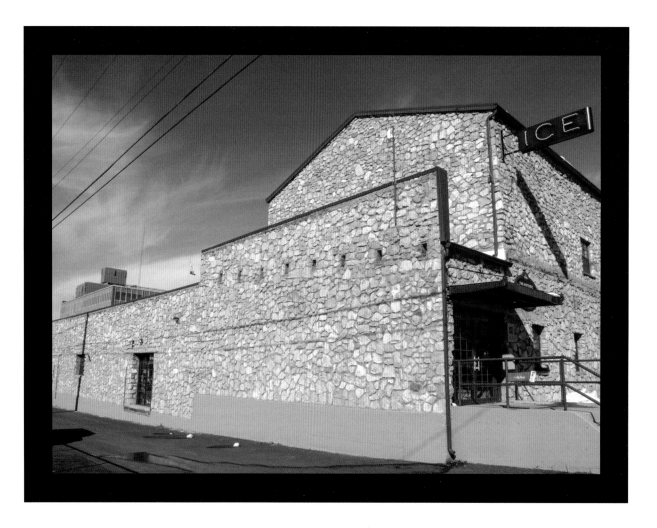

Allowing the eye to move from minutiae to middle distance
to zoom to panorama will show discernible scenes not
noticed before.

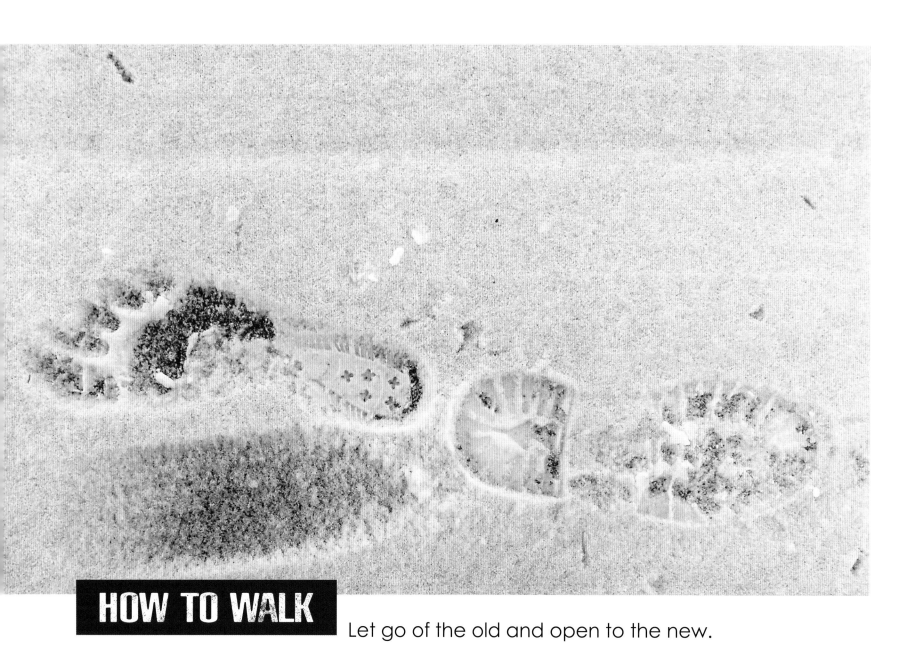

HOW TO WALK

Let go of the old and open to the new.

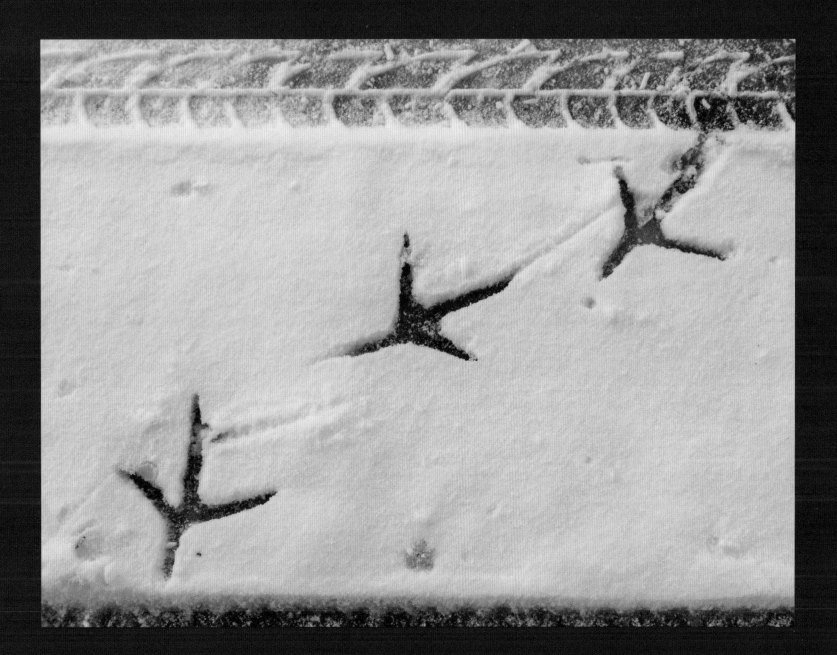

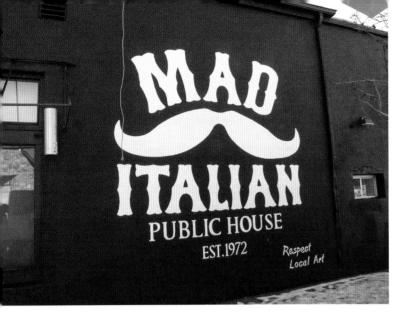

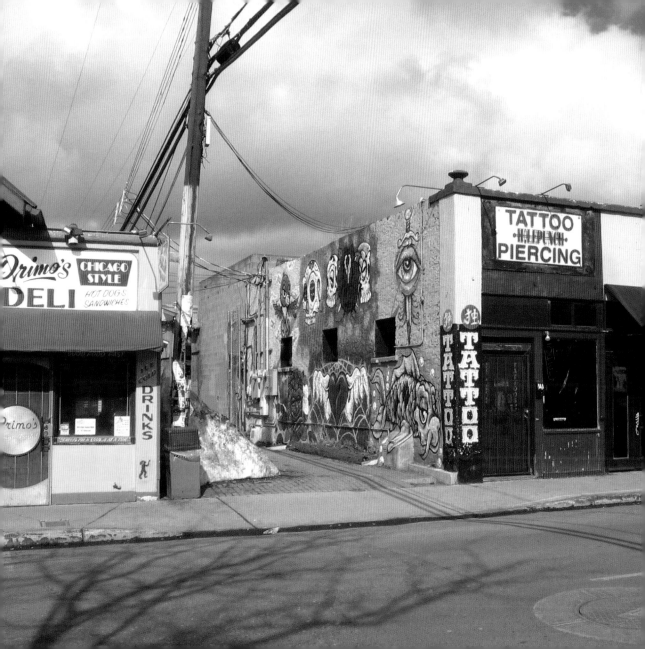

I called to her,

"Hi! Don't move!

May I take your photo?"

She smiled and said yes.

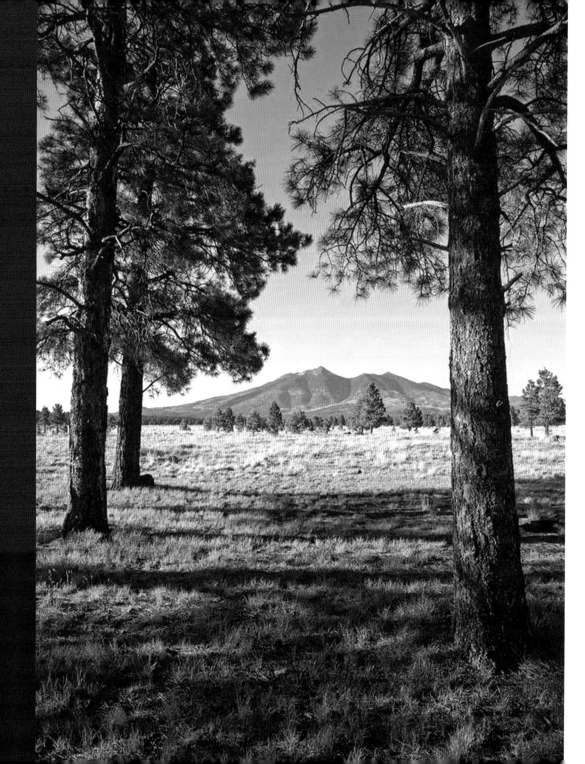

Walking is not just physical. Walking, to be true walking, is spiritual. Yet there are times in our walk that our "spirit is overwhelmed." Our yoga practices and meditative disciplines have dropped away like scaffoldings on an empty building.

What to do when you "wander lonely as a cloud?" How can you get yourself back together? You cannot. But the Spirit that breathes us, that has been breathing us since our irruption into this world, can.

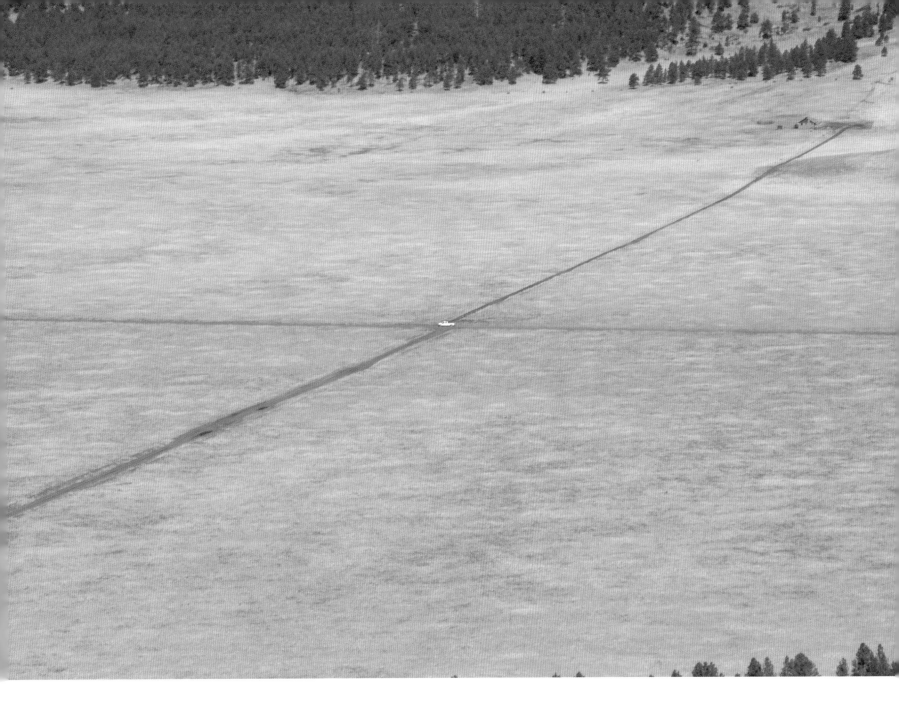

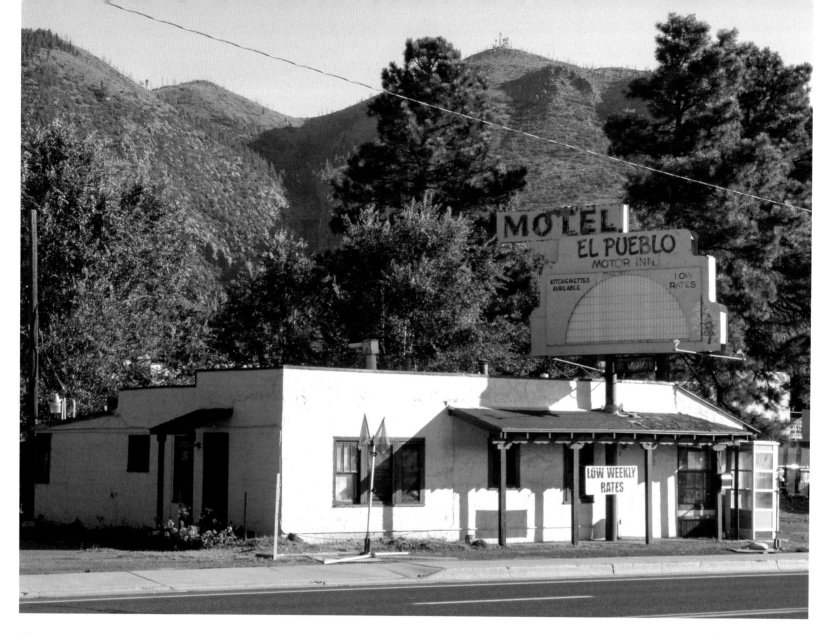

GREAT THINGS COME IN HUMBLE PACKAGES. Here is where planning took place for the Navajo Code Talkers program in World War II.

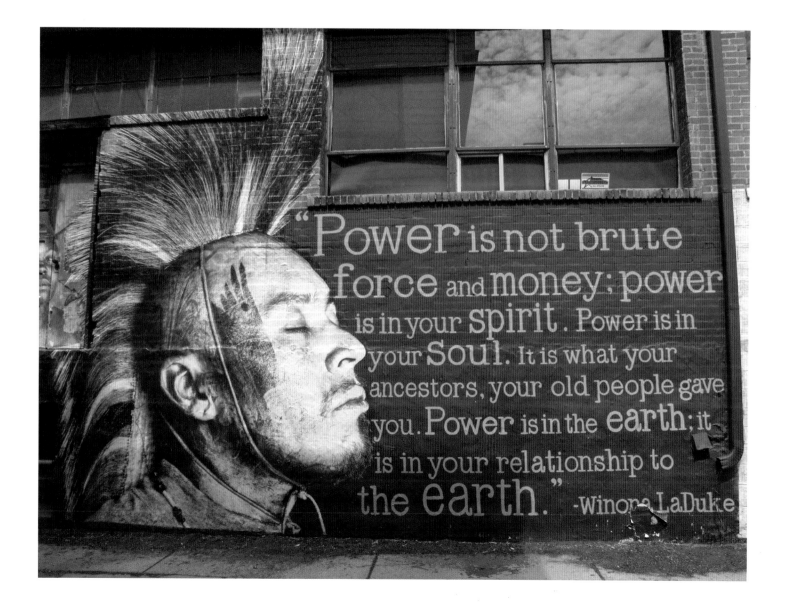

We are wondrously made. What we call our legs are not fused together so that we have to resort to a bouncing hop to move around. No, no. We are split all the way up to our trunk. We learn early on to move that splitness in a scissor-like motion, a marvelous learning which we soon take for granted.

"Look at me, Mama! I can stand!! And I don't just stand there! Now I fling one leg forward and move my body weight to it! Look! I can keep going! I fling the other leg forward and repeat the process!"

Walking can become so familiar that we take it for granted. But it's a miracle! We can and do move from "here" to every place on Earth. And the sights we see, the smells we smell, the sounds we hear along the way!

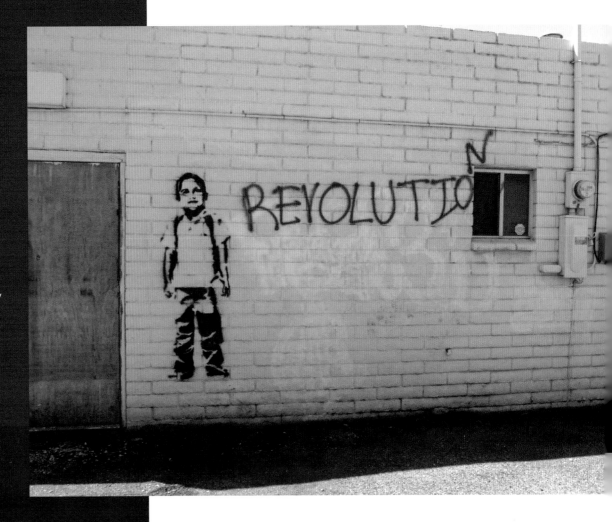

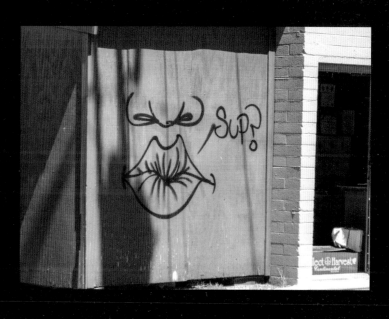

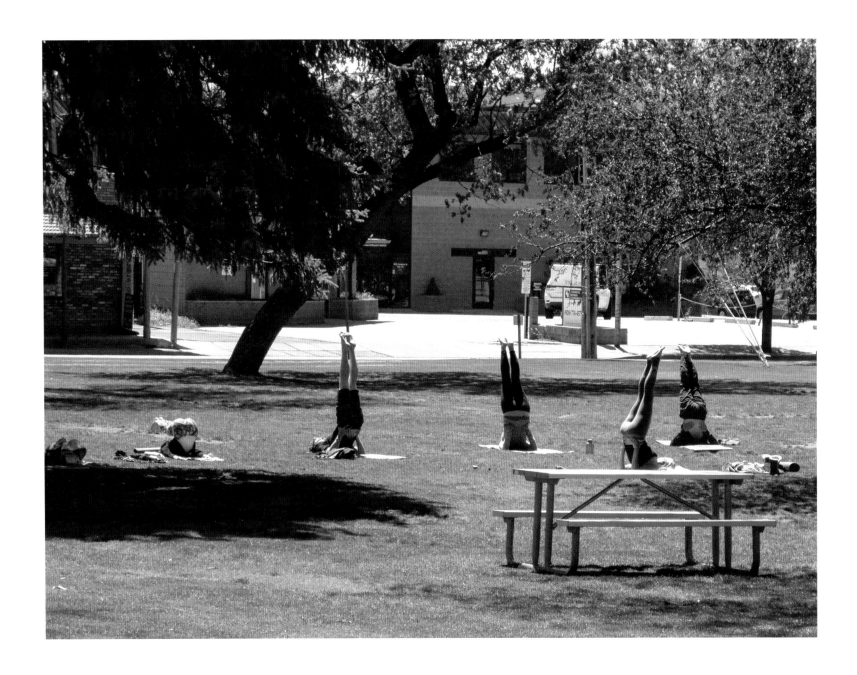

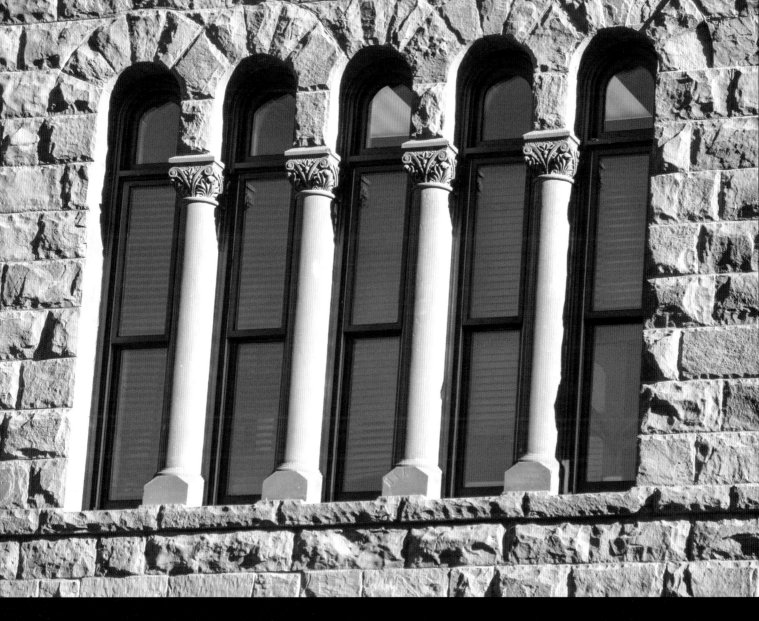

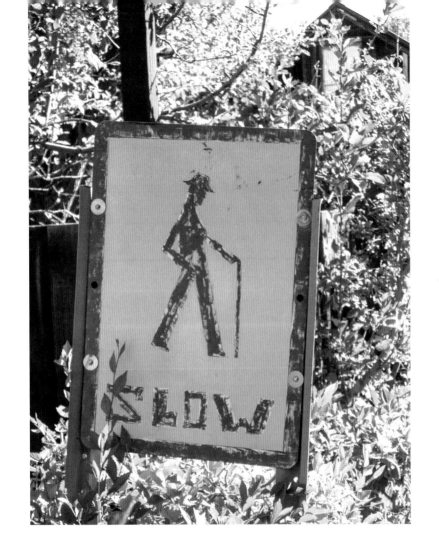

SHADOWS ARE MYSTERIOUS,

telling a story that light tells,
but secondhand.

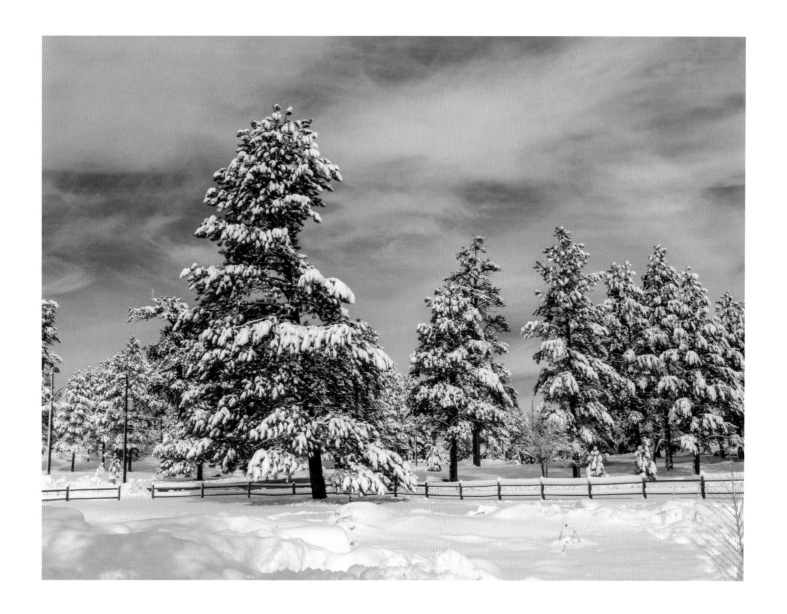

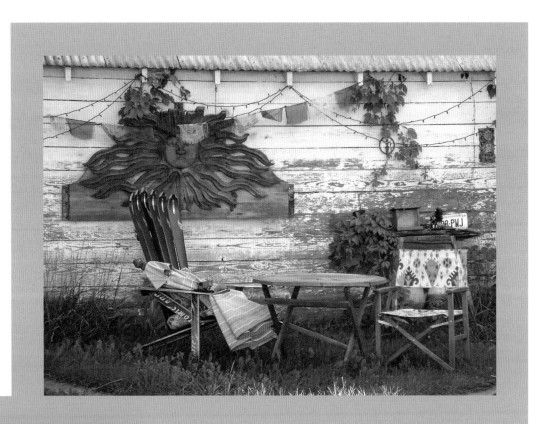

A bench is not for fidgety "waiting," but is a place of calm repose. Sit for a bit, allow your bones to settle, then move on.

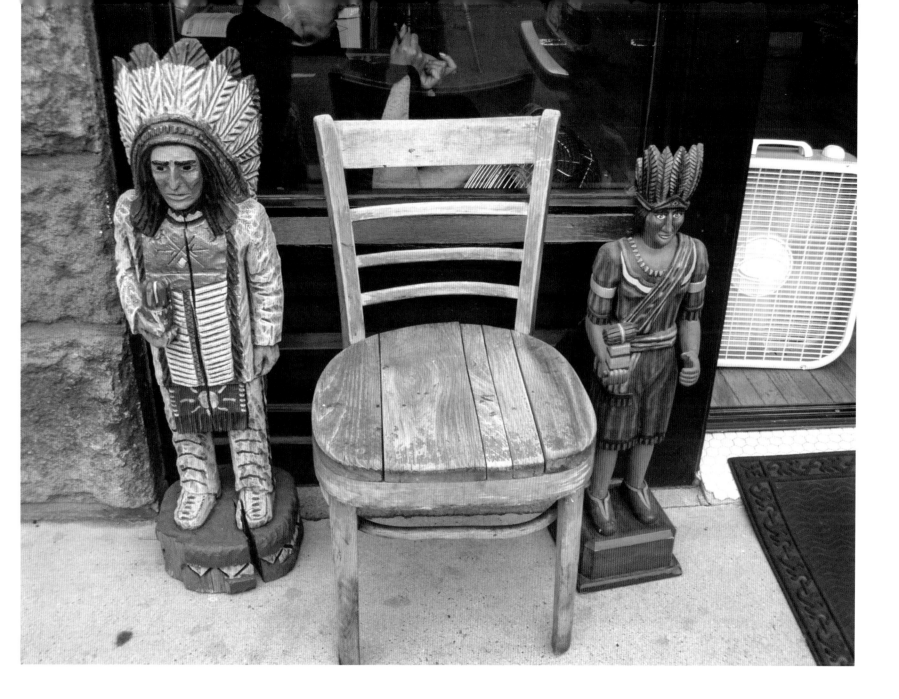

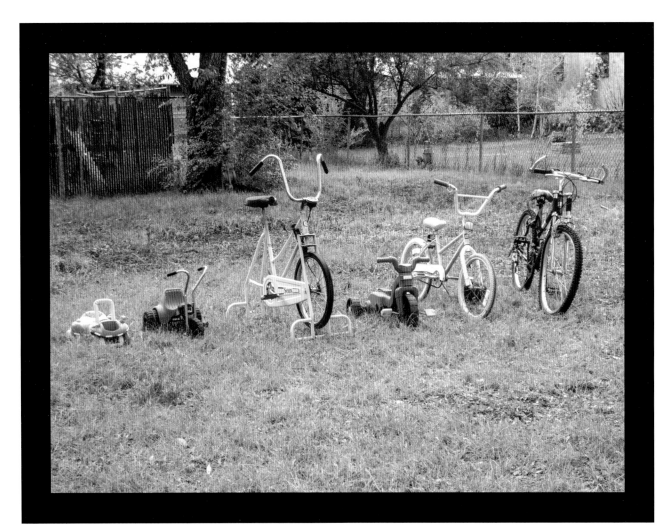

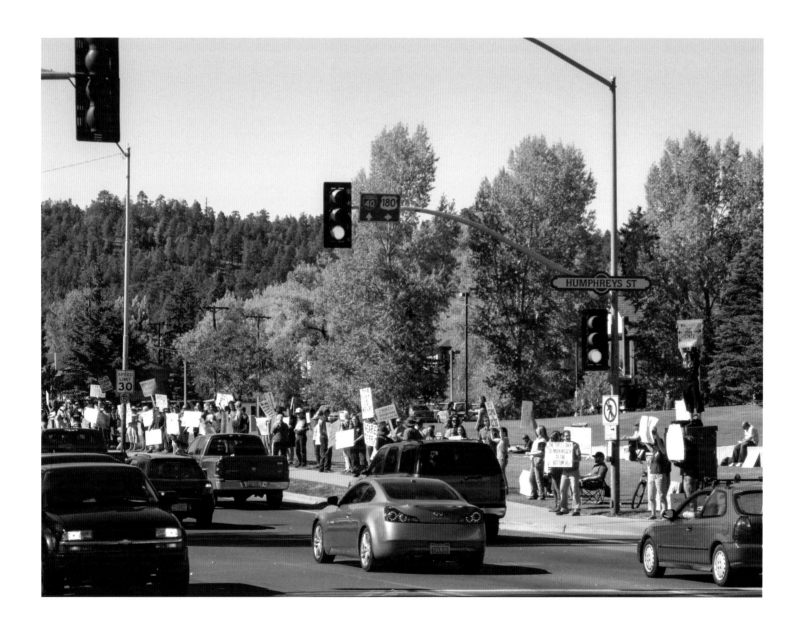

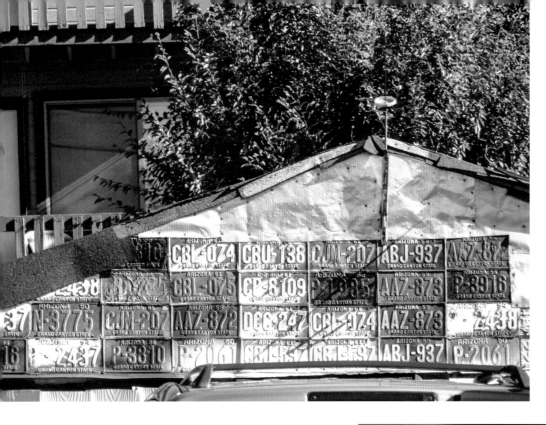

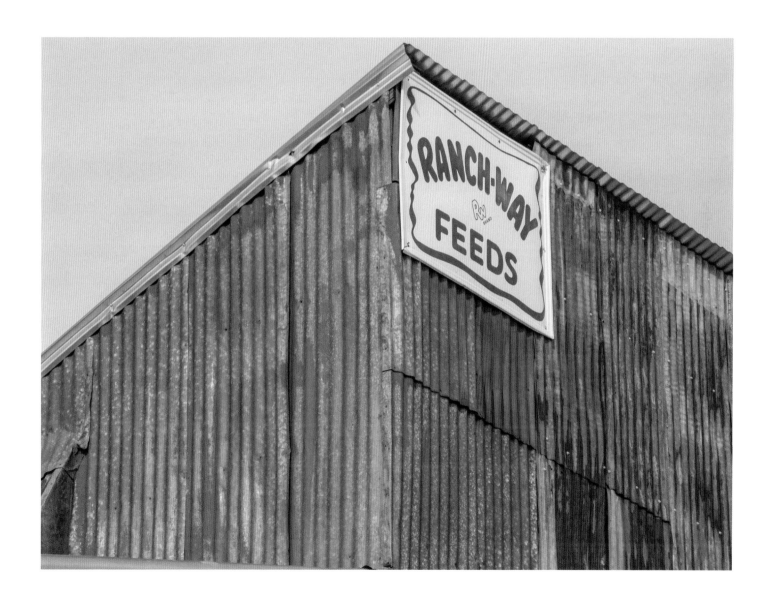

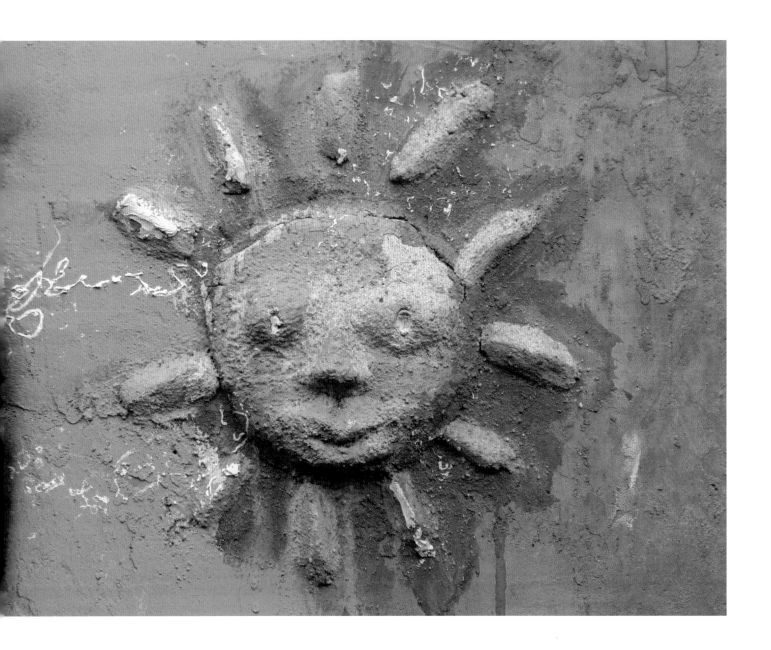

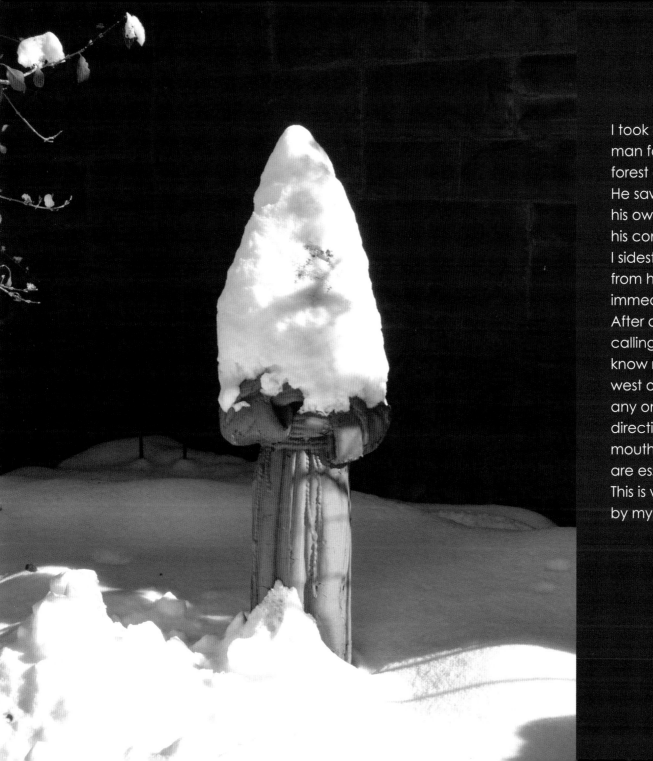

I took a self-absorbed man for a walk in the forest once. Once. He saw nothing but his own image amidst his constant blather. I sidestepped away from him without his immediate notice. After a while he began calling out. He did not know north or south or west or east, and by any one of those, the direction home. Closed mouth and silent mind are essential for seeing. This is why I mostly walk by myself.

113

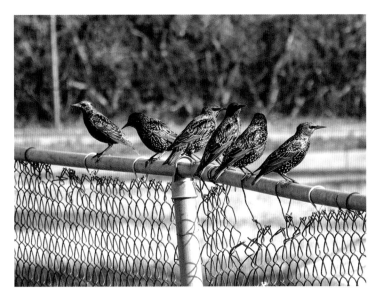

When your eyes are
open, you do not
see things: they show
themselves to you.

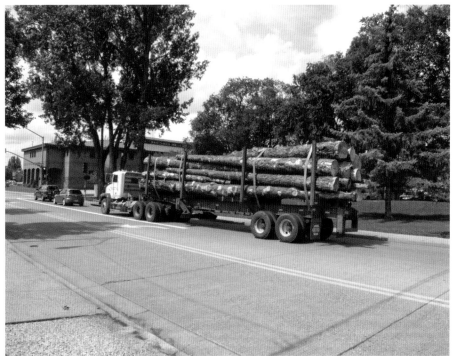

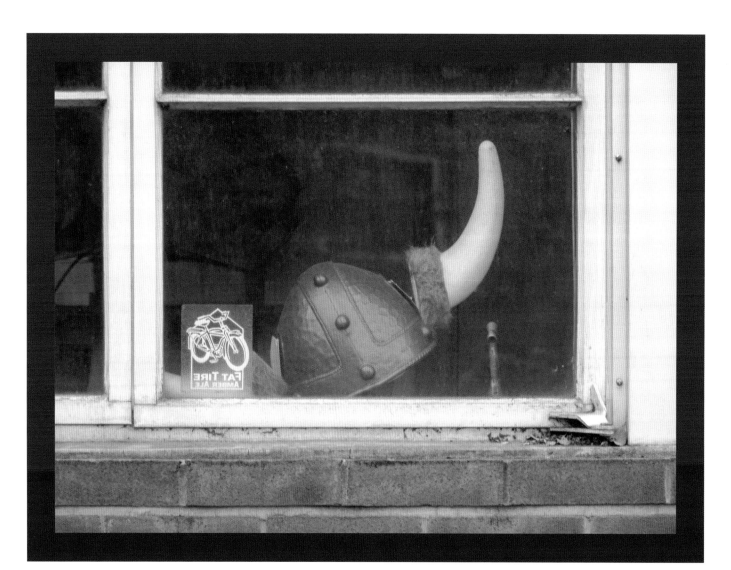

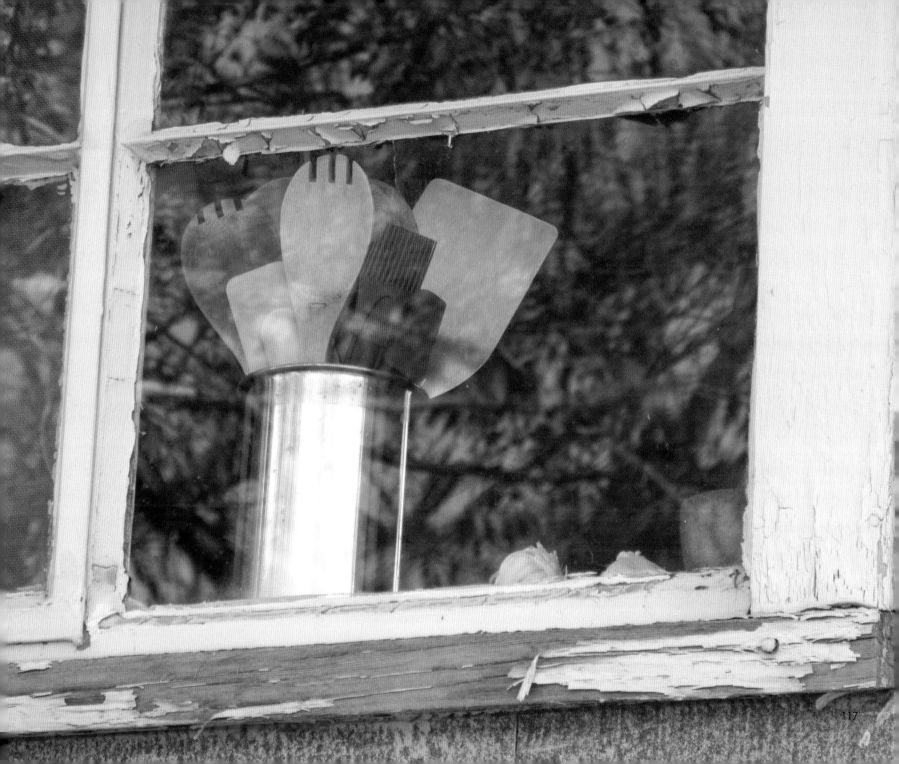

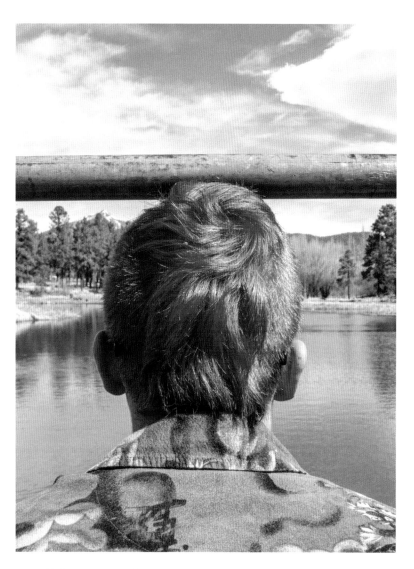

Walking produces calmness of mind.
Calmness of mind allows clear seeing.

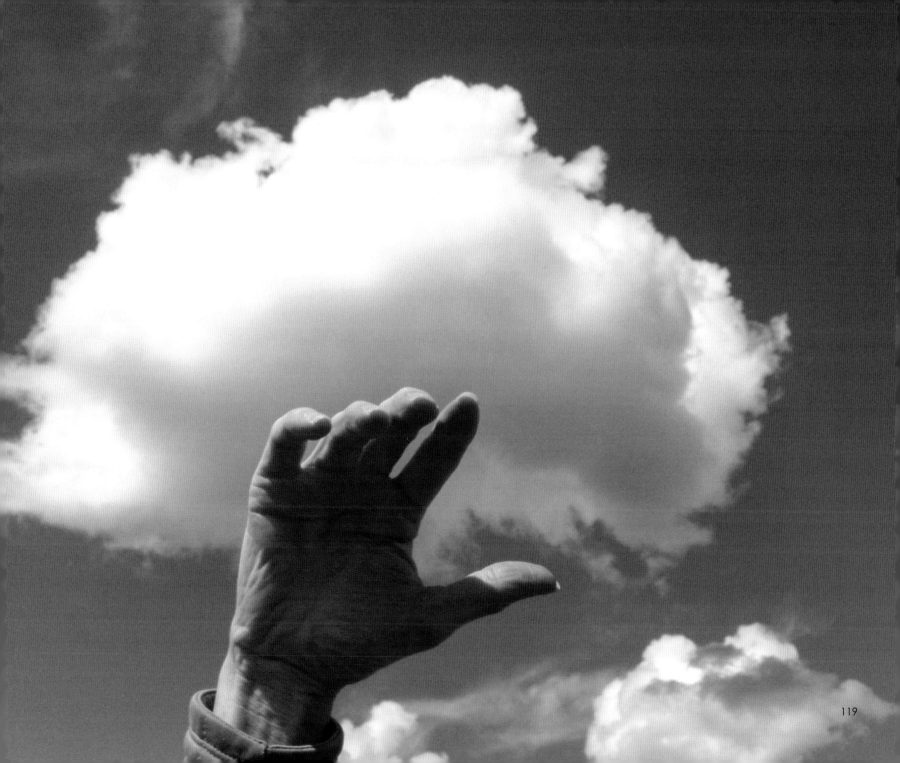

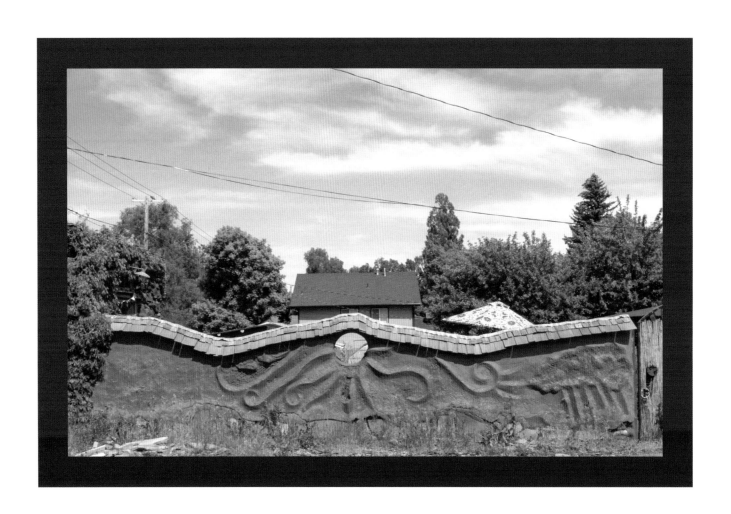

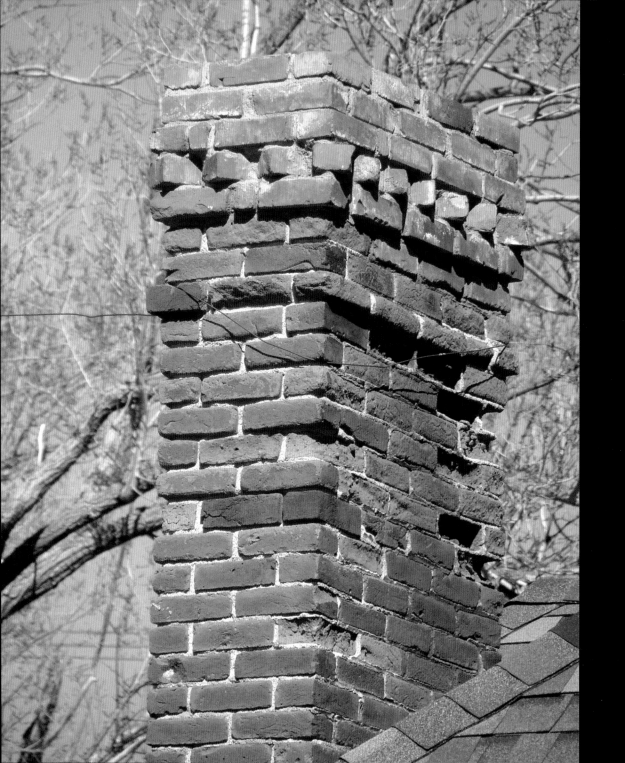

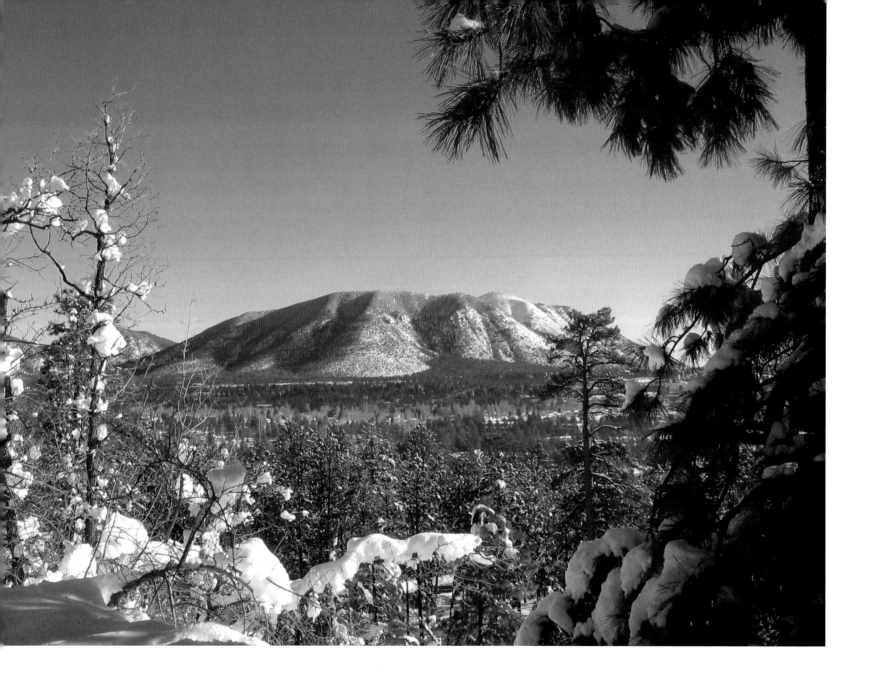

GET UP

To walk, the first action has to be to get up. Get up out of the stale old, the frozen positioning. Arise. A good word, "arise." Reminds me of bread dough preparing for an oven bake. You may look as if you are doing nothing, but inside you are rising up; the body then follows.

Arise. Walk through the land. The land may be from here to the bathroom or from here to the kitchen. Doesn't matter. Walk it. The length and breadth of it. As you walk, it is claimed. It is given to you. And you are given to it. You are each other's. You are the path you walk.

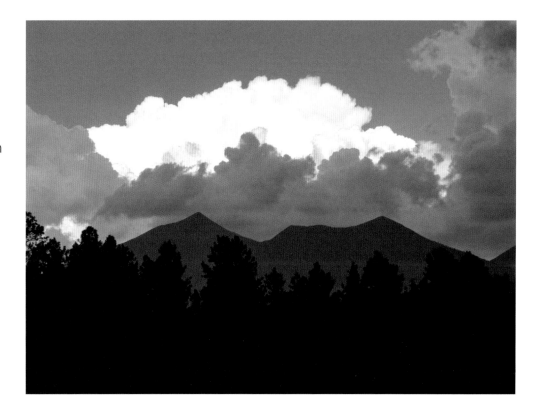

After claiming the land of your dwelling place, your house, your apartment, your shelter, walk outside. Feel your feet on the earth. Look at the sky. Breathe the air. Listen to the sounds. Claim the ground you walk on and in as your spiritual space. Allow it to claim you.

Go for your walk. Kiss the earth with your feet. Swing your arms. Lift your face and laugh. Breathe! Walk. Continue walking through the day, whenever you are on your feet. It will be given to you. What will? You will find out.

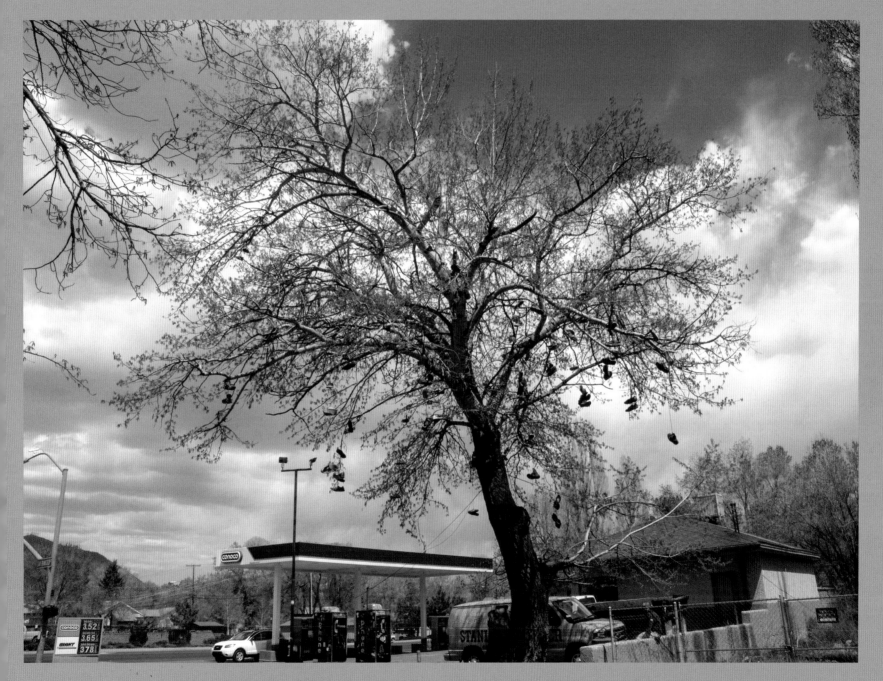

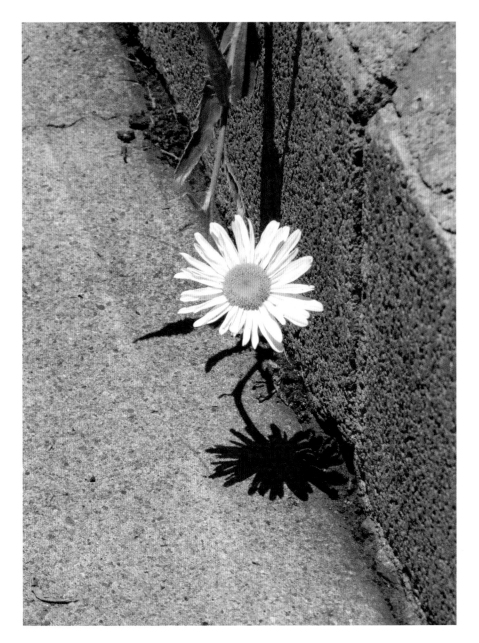

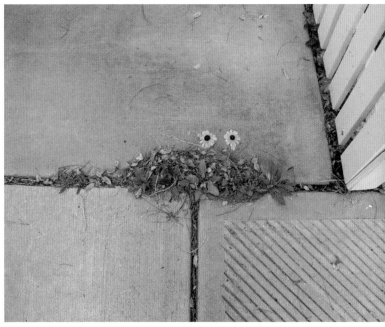

As each step touches ground, I send loving-kindness and blessings to the Earth, all in it, and all upon it. As I walk, flowers bloom in my footprints.

LOOK

I dunno. Getting out and walking around with my camera does a few things.

① I get fresh air and "motion is the lotion" that lubricates my joints.

② I see things and often they see me. Reciprocal enthusing.

③ I capture an image of the reciprocity.

④ People yell at me and I yell at them.

⑤ Some conversations unfold.

⑥ I don't sit indoors all day being all intellectual and such.

⑦ I post photos and some folks experience momentary bursts of brain chemicals.

⑧ Finger exercise accelerates as some folks click "Like."

⑨ Potentially, possibly, I am documenting Flagstaff for some future anthro-hound who will say "Look, here is how it was back then."

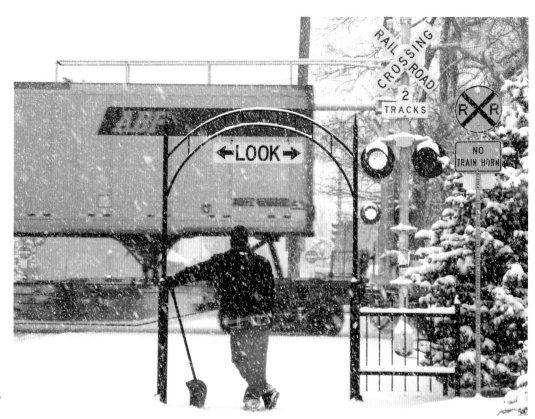

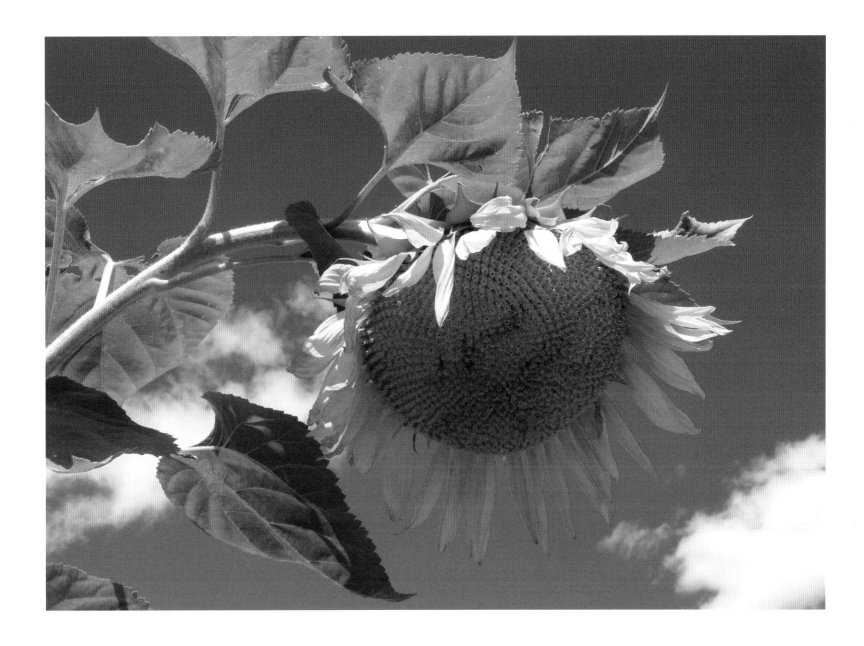

Was walking along feeling like Bah humbug! to it all, not self-pity but a form of calcified belligerence, when a little boy about knee-high, walking with his mother on the other side of the street, called out "Hi!" I turned and returned his bright smile and told him "Hi!" and walked on, smiling in my heart.

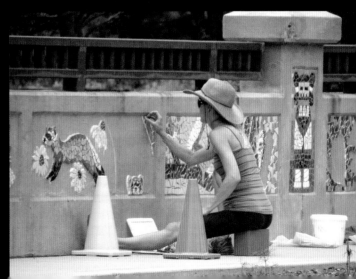

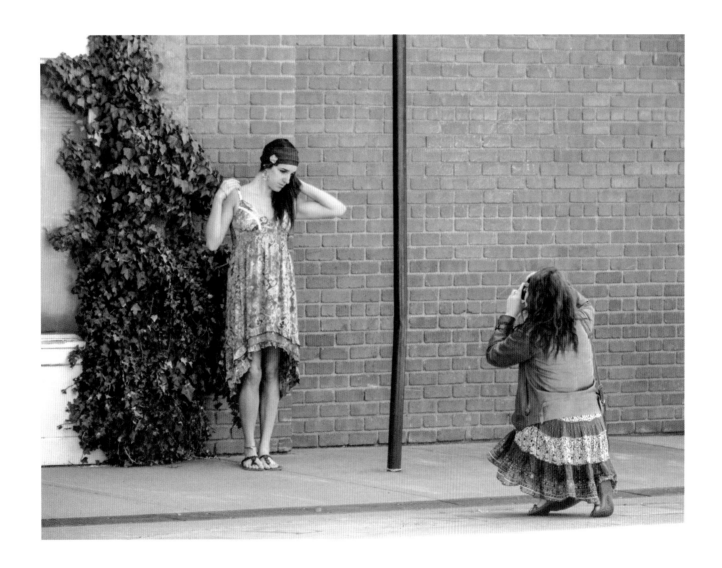

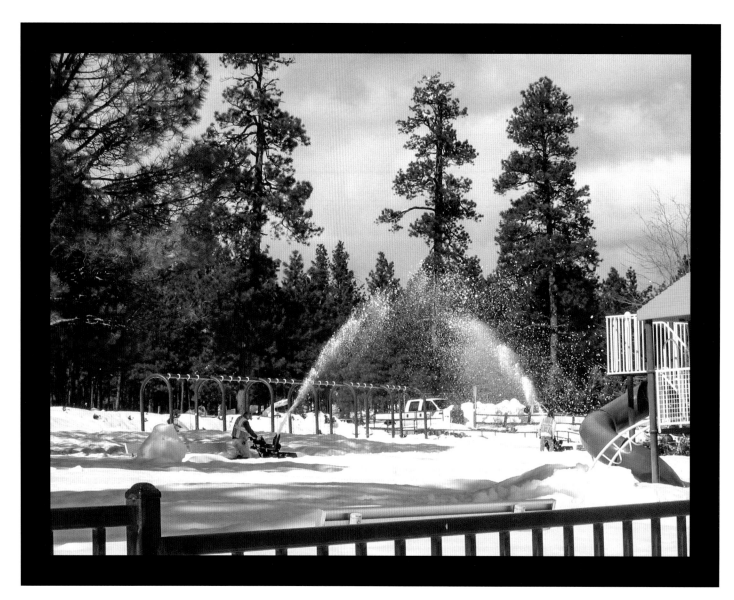

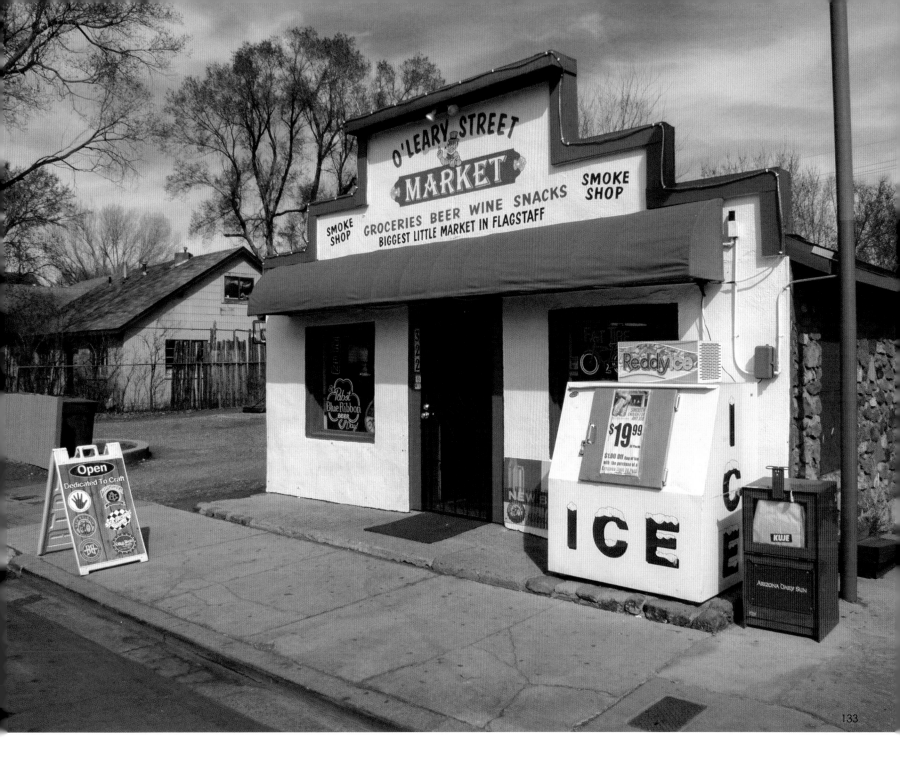

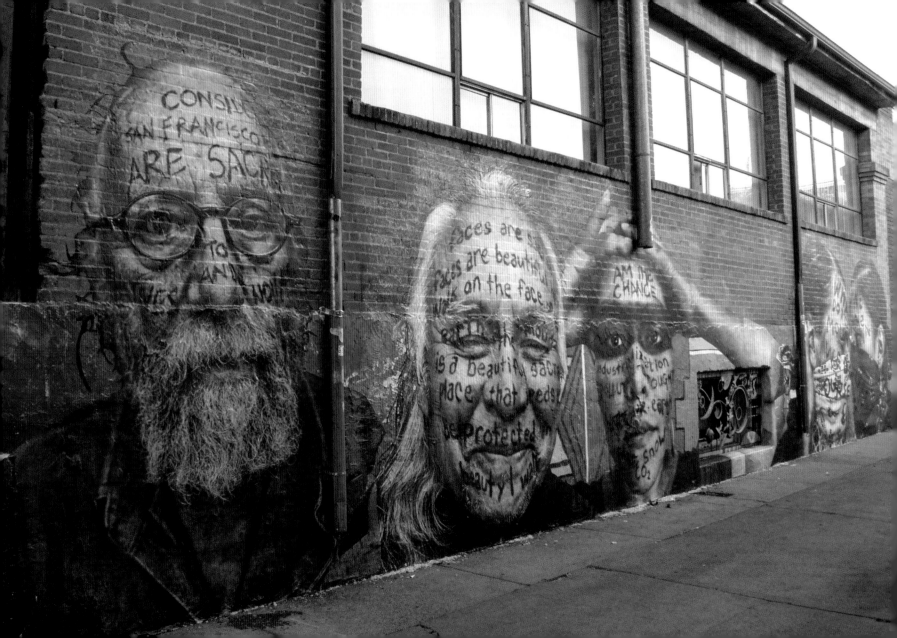

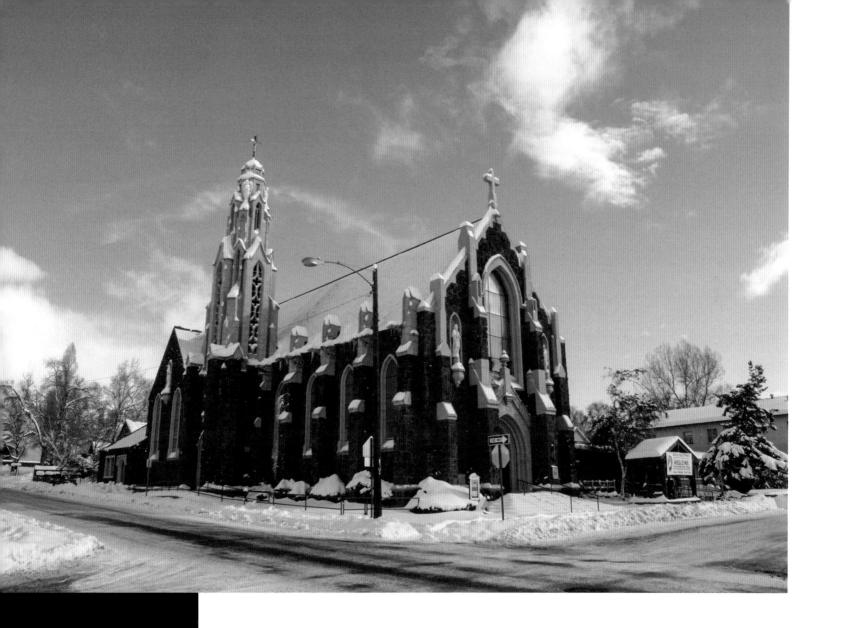

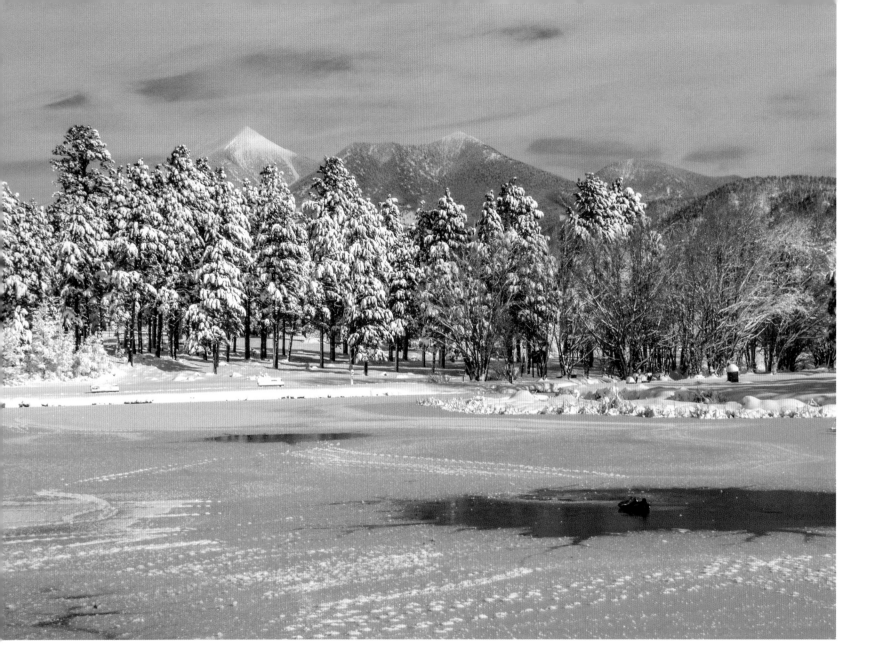

Some scenes **SCREAM** for a photo. Others **WHISPER** gently.

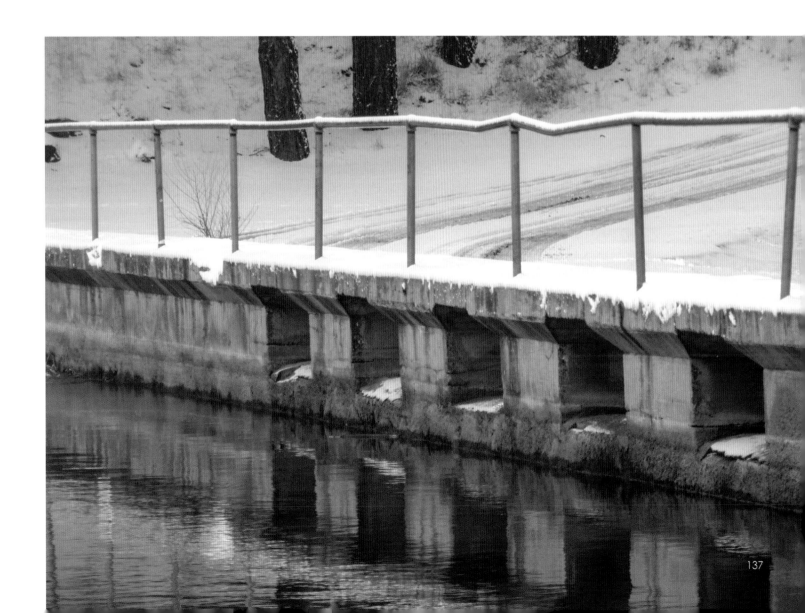

LIFE ON EARTH supports the creeping, the crawling, the rooted, the winged, the finned, the four-legged, and the two-legged. We two-legged move around amongst our cousins. We tread softly and with reverence. Feet on the ground. Heads in the sky.

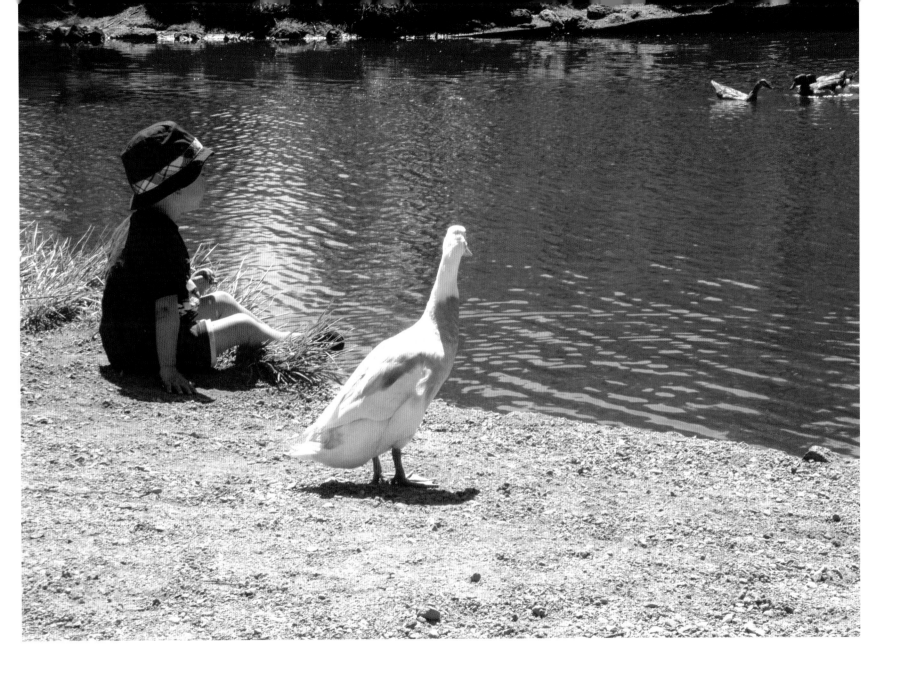

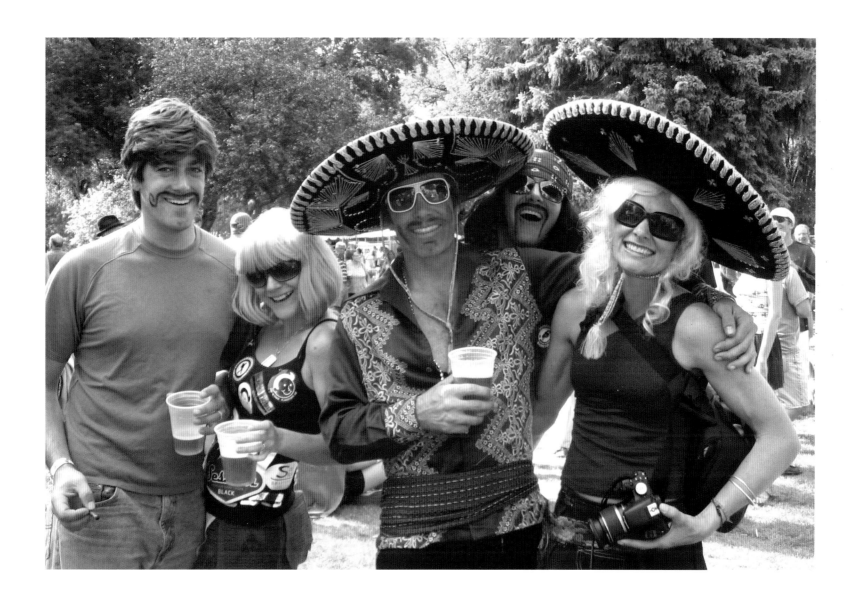

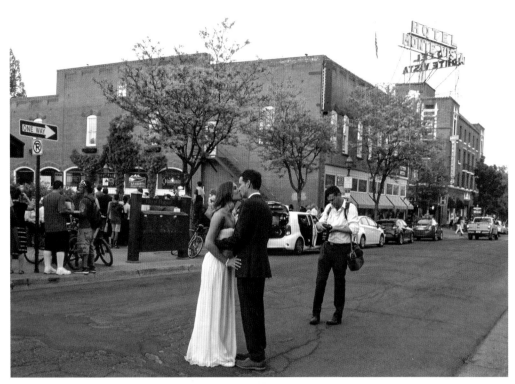

Give a person a camera and the whole world becomes a photo shoot.

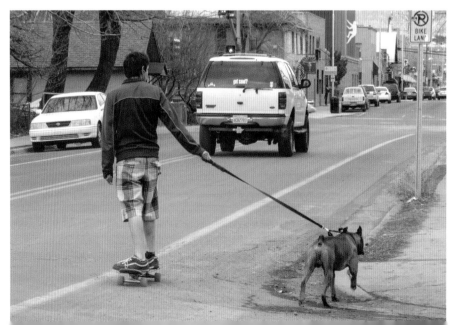

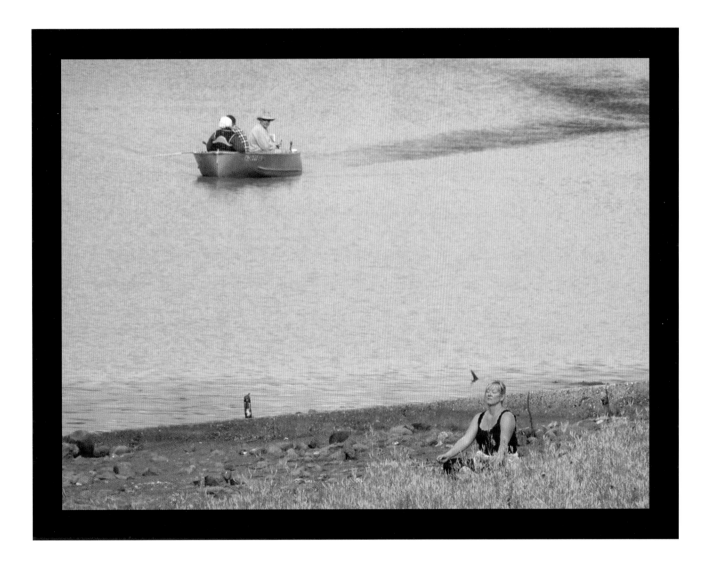

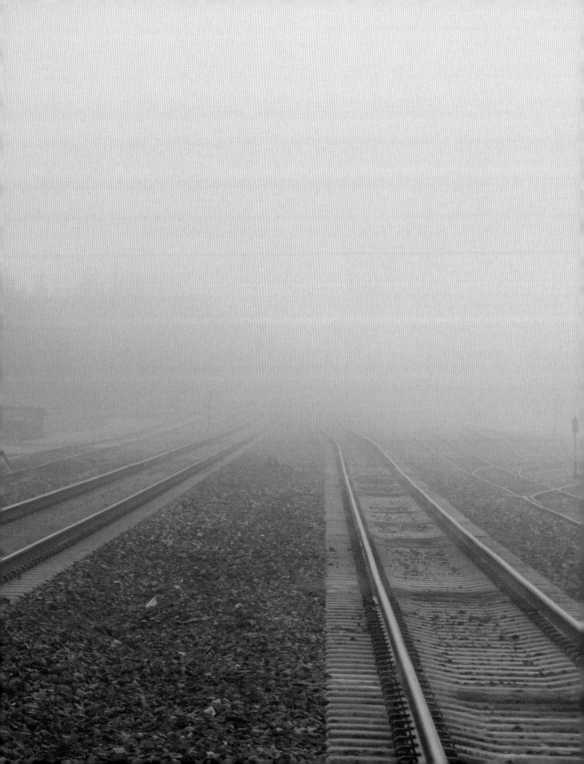

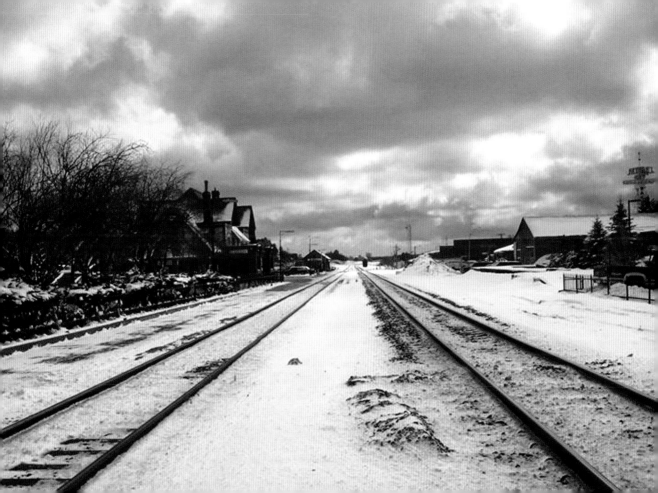

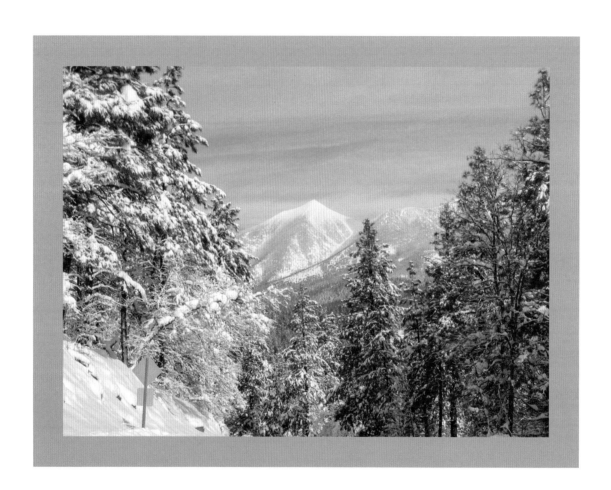

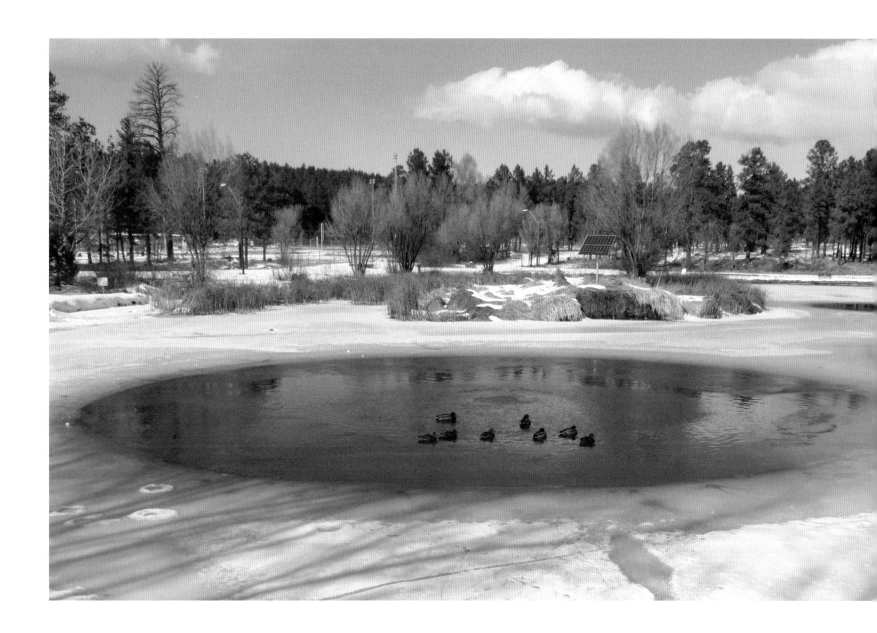

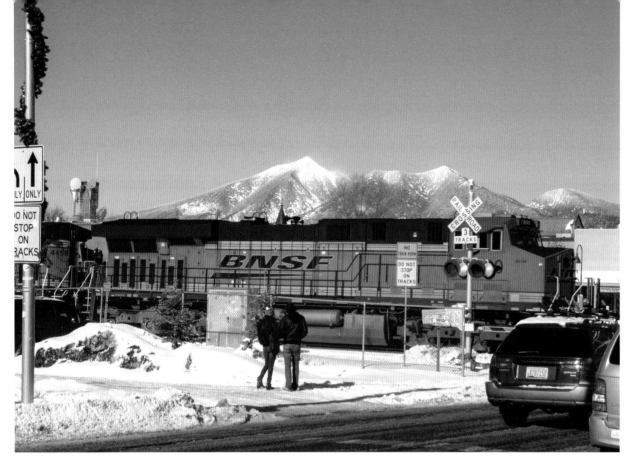

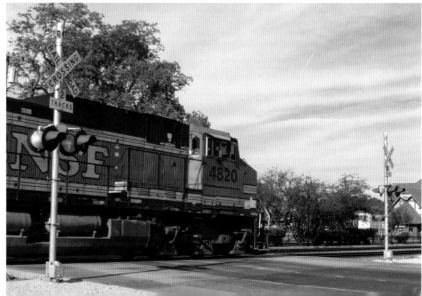

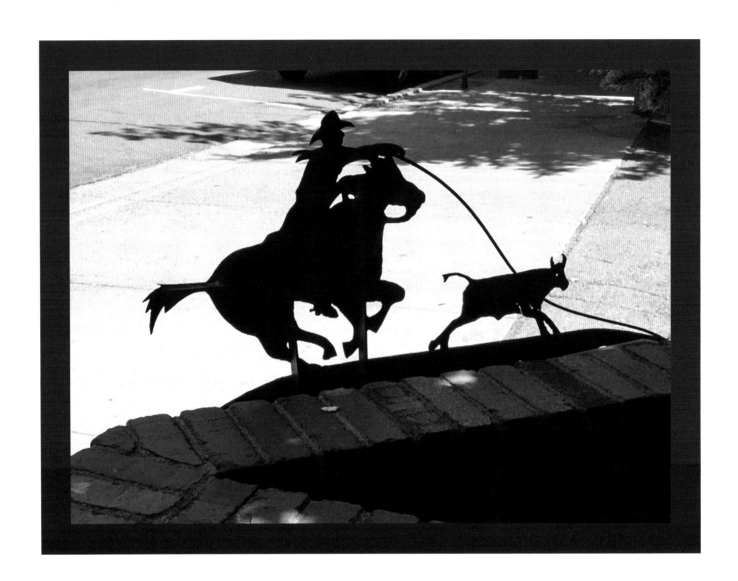

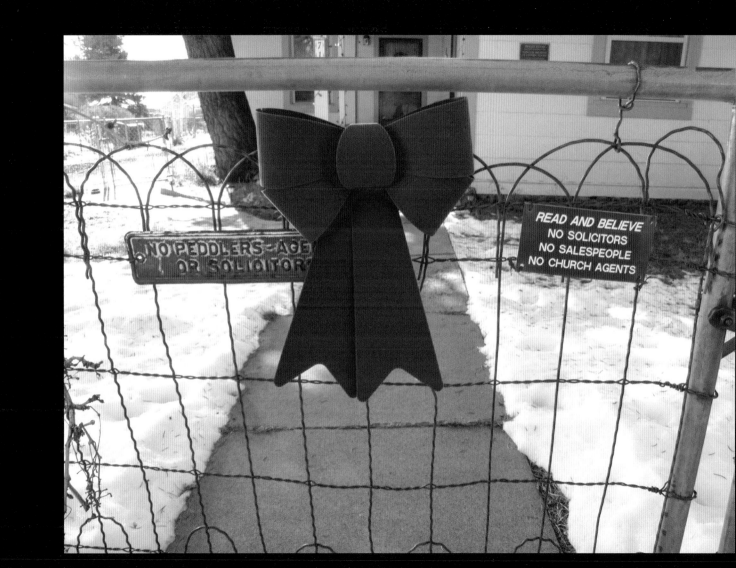

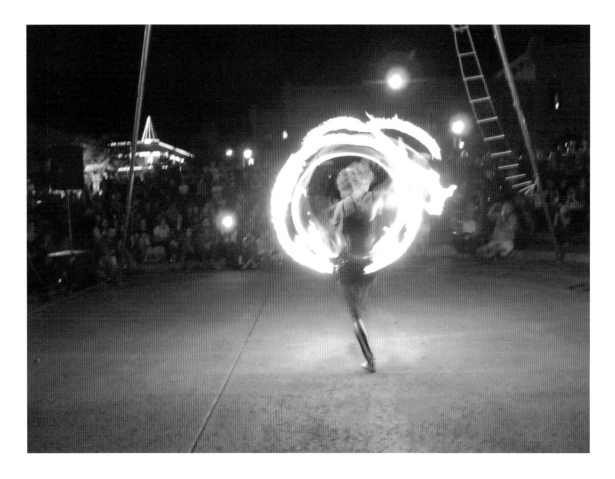

When I was attending Jon Kabat-Zinn's mindfulness retreats, the watchwords I kept hearing were, "Go straight ahead!" This is consistent with the Zen way and with the inner discipline of the martial arts. Straight ahead means to move into the next nanosecond arising out of Now. An unbroken chain of nanoseconds, of moments, creates a straight path, no matter how circuitous. The new you continues to be born out of the old you, **EFFORTLESSLY**

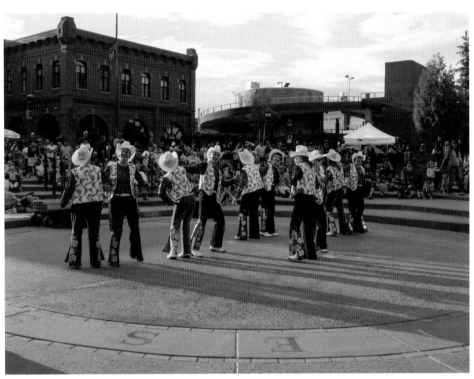

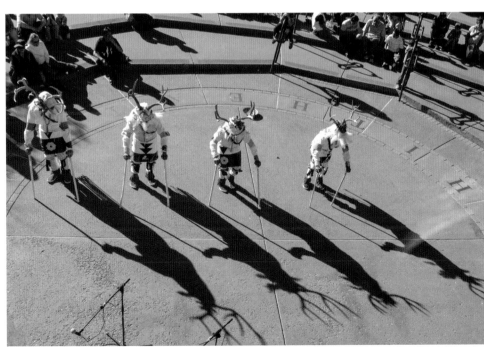

153

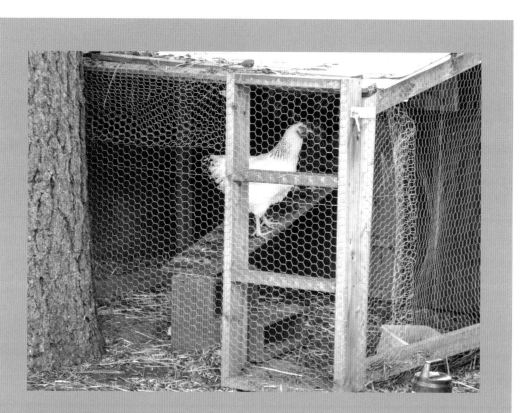

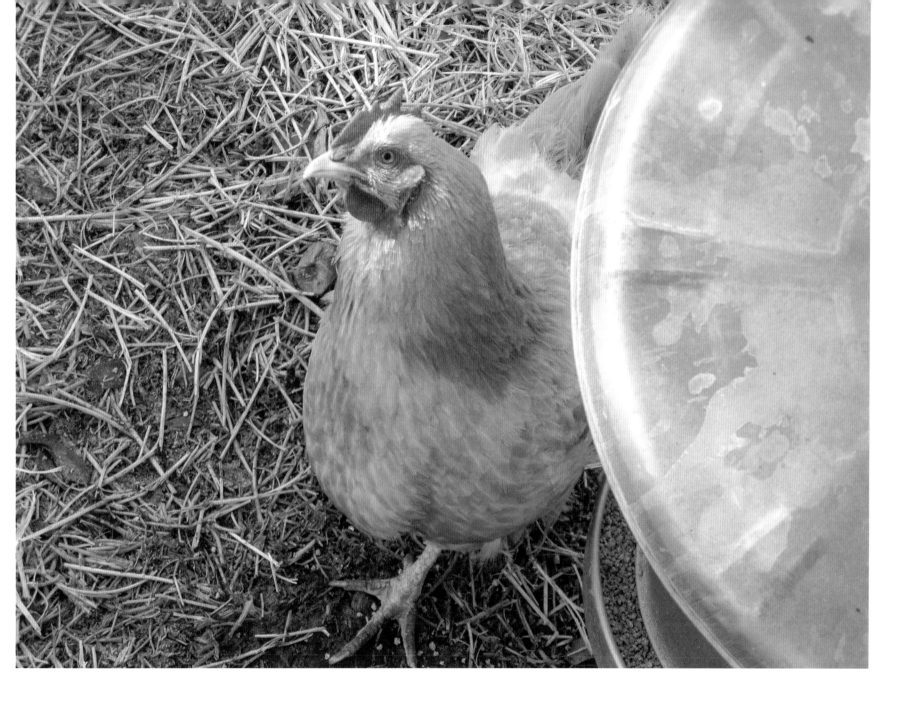

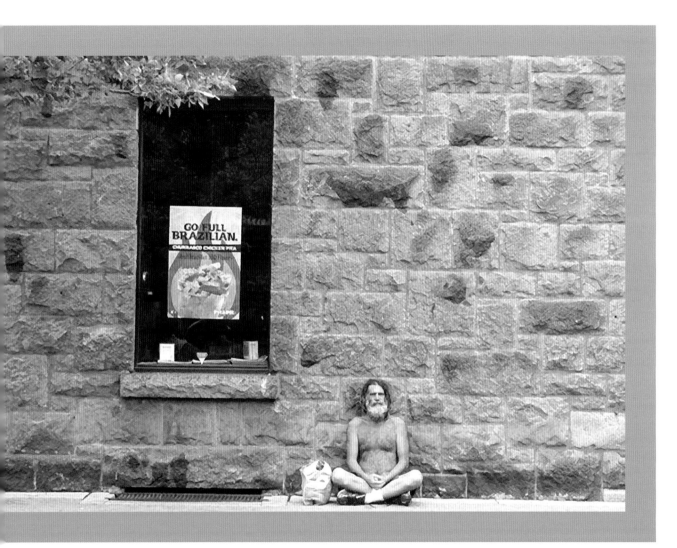

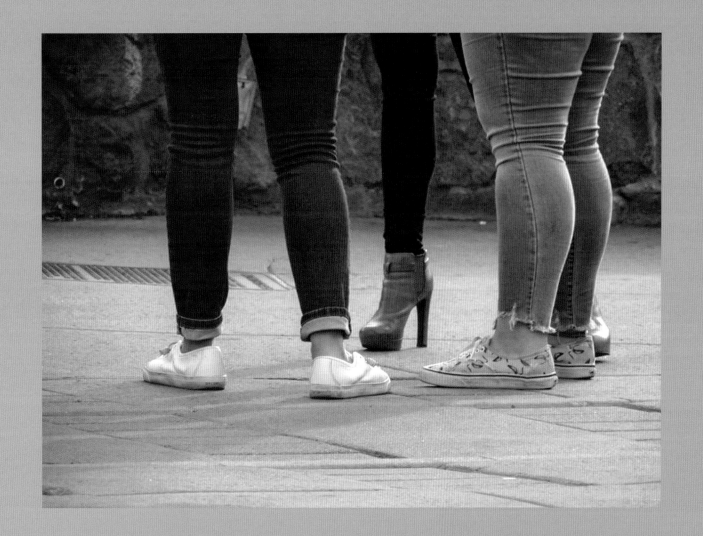

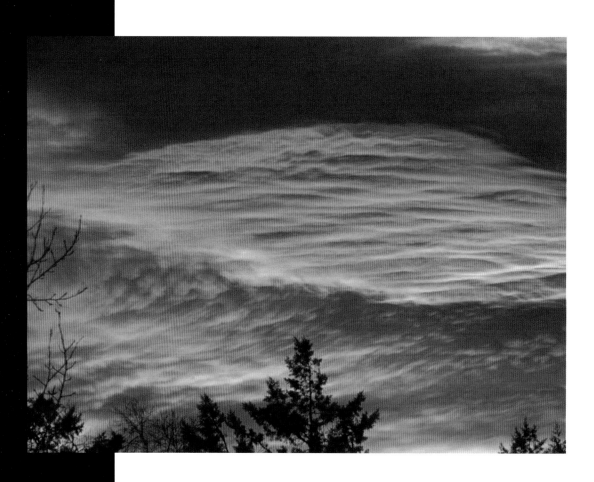

Sometimes I get stuck in my head with its visions, its imagery. I catch myself. Hey! With a leap I stand upright, grab my hat, my coat, my camera, head outdoors and begin to walk.

Then the miracle happens. My entire consciousness changes. Birds call. Barren wintry tree limbs wave. Feet feel the earth. The winds sigh. Head stuff lags way behind, disappears. My heart opens and sings.

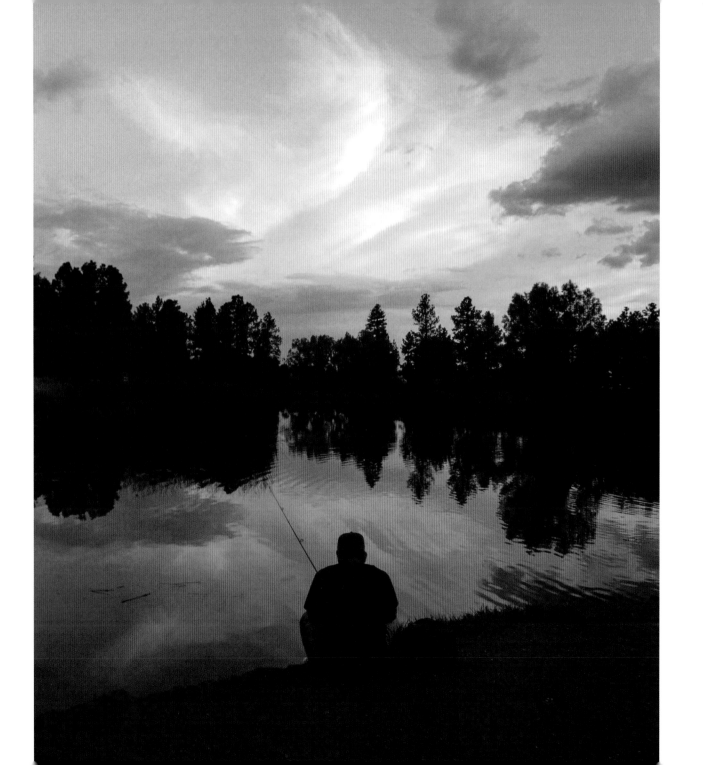

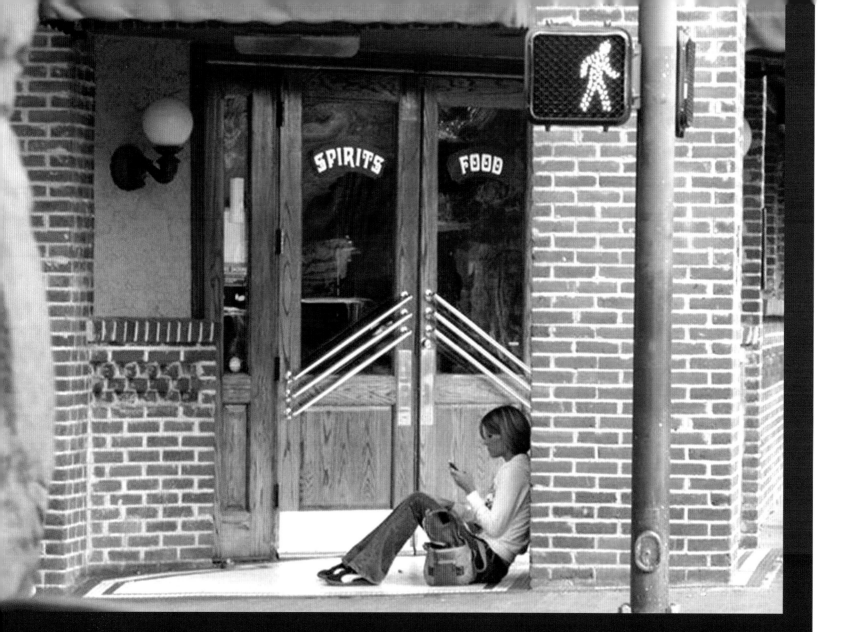

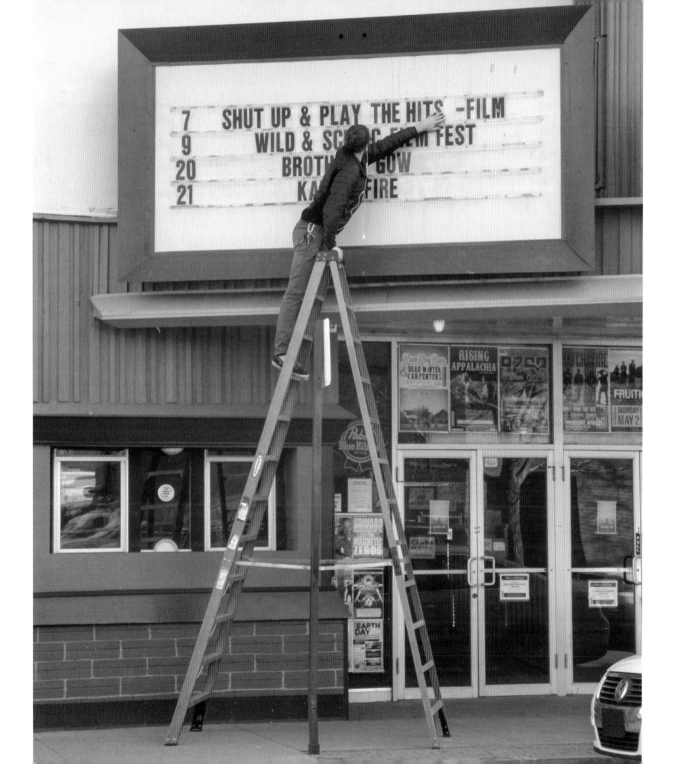

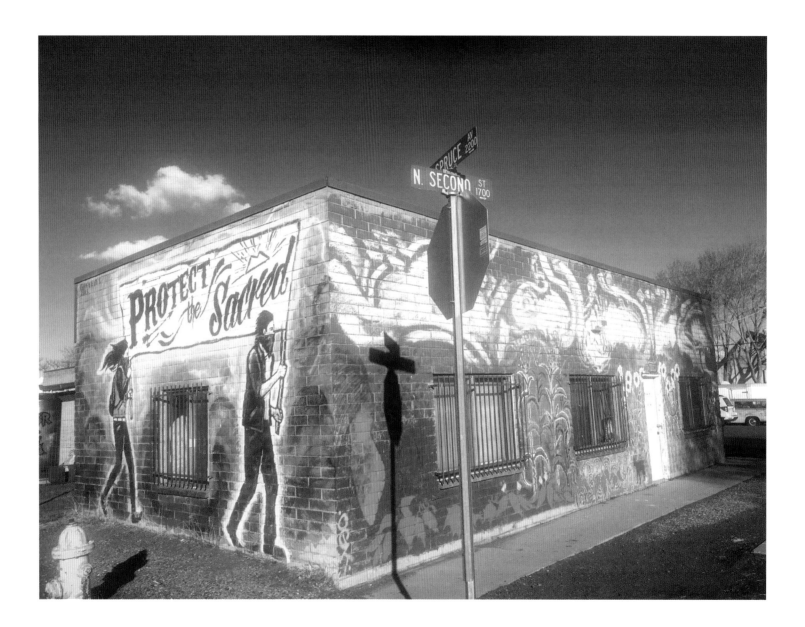

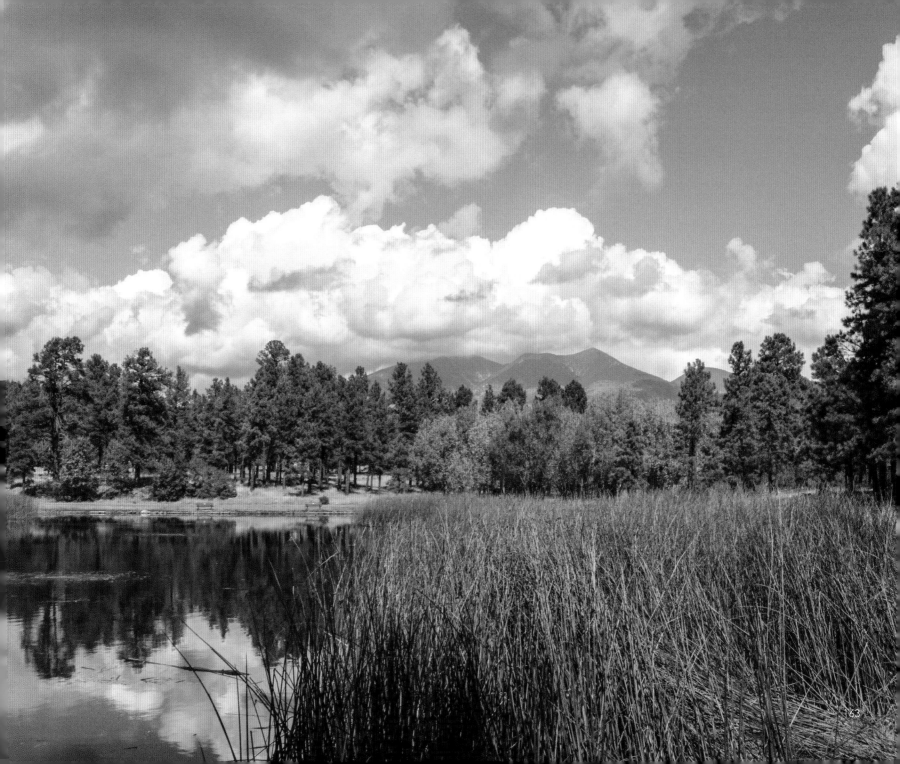

"Hey! You're that guy who takes photos! What's-his-name!"

"George."

"Yeah! That's you!"

I simply must stop carrying my camera around.

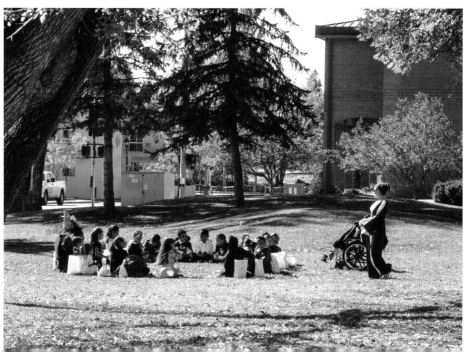

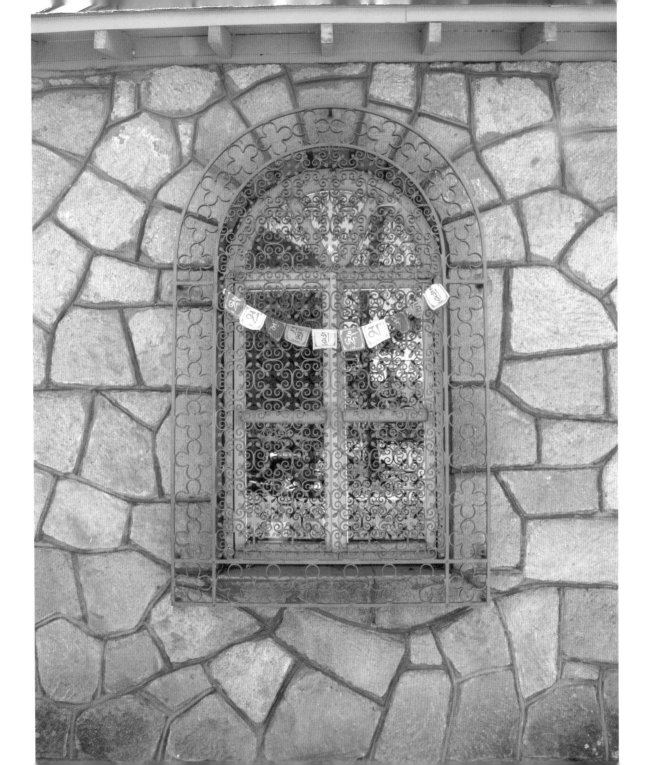

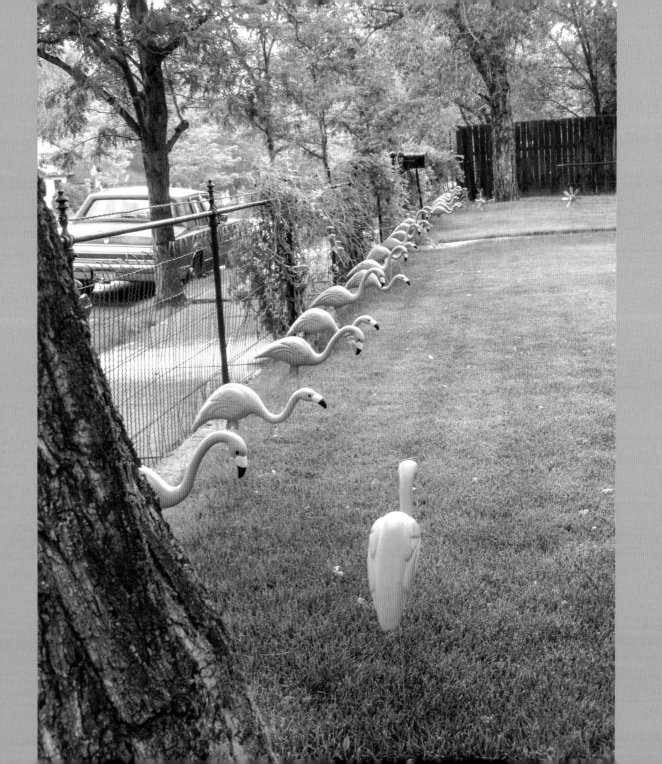

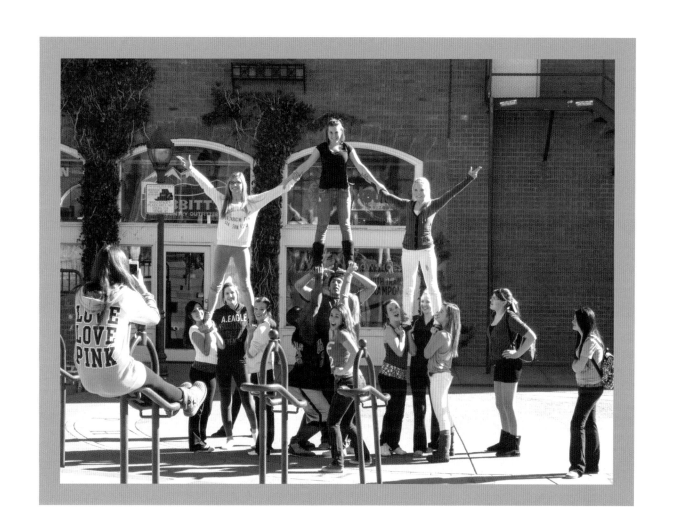

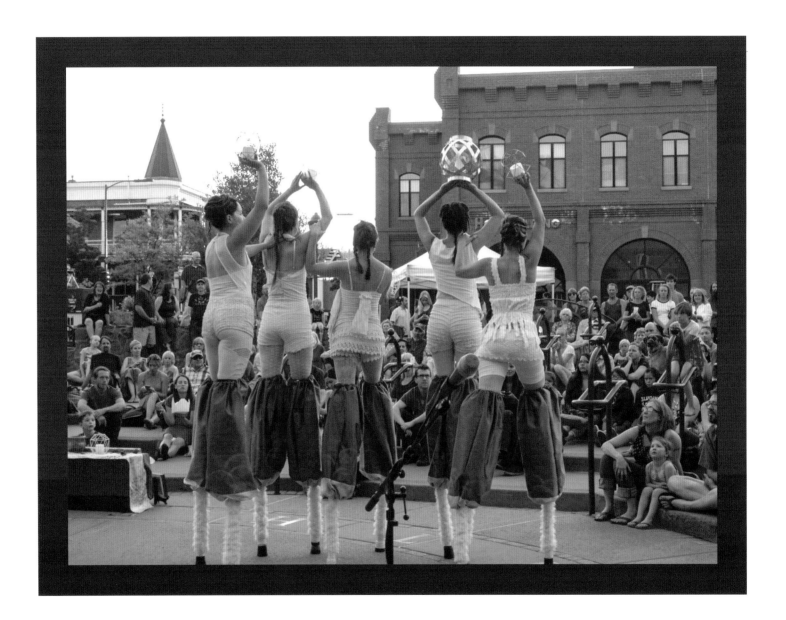

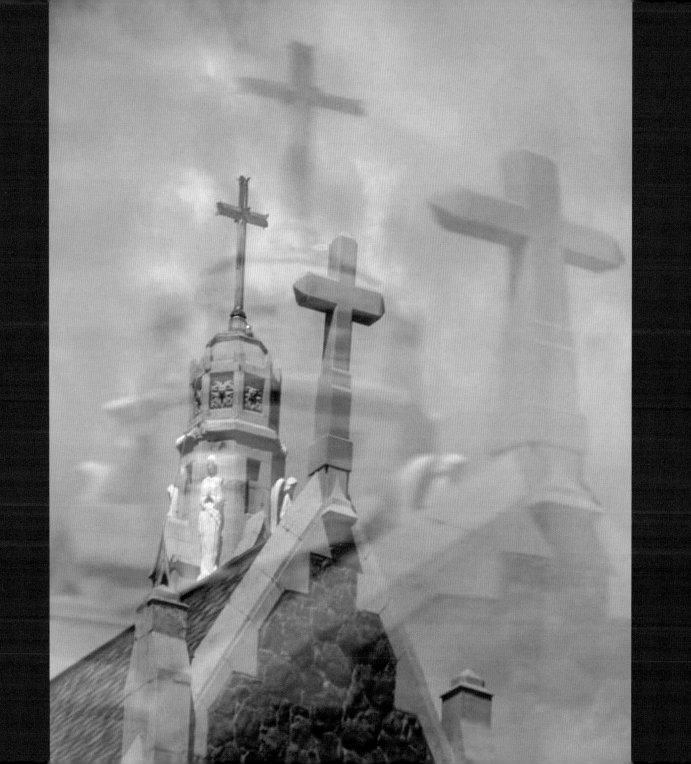

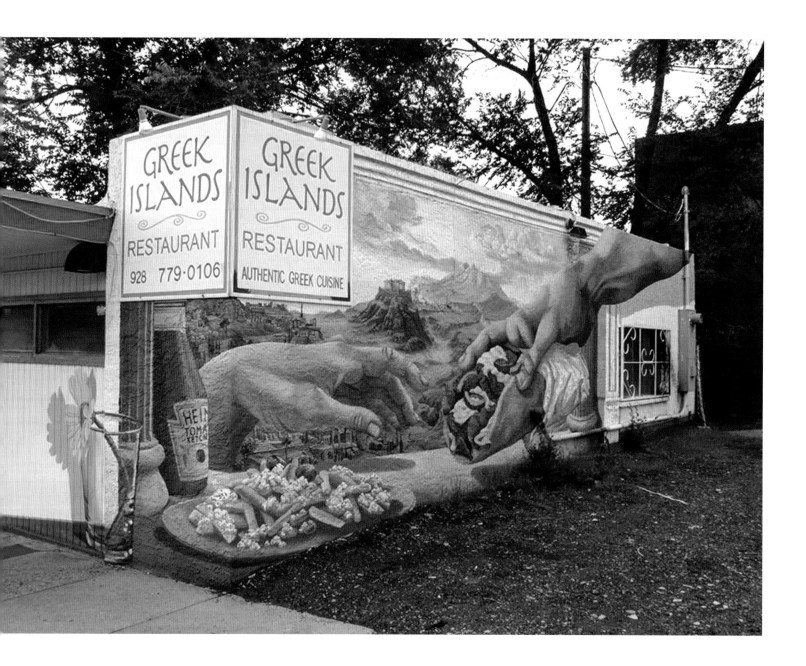

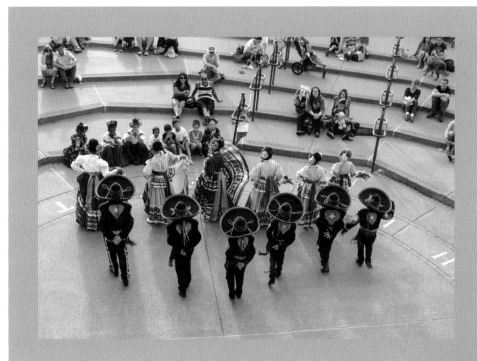

As I step forward, my front leg fills with strength and energy as the rear leg empties. With my full weight now on the front leg, the rear leg moves forward, foot touching ground, becoming front leg and filling with strength and energy.

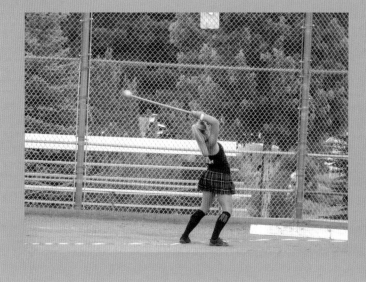

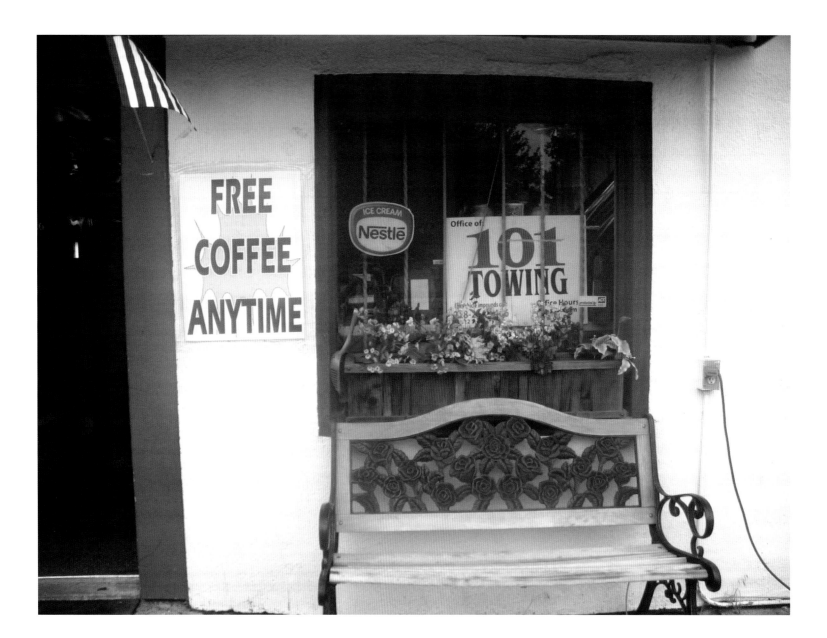

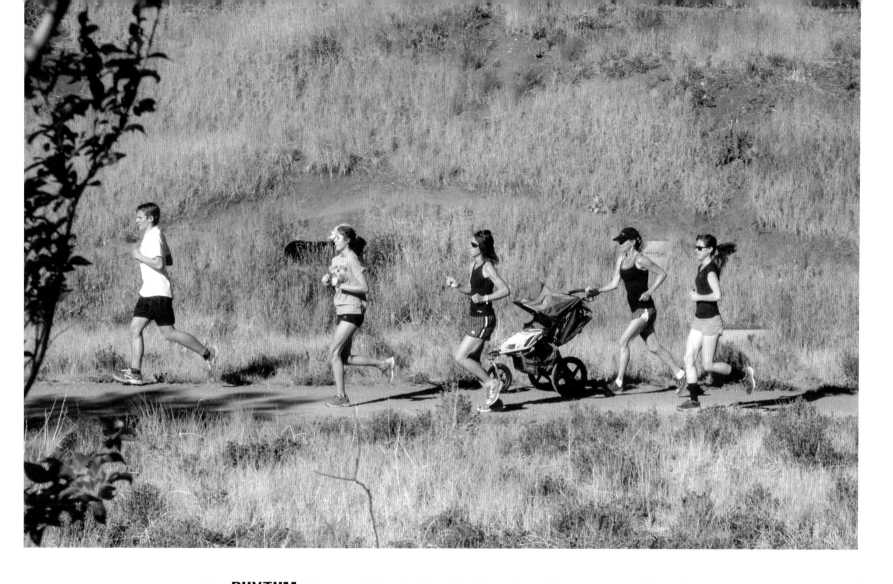

The **RHYTHM** of our walking both reflects and produces our emotional state. Look around. The sad drag along. The excited bounce. Those in hot pursuit of a chosen goal speed on a direct trajectory. Change your walking rhythm, change your mind. Motion is linked with emotion.

It is 1,066 steps from the library to my house (and presumably the same number going the other way, though it is a mysterious world). If the length of each step is three feet, though some may be less due to periodic icy conditions, that means 3,198 feet, or somewhat less than two-thirds of a mile. It is a pleasant walk that offers the occasional convivial encounter with a humanoid, feathered, or furry neighbor. Today, I returned the Swedish author Henning Mankell's *The Troubled Man*, which is the swan song of his aging detective, Kurt Wallander, and bumped into and gave a lift home to Vaclav Havel's autobiography *Disturbing the Peace* and to Jim Harrison's *Sundog*. I thoroughly enjoy walking. Solvitur ambulando! It is solved by walking around. Or as Jim Harrison writes in his Author's Note to *Sundog*: "I shouldn't have been caught standing in the first place. It is an unnatural act. Fluidity and grace are all."

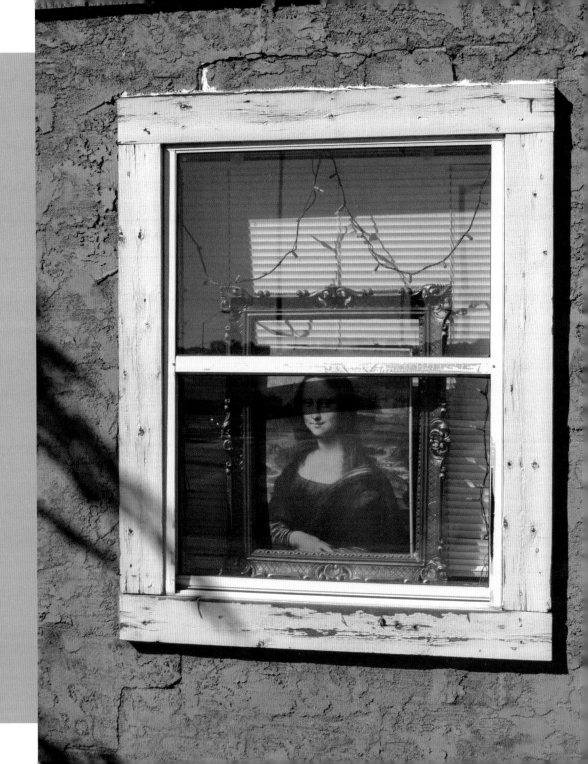

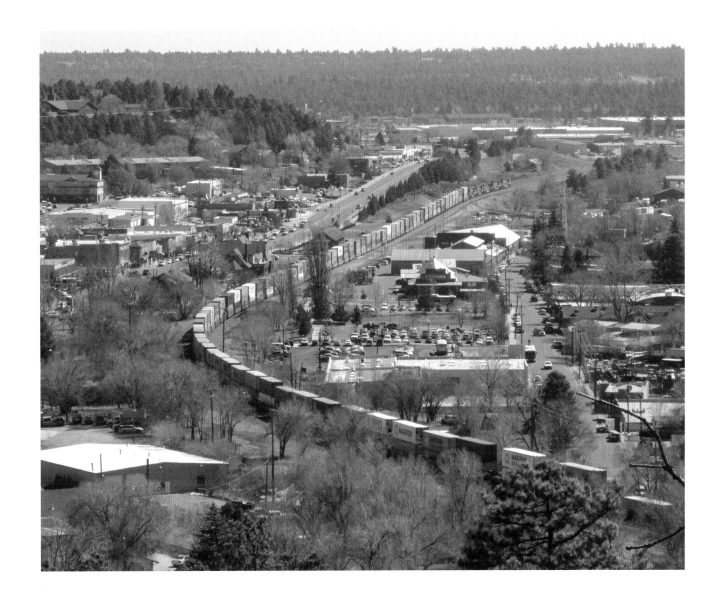

TO MAKE A MOVE, you have to find your ground, merge with that ground, become the ground. Then spring with quick release. No clinging. An immersion and a letting go. Walking through life requires that this be done repeatedly. And yet it is no repetition, no mindless endeavor of an automaton, zombie-walking...unless we make it so. Each immersion is a new immersion. Each release is an act of daring, a launching into the unknown.

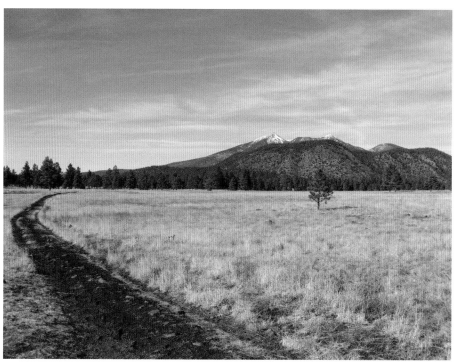

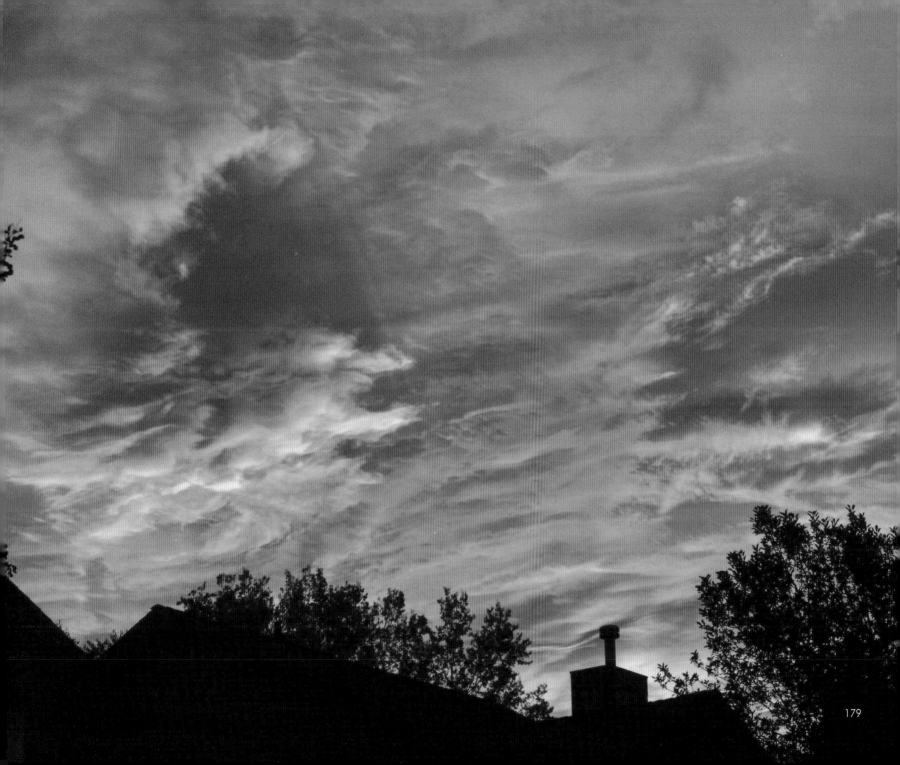

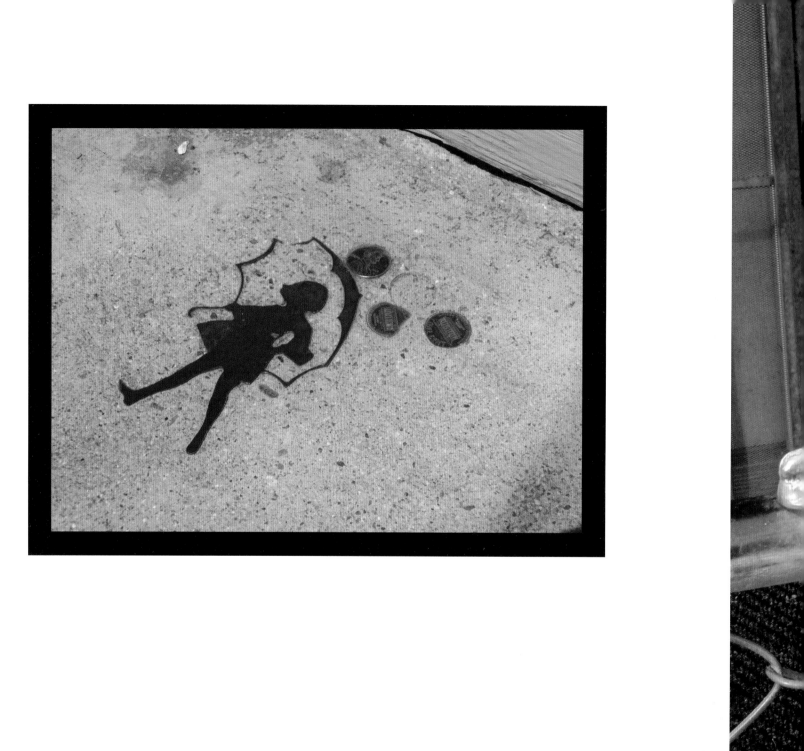

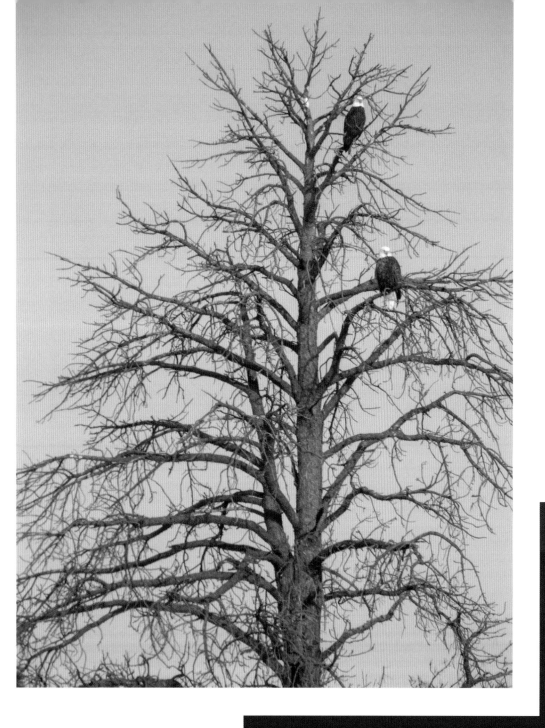

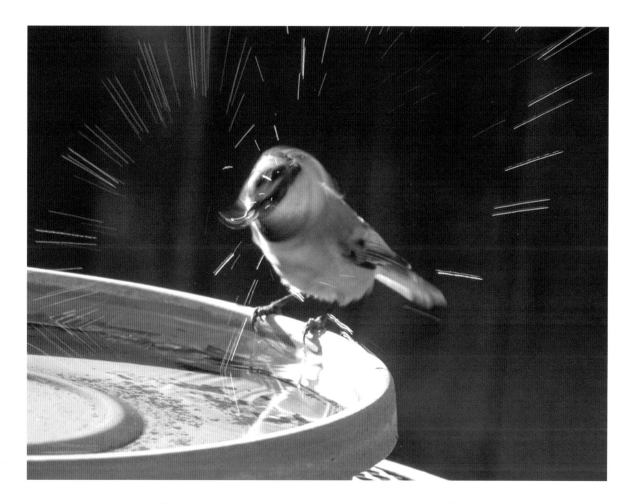

Dis-cover: to uncover, to throw off the covers of the bed of thought of yesterday and last night and get up. No easy task. But what do you want to do, lie in bed all day and be fed peeled grapes? Get up and go.

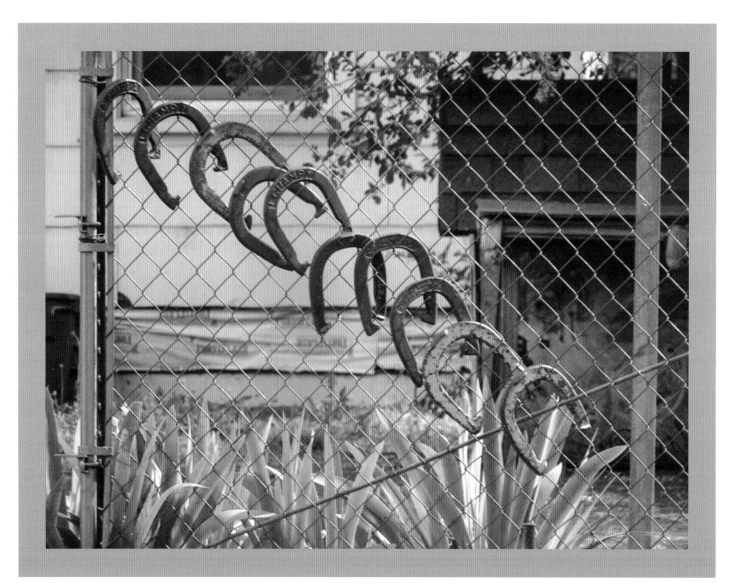

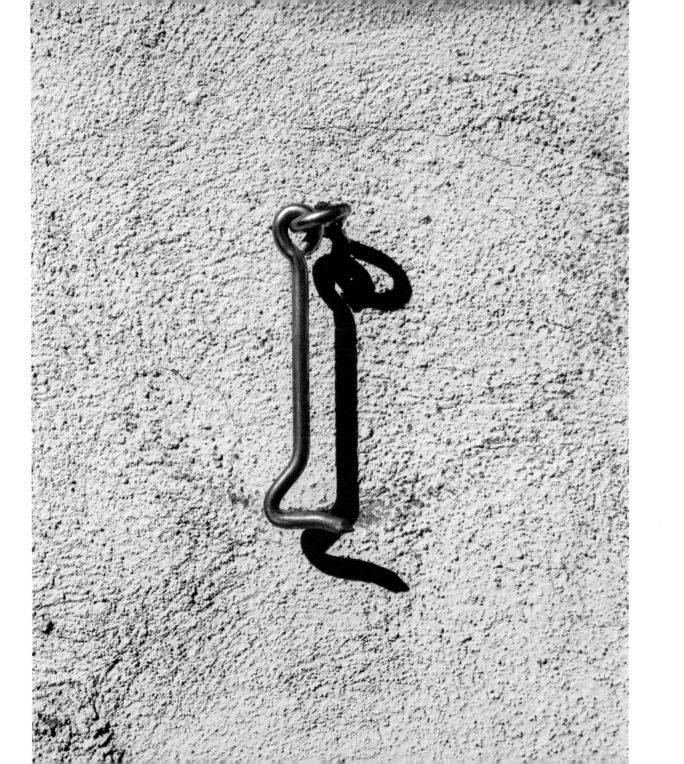

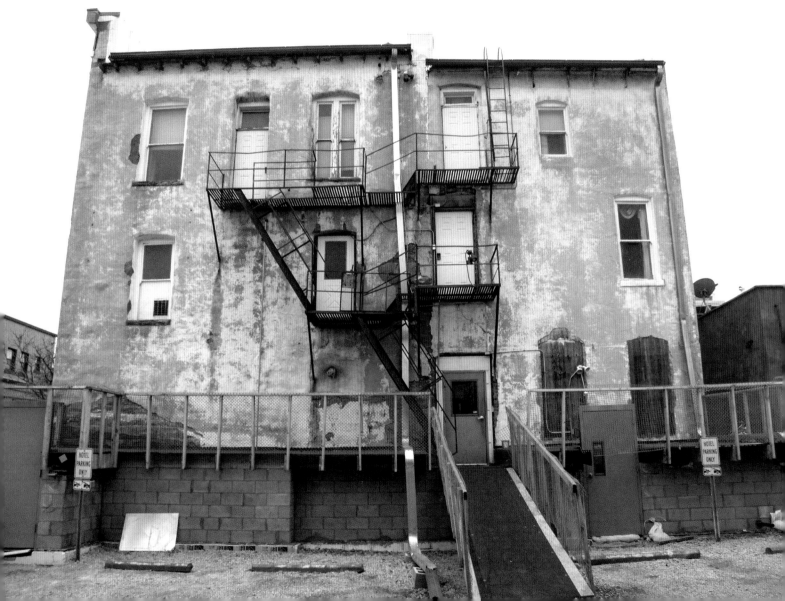

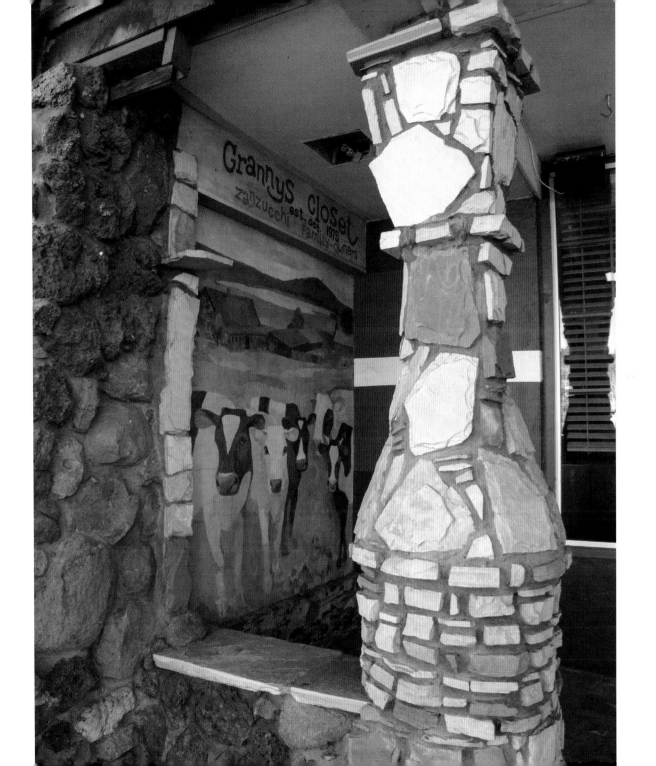

187

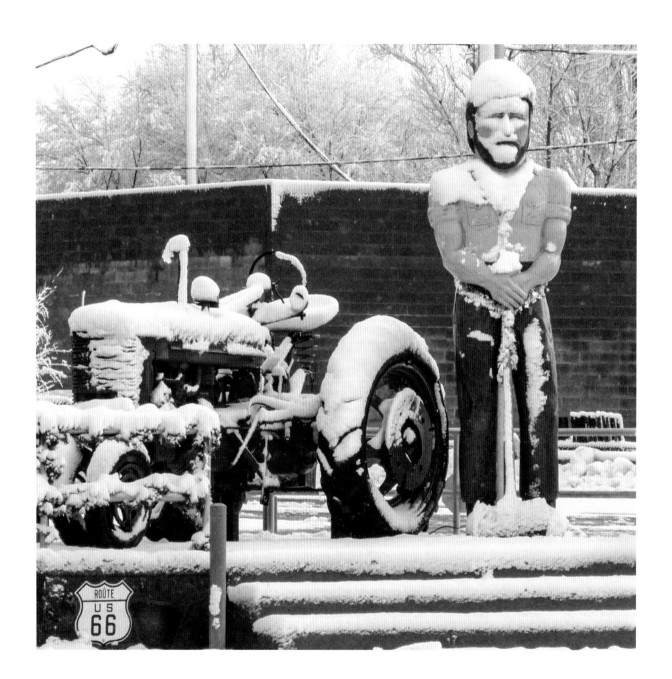

189

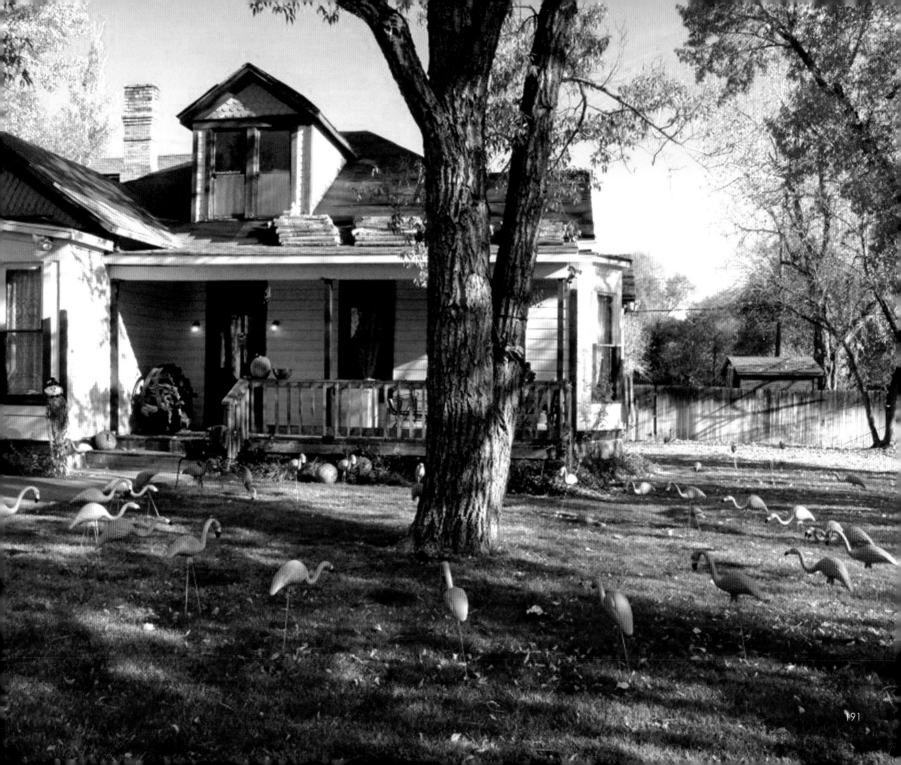

In addition to the other morning runners, a woman just went by with a large bulldog sitting erect in a 3-wheeled jogging stroller.

I LOVE THIS TOWN!

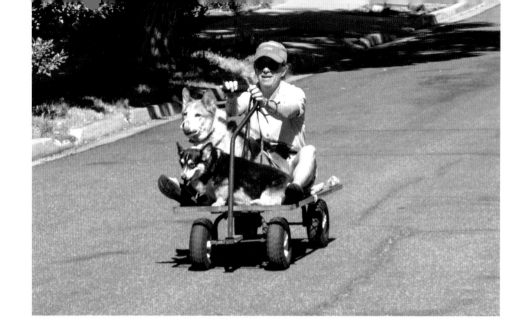

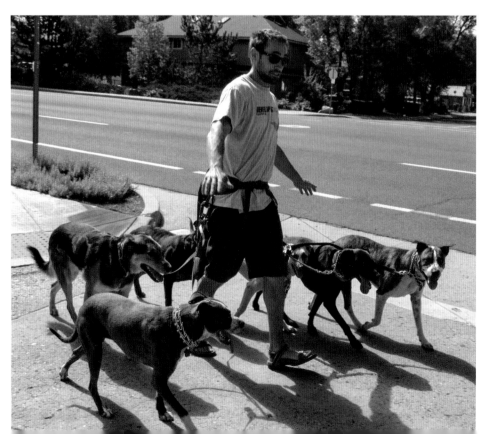

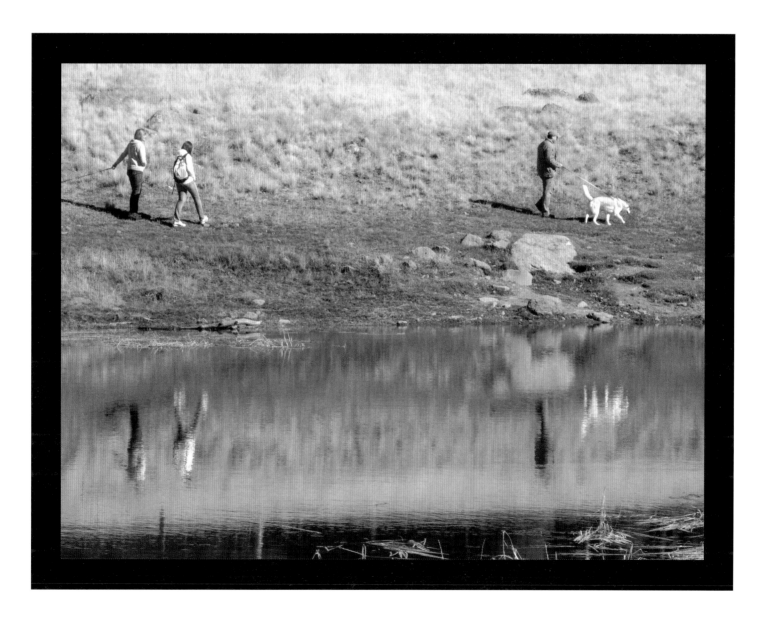

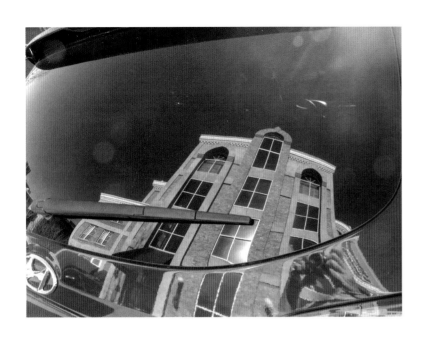

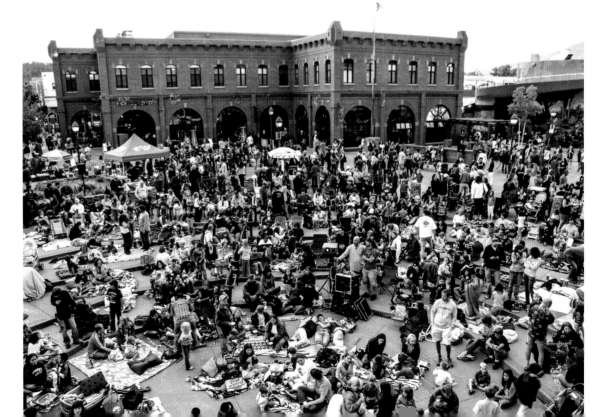

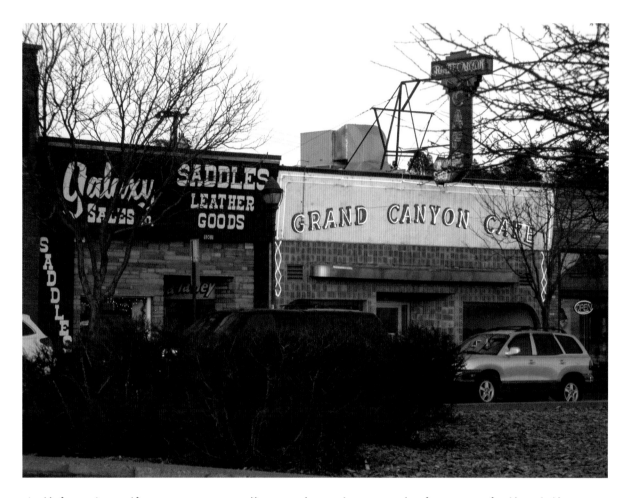

A thing I notice, as a walker, about people in cars is that they will pull into a parking place and leave their lights on while they sit in the car. For a long time. Talking on their smartphone, I guess, or adjusting their underwear. Ruins my night vision. I like the night and walking in the night partly because I can see . . . until someone drives up and blazes those lights like they are the Blessed Jesus Himself returning to Earth in glory.

When you go for a walk with your phone or with earbuds or with your continuous parade of thoughts, your head is stuck inside a cul-de-sac, inside a thought bubble. You move with unseeing eyes, impervious soul. You are like a fish wrapped in yesterday's newspaper. So caught up with your own imaginings, you do not allow yourself the pleasure and the rejuvenation of simply walking the earth.

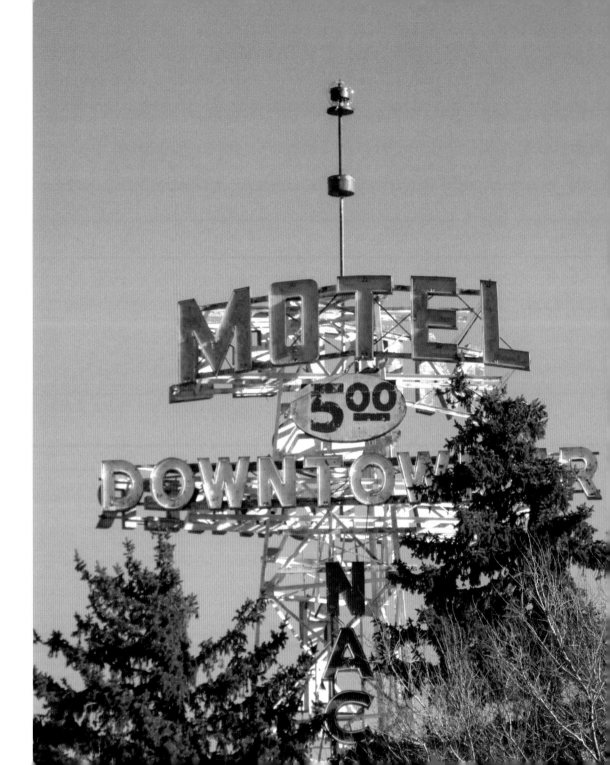

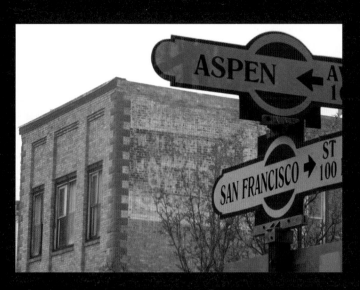

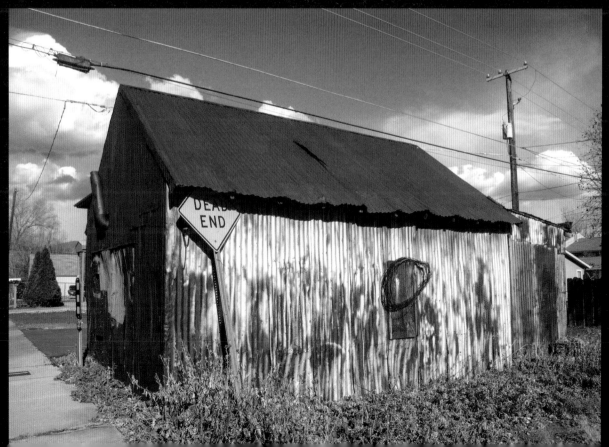

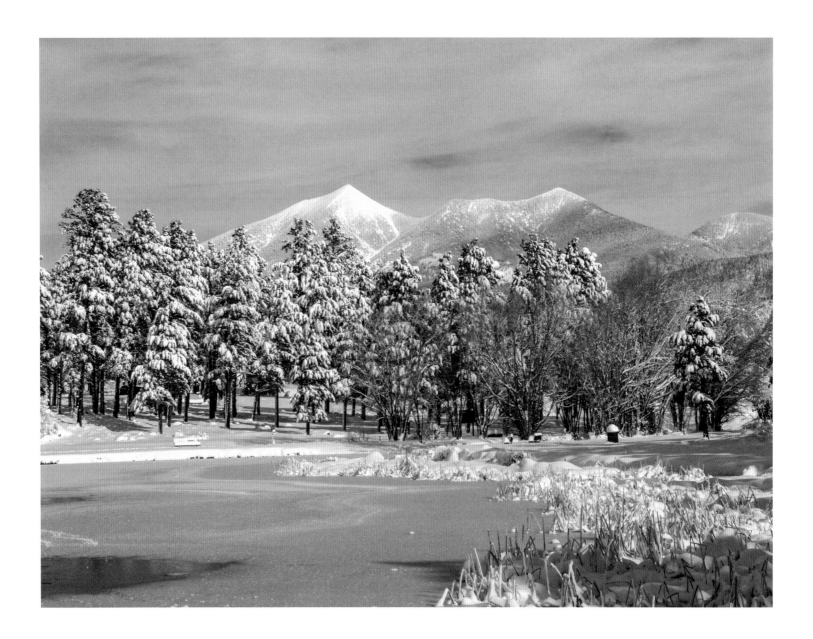

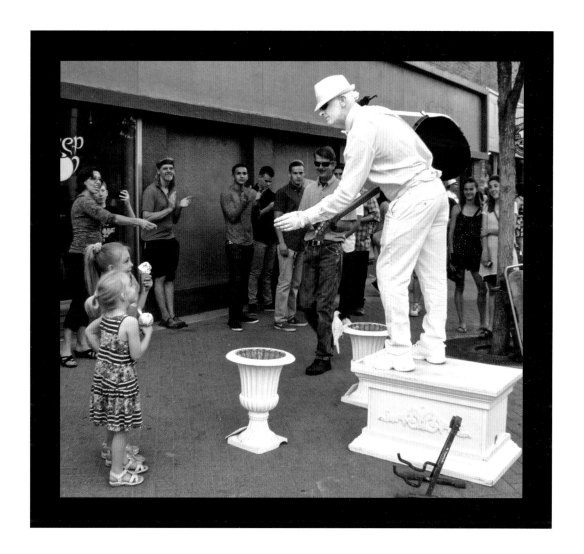

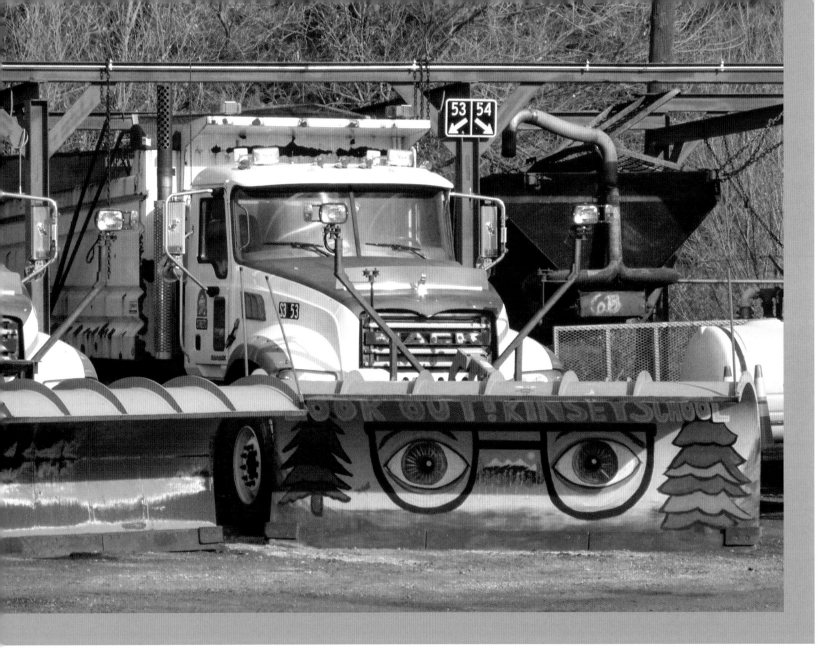

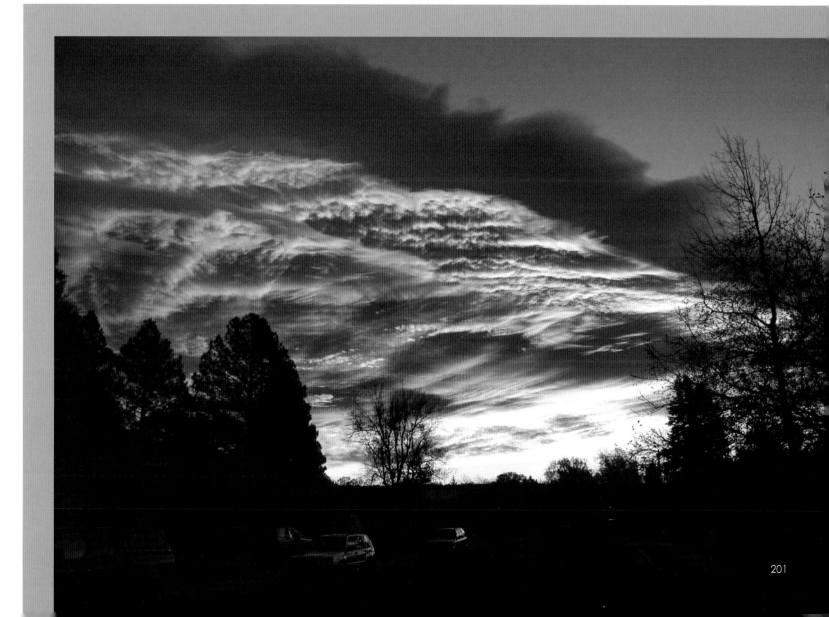

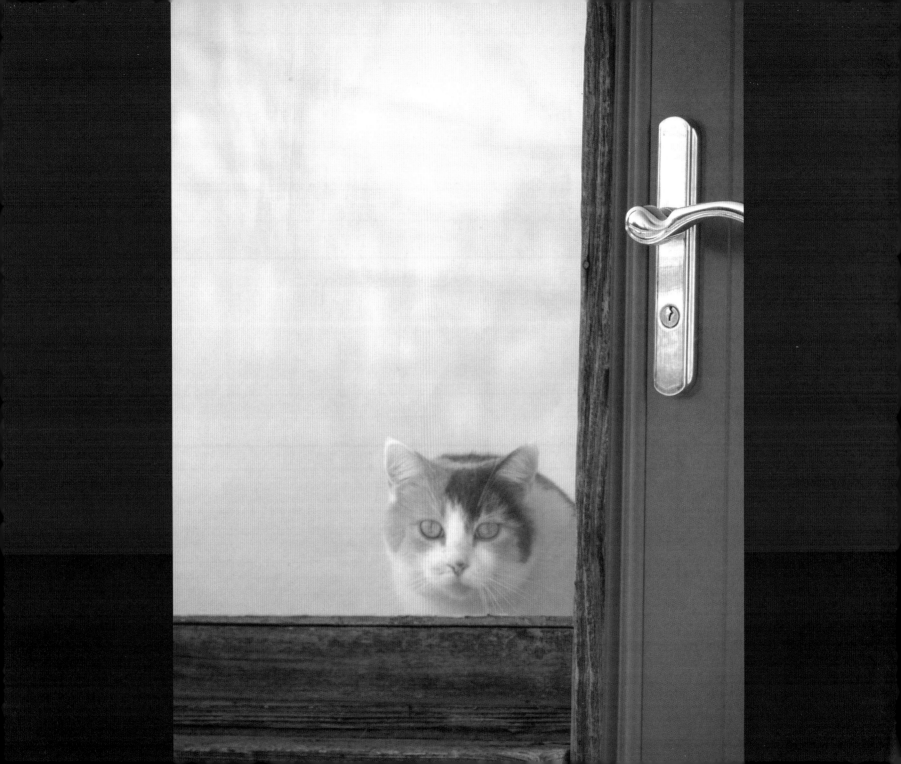

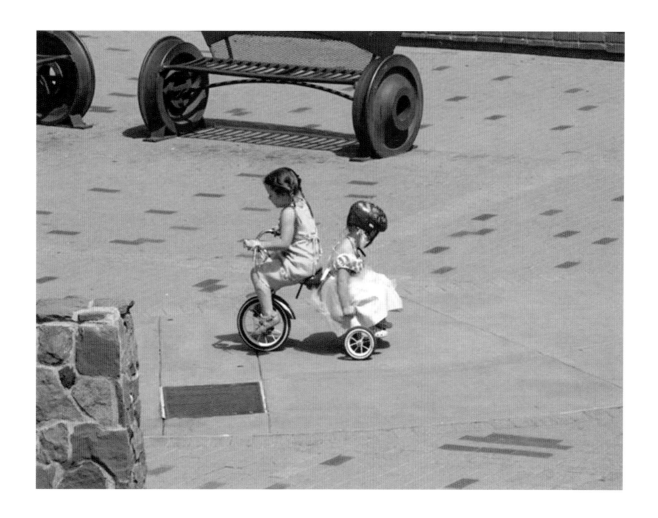

When there is no obvious path to walk, the path is still known, encoded within us and more. This is a loving universe, up close and personal. We are known and our path is known, though at the moment we are lost in the woods. If lost in the forest, David Wagner writes, "Stand still. The forest knows where you are. You must let it find you."

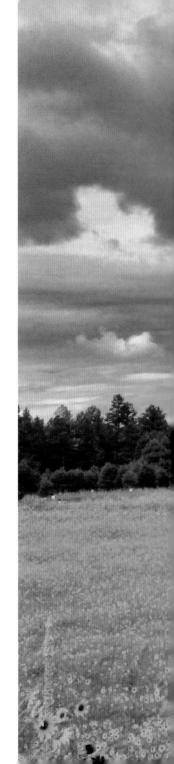

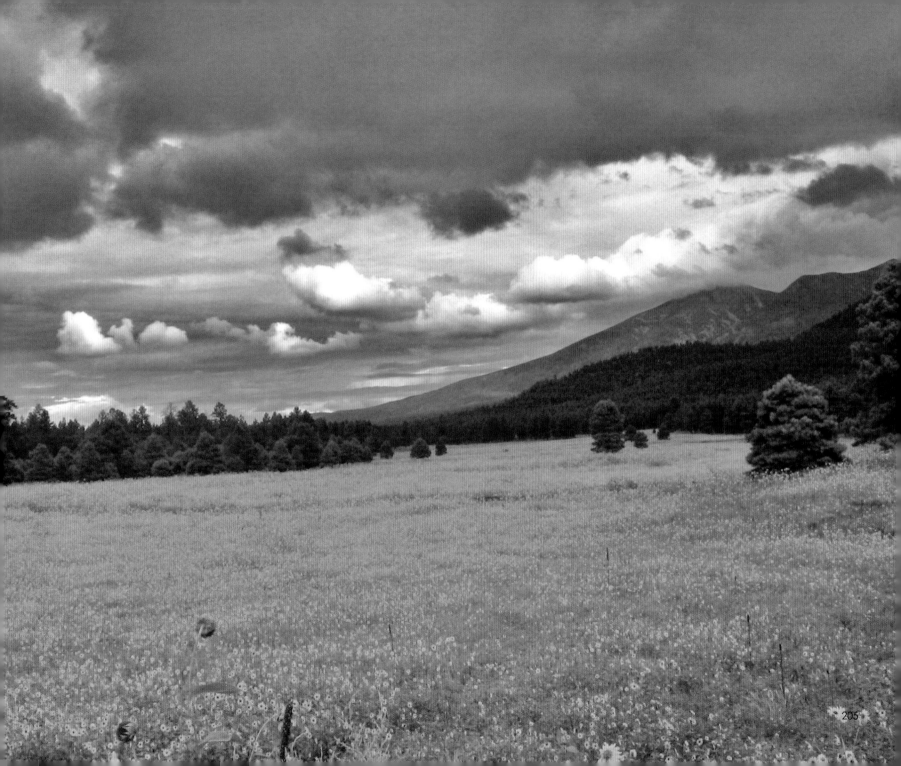

ACKNOWLEDGMENTS

Great appreciation goes to Sasha Karcz, who both suggested and provided a backup system for my photos, then spent hours downloading the photos into a format easily accessible to me and others. It seemed touch-and-go for a while, but you persevered with your usual calm and steadfast manner and made it happen. I love you, Brother!

My Flagstaff friend Mary W. Black, a lover of my duck photos, came immediately to my rescue when my first camera died. Mary gave me a camera of the same make and model, sending one of her sons over that very night to leave it hanging on my door while I slept. Thank you, Mary; you're now and always in my heart. See you on the other side.

When Mary's camera was stolen from me, Jake Bacon showed up with a gift of a third Olympus SP-800UZ camera, allowing my virtually uninterrupted photo-taking. In addition, Jake agreed to be photo editor for this book. I love you, Jake. Your contributions are invaluable both in these pages and to the Flagstaff community at large.

Kayley Quick, with her boundless enthusiasm and lively spirit, helped guide us through the Kickstarter world, where we found community support in both dollars and well-wishing. Thank you, Kayley, for making room in your already incredibly busy life to join your energy to this effort.

This book would not exist without the patient guidance, knowledge, and hard work of Julie Hammonds, whom I now proudly call my friend. Thank you, Julie. You and your Soulstice Publishing co-founder, Myles Schrag, have brought a long-sought vision of mine into being in a beautiful and delightful form beyond my expectations! Your talents and your personality are a gift to us all.

I am eternally grateful for the loving support of Karen Mattingly, my partner, who helps me keep my head on straight and my feet on the ground. I would be nowhere without you, honey.

WALKING FLAGSTAFF BENEFACTORS

These generous people backed the *Walking Flagstaff* book project through a crowdfunding campaign on Kickstarter and via other avenues. My gratitude goes out to them. –George

Abbie Gripman

Abe Springer

Alice Freet

Alison Rucker

Allison Bair & Sasha Karcz

Amanda DeLano

Amanda Elson

Amy Kelly

Amy Nunemaker

Amy Reams

Ana Novak

Andrew & Katelynn Braatz

Angela Cooper

Angela Yamauchi

Anne Doyle

Anne Leota Hart & Liz Brauer

Anne McGuffey

Anonymous

The Atiemo Family

The Baldwins

Barb Boznak

The Baumgartel Family

Becky Daggett

Becky, the dentist office chick! xoxox

Betsy Kerr

Beverly Miller

Bill Ferris

Bob & Alicia Voytek

Brad

Buck Manhands

C.R. Doherty

Carli Moncher

Carly & Matthew Banks

Carol Ann Stapleton

Carol Scholing

Caroline Sokoloski

Catherine Bell

Cathy Gazda

Cathy Snow Speirs & Eric Speirs

Cathy Spitzer

Chance Boultinghouse

Chris Greenough

Chris Gunn

Chris S. Johnson

Chris Scully

Christine M. Brown

Cindy Ferkenhoff

Cindy Kirkeby

Clara Machado

Colin Taber

Colleen O'Neill

Corey Allen

Cristy Zeller

Crystal

Cynthia Herron

Cynthia Knox

Dan Hellman

Dara Marks Marino

The Darr Family: Ryan, Sarah, Quinn, & Claire

Dawn Dyer

Debby McCormick

Dena Dierker Kuhn & Helmut Kuhn

Dennis Steigerwald

Devonna Mcrae Preston

Diane A. Rechel

Duane & Patricia Nelson

The Dudz

Dwayne & Gary

E. Mahoney

Elizabeth Blaker

Elizabeth Croston Buckalew

Emily Markel

Emily Omana Smith

Erika N. Palm

Erin Engelmann

Ernest L. Bontrager

Estacia Halfelven

Evie & Ella Lewis

Gil Gillenwater

Gina Young

Gregory LeFever

Guest

Hattie Loper

Heather Bell

Heather Bustrum

J.B. DeWitt

Jack & Patricia Johnson

Jacquie Kellogg

James Byas

Jamey

Jane MacDonald

Janis

Jen Mills

Jessica Lawless

Jim Torson

Joan E. Enoch, M.D.

Joanna Van Oss

Joanne

Joe Grumbo

Joe Williams

John B. Moore

John G. Willis

John L. Rogers

John McCulloch

John Mulhern

John Vanlandingham

Jonathan Whitehorn

Juanita Heyerman

Judith Manoogian

Julie Hammonds

Julie Morrison

Karen Kline

Karen Lee Glick

Karin Ross

Karla J. Kennedy

Kate

Kathleen Haley Jenkins

Kathryn Willis
Kathy McConnell
Katie Stitzer
Katie Woodard
Kelly Poe Wilson
Kenneth McIntosh
Keri Postlewait
Kiersten Parsons Hathcock
Kimberly Harn
Kiona Kay Allen
Kurt & Tracy Braatz
Lacy Ravencraft
Lance Diskan
Lara Gomora
Lindajean, the sister
 Marine. Semper fi!
Lisa Cantor Ganey
Lou & Joyce Klejbuk
M. Lane
Mac England
Marcelle
Margaret H. Pease
Marie Jones

Marilyn Korber
Mary Mohr
Mary Ross
Mathijs van den Bosch
Matt Anderson
Maurine Wise
Megan Good
Mei Ling Chun
Melinda R. Bloom
Melissa Boren
Melissa Cripps
Michael
Michael Edward Gerner
Michael McBride
Michele A. James and
 Peter Friederici
Michele Schiavone
Mike Bencic
Mike Taylor
Morgan
Morgan Braatz & Will Rieve
Myles Schrag
Naima Schuller

Nancy Dorffi
Nancy Pitz
Neil Weintraub
Nicholas Geib
Nora Welsh
Oliver & Theodore
Pamela Green (Sam)
Patrice Horstman
Patti Jenner
Paul, Sue, Will, & Kate
 Wagner
Peggy Sheldon-Scurlock
Perry Davidson
Phil Breed
Phillip R. Furgason
Pipp Piatchek
R. Daniel Duke
R. Eileen Moore
Rachel Gibbons
Rachel, Brittain, & Ari Davis
Rand
Rhys Lysandra Davies
Rich & Benita Boyd

Richard Miller
Roabie Johnson
Rob Dutton
Robbie Bergman
Roberta Bloss
Rona & Kelly Mortensen
Rose Houk
Ruth Kenney
Sally Evans
Samantha Ward
Sandra Lubarsky &
 Marcus Ford
Sara Herron
Sarah
Sarah Witham
Sharon & Larry Fox
Sherri & David Leetham
Shonto Begay
Stephen DiBitetto
Steven & Susan Patrick
Sue Ordway
Super Bob Sally
Susan J. Rain

Susan Stark-Johnson
Sybil I. Smith
Tamera Martens
Terri & Jim Palm
Theresa Bierer
Theresa, Alex, & Maisie
Tim Quigley
Tina La Chance
Tina Martinez
Tom
Tom Bean
Tom Vendetti
Trevor Schorey
Trish
Troy Galloway Gillenwater
Valerie Caro
Wayne & Helen Ranney
Wendy Evans
Wendy Wildey
William & Mary Spears

Benefactors who pledged $100 or more to the crowdfunding campaign that supported the creation of *Walking Flagstaff* were invited to designate a loved one—or a special Flagstaff location they wished to remember—on this page. We pause a moment to honor these special memories.

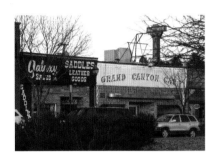

Al Korber

Andy Womack's Flaming-O Motor Hotel

Angie Lindbergh

Bette O'Connor

Dick McCallum

Don Neff

Dr. Donald V. Bendel

Emily Marie Benson and Jackson Patrick Haughey, forever in our hearts

Mr. Flagstaff (Jim Roy)

Gammage the Cat

Haven Walker

Henry and Sam Taylor

Henshook, old hunting and fishing buddy and honorary grandpa to Harrison and Audrey

Howard Hill, who also loves seeing the world through a camera

Innocence lost but wisdom gained; such a harmonious turn of the leaf.

Jacqueline Weintraub

James R. "Jim" Hammonds, who would have loved this book

Jan Hovan

Joe Sharber

John Running

Joleen Schrag: May she be walking now.

Joni Duran

Kato

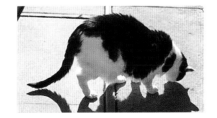

Marilyn and Owen Seumptewa

Marion Milburn, gone for now, in our hearts forever. Thank you for bringing me "home" to Flagstaff.

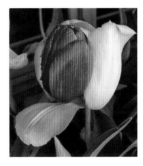

Mary W. Black, always in our hearts

Matt Kelly

Mia's, where you could always find a friend

The 90s in Flagstaff and all the "wild women" and guys I hung out with, from Joan. Miss you all. You know who you are.

My father, Powell Gillenwater, who introduced me to the enchantment and wonders of Flagstaff when I was a very young boy

Randolph Jenks

Tim Westbay, beloved father and grandfather

Tom and Barbara Vendetti

Tony Krzysik, Ph.D.: ecologist, herpetologist, naturalist, and fisherman supreme!

To walking Flagstaff with my soul bro George, from Steve.

With eternal gratitude to our WWII Navajo Code Talkers

Rather than create an exhaustive list of subjects and locations, we offer here a selective set of notes for those who want to learn more or check their memory (especially of certain iconic sights, including places that no longer exist as they did when the photo was taken).

Aspen trees, Inner Basin of the San Francisco Peaks: 6, 7, 21

Autumn atop Snowbowl Road: 5, 20

Basque Handball Court near South San Francisco Street: 18, 149

Bridge (no longer existing) spanning the Rio de Flag outside downtown Flagstaff City–Coconino County Public Library: 2, 3

Burlington Northern Santa Fe trains and tracks through downtown: 28, 60, 61, 128, 144, 145, 148, 177

Café Ole (no longer in business) on South San Francisco Street: 27, 58, 140

Chip Thomas, muralist and physician: 32, 114

Chip Thomas's mural art: 32, 97, 114, 134

Circus Bacchus (no longer performing): 64, 75 (bottom)

Cline Library at Northern Arizona University: 46, 80

Coconino County Courthouse on North San Francisco Street, built in 1894: 78, 101

Downtowner Motel sign a block south of Historic Route 66: 196

El Divino Redentor, Flagstaff's oldest surviving church (built in 1892), at South San Francisco and Dupont streets: 51

El Pueblo Motor Inn on Historic Route 66: 96

England House, built in 1902 by master stonecutter William England: 29

Flagstaff Armory, built in 1920: 33, 88 (bottom)

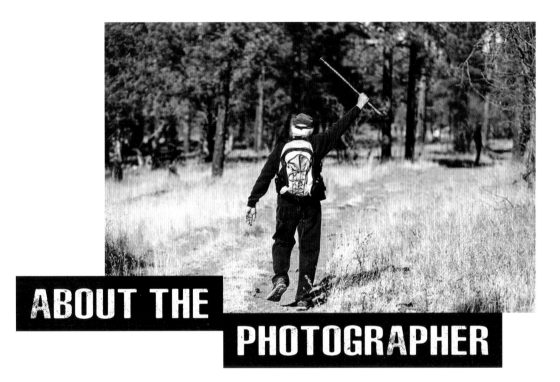

ABOUT THE
PHOTOGRAPHER

At age 71, Marine and martial artist George Breed retired from a career in psychology and began walking the paths, streets, and back alleys of Flagstaff. He soon added a camera to his daily stroll. His photo blog, "Walking Flagstaff," blossomed into a popular Facebook page. He became friends with Flagstaff's street people, business owners, politicians, river runners, canyon hikers, street musicians, fabulous artists of paint and jewelry and acrobatics, and other photographers. More than a decade later, George is happy to be sharing the sights and stories of this special town with you.

ABOUT THE PUBLISHER

Soulstice Publishing took root between the ponderosa pines at the base of the San Francisco Peaks. Our mountain town of Flagstaff, Arizona, abounds with scientists, artists, athletes, and many other people who love to live in such an inspiring natural setting. Considering the dearth of oxygen at our 7,000-foot elevation, you might say life here leaves us breathless—which is what we strive for when you read a Soulstice book. We work with authors at every stage of the publishing process to shape their ideas into books with impact and purpose.

Learn more at **soulsticepublishing.com**.

Soulstice
PUBLISHING
books with *soul* • Flagstaff, AZ

Soulstice Publishing, LLC
PO Box 791
Flagstaff, AZ 86002
(928) 814-8943
connect@soulsticepublishing.com